Riding Astride

RIDING ASTRIDE:
THE FRONTIER IN
WOMEN'S HISTORY

PATRICIA RILEY DUNLAP

ARDEN PRESS, INC.
Denver, Colorado

Library of Congress Cataloging-in-Publication Data

Dunlap, Patricia Riley, 1943-
 Riding Astride : the frontier in women's history / by Patricia Riley
Dunlap.
 p. cm.
 Includes bibliographical references (p. 177) and index.
 ISBN 0-912869-17-8 (hardcover). -- ISBN 0-912869-18-6 (pbk.)
 1. Women pioneers -- West (U.S.) -- History -- 19th century.
 2. Frontier and pioneer life -- West (U.S.) 3. West (U.S.) -- History.
 I. Title
 F596.D78 1995 95-21682
 978'.02'082 – dc20 CIP

*Cover photo reprinted with permission of the
Nebraska State Historical Society, Lincoln.*

Typography and design by AK Graphics, Inc.

Published in the United States of America
Arden Press, Inc.
P.O. Box 418
Denver, Colorado 80201

TABLE OF CONTENTS

ACKNOWLEDGMENTS

My family's efforts at creating an atmosphere of quiet encouragement during the research and development phase of this book are greatly appreciated. It isn't easy for three teenagers progressing into adulthood, Steven, Tricia, and Matt, and an exuberant husband, Steve, to become silent on command, but they've been enormously considerate.

I'm thankful for the awareness my parents instilled in me. Not only was I reared by an historian amid the historical atmosphere of Yorktown, Philadelphia, and Williamsburg, but I learned early to apply the lessons of history to my daily existence. History continues to hold for me an excitement I cannot explain, but for which I am eternally grateful to my parents, Edward Miles Riley, Ph.D. and Annette Powers Riley.

The marvelous library at Mary Washington College in Fredericksburg, Virginia stocks a wealth of material concerning women's history, and its staff is dedicated to assisting those in the pursuit of knowledge. No other library in the greater Washington, D.C. area, with the notable exception of the Library of Congress, is as complete on the subject of women.

My contacts with individuals, libraries, historical societies, and archives throughout the western states resulted in a variety of responses. The most helpful individual by far was Nancy Sandleback, manuscript specialist for the University of Missouri's Ellis Library in Columbia, Missouri, who provided me with invaluable information on several women. Nearly as helpful were Betty Penson-Ward, delightfully eccentric Boise, Idaho historian, journalist, and author; Elizabeth P. Jacox, librarian for the Idaho State Historical Society in Boise; and Carol Downey, reference librarian for the Arizona State Research Library in Phoenix. Their knowledge of both history and regional mythology helped contribute a certain intrigue to this work that might otherwise have been lost. Finally,

Sylvia Rortvedt, instructional services librarian for Northern Virginia Community College's Alexandria campus, is extremely well versed in the use of the interlibrary loan network, an ability that allowed me to benefit from precious primary and secondary works I had been unable to locate on my own. Thanks to all of you.

INTRODUCTION

The eminent historian Frederick Jackson Turner attributed the characteristics of American society and institutions to the frontier experience. According to his thesis, the ready availability of unclaimed land and the primitiveness of pioneer life were the determining factors of American democracy and culture.

Turner's insight aside, he was a typical nineteenth-century male. For him, as well as for his professional colleagues, history was the study of men. The attempt to introduce women into the American chronicle is less than a generation old. Had Turner and his associates studied women as well as men, they would have found an even more radical transformation than that which they trumpeted. As women adapted to the hardships of the frontier, they learned that the tendency toward egalitarianism and individualism shared among men worked nearly as well for women. They developed the self-assurance necessary to expand their social and economic horizons. In a fundamental way, Turner's frontier thesis is as real for the women of the United States as for the men.

Thanks to recent efforts, immigrant pioneer women have been discussed at length. These women set a standard that ultimately helped to civilize the "Wild West," but they did little to change the role assigned to women back home in the East. The more eccentric western women have yet to be heard. Their extreme and even militant behavior helped crumble the strict social codes of the nineteenth century. These mothers and daughters of the trans-Mississippi West and the conversion they compelled are the subjects of this study.

The "Turner Thesis" has been under attack by revisionist historians who condemn Turner for a "white male" focus in his frontier histories. Critics rightly point out that the frontier West was more diverse than

Turner appeared to notice—that women, Native Americans, African Americans, and Latinos peopled the wide open spaces as well. In recognition of the influence of the "Turner Thesis" on my own historical awakening and in honor of his unique (for the nineteenth century) talent for synthesizing the logical, I intend to transform his thesis concerning the frontier's repercussions on the American character to include women, because it worked for them, too.

In achieving this goal, primary issues regarding the history of women should not be overlooked, although certain aspects of those issues may not belong in the text itself. Because of their reproductive function, women have traditionally been identified solely as biological creatures. Before the early twentieth century, the business of propagation consumed the adult woman from adolescence to death. It was the primary cause of death and disability in women, and there seemed to be no safe way to prevent it other than abstinence—an unacceptable option to most married couples.

Until the second quarter of the twentieth century, the use of birth control was usually illegal and nearly always considered immoral. Its availability was severely limited and knowledge of its use confined to the most sophisticated individuals and, antithetically, informed prostitutes. The only methods regularly used were pre-ejaculation withdrawal (considered sinful by many religions) and celibacy, often practiced by more dominant middle-aged women to the disappointment of their husbands. Self- or illegally induced abortions were common as well, although the secrecy surrounding them make accurate statistics impossible. The use of diaphragms and then condoms didn't become popular until after World War I, when advancing technology made them both more dependable and more comfortable.

Before the twentieth century, a married woman could expect to become pregnant every two to three years during her twenties and early thirties and to be giving birth to her youngest children in her forties, if she lived that long. Six to eight pregnancies was typical and fifteen not unheard of.[1] Thanks to ignorance concerning prenatal and infant care plus the proliferation of childhood diseases, slightly less than two-thirds of the children born in nineteenth-century America lived to become adults. One out of seven American babies died at birth.[2]

Mothers were in as much danger as babies. Deaths caused by infections such as "childbirth fever" or "Bright's disease," breech births, and other complications killed them as often as they did their offspring. Knowing no better, doctors and midwives delivered babies with hands

that had seen no soap for days, used dirty, rusty instruments, and were too often helpless in the event of hemorrhaging and prolonged labors. At the turn of the twentieth century, a woman's life expectancy was forty-eight years, and one out of thirty women could expect to die in childbirth. Tuberculosis (often called consumption) was the only medical condition more hazardous to women.[3]

Generally speaking, if a nineteenth-century woman wasn't pregnant, she was lactating. Only the wealthiest of families could afford wet nurses on a regular basis, and glass bottles with rubber nipples were used only in cases of emergency and then temporarily. A new mother breast-fed her child one to two years, sometimes producing an additional baby before weaning the elder sibling. In those tight-lipped days, breast-feeding was regarded as shameful because it necessitated the baring of a breast. Only the most lowly women dared nurse babies in public, and then usually under wraps. "Ladies" simply stayed home most of the time.

Each new child, therefore, generated approximately two years of confinement for its mother. With pregnancies usually no more than two years apart, the isolation was nearly continuous until death or menopause. Before the twentieth century and its de-mystifying of the reproduction process, women were literally prisoners of sex, as well as the births, tragedies, offspring, and delicate conditions that accompanied it.

Menstruation tended to be nearly as disabling as pregnancy, although the average married woman experienced it infrequently since she was usually pregnant or lactating. Hampered by the lack of satisfactory sanitary attire as well as by volumes of superstitions regarding the monthly "curse," non-pregnant women were essentially out of commission one week out of four. The term "on the rag" was an accurate one before the 1920s, for that was the only means of sanitary protection available. Women literally wrapped rags (soft flannel if they could afford it) through their legs, over their lower torsos and around their waists. The cloth was bulky, far from waterproof, and quickly became odoriferous. Add to this already unpleasant situation predominant early American superstitions regarding the dangers of bathing during menstruation, and one quickly understands why American women wore floor-length skirts crammed with numerous petticoats.

Liberation came disguised as a first-aid treatment for soldiers during World War I. A wood fiber named cellucotton was invented to ease the scarcity of bandages on the front lines. Its absorbency was impressive enough to prompt manufacturers of the Kimberly Clark Company to produce the first disposable sanitary napkins in 1920. Given the

mood of the times, these "catamenial receptors" went on the market in plain brown paper wrappers, but within a year, the "Kotex" brandname had been adopted and printed discretely on the packages.

At first, it was a lucky woman who could find out what these strange parcels held. Because of the embarrassment surrounding the entire subject of feminine hygiene, Kotex was advertised as an item that allowed women to move about more freely. Nothing more was said about its function. In 1923, the Sears and Roebuck catalogue first offered Kotex as a sickroom supply, and women began to promote the product among themselves through the private network that had kept them informed about such things for centuries. By 1925, those brown wrappers were hard to keep on the shelves of local pharmacies. Women relieved of the constant biological burden discarded their voluminous petticoats and yanked their hemlines up to their knees.

Despite considerable impediments, exceptional nineteenth-century American women of the frontier West somehow overcame their biology to achieve unusual and often daring feats. They rode horseback astride rather than sidesaddle, branded cattle, taught school, mined fast-moving rivers for gold and silver, farmed, ranched, performed in rodeos and wild west shows, worked as journalists, doctors, attorneys, and much more. These extraordinary individuals are the subjects of this work, but they're also its challenge.

A probe of western women immediately runs headlong into a double dose of romanticism. Americans have traditionally preferred to believe in an idealized vision of the pure, moral, domestic female. They've been equally adamant in their perception of the wild and woolly, gun-slinging West. Until recently, much of the history of both topics had been accommodating to those preferences.

Historically, women as a group have held domestic positions that removed them from the concerns and challenges of the outside world. Men indulged women as a means of keeping them home and because the American culture was infused with notions of female delicacy, and women, enjoying the vulnerability and worship, encouraged them without seeing the injustice and ludicrous nature of the situation. Those who didn't conform to protocol were considered peculiar and, because of their "eccentricities," were either ignored or maligned by historians. Yet it was those "peculiar" women who transformed American culture. Their courage and determination served as the loam in which the seeds of change were planted. The very fact that they refused to conform made

them the initiators of women's rights in this country. They deserve recognition and as much historical accuracy as it is possible to grant them.

Because the history of these women is affiliated with that of the American West, the problem of accuracy becomes even more complex. As early as the mid-nineteenth century, frontier legends have been popular with American readers. The West has been a marketable commodity for so long that its history is often embedded in cinderblocks of fantasy. The dime novels of the late nineteenth century glamorized the West. Novelists idealized it, and recently, films and television have glorified it almost beyond recognition. Anybody could and did write about frontier history. Thousands of first-hand accounts of pioneer experiences were recorded, and many of them survive. Those written as journals or letters are generally reliable, as their purpose was simply to record and inform. Those composed for self-aggrandizement or to justify a controversial way of life must be more carefully scrutinized. The latter tend to polish facts with a varnish of fiction that blurs the truth. Still, to ignore these accounts is to omit some of the most intriguing characters the West has produced.

Second-hand accounts are even more ambiguous. Nineteenth-century newspaper publishers often felt their mission included indoctrination as well as information. Many feature stories contained forceful morals arrived at by twisting the truth in a manner that was relevant to the editors but inaccurate for posterity. To further complicate the issue, factual histories of the West are interspersed with numerous accounts of western legends disguised as history. The latter cannot be ignored when working with the "eccentrics" of the time, for many of them became legends and because of their eccentricities were ignored by more qualified historians.

Conscientious historians are left with a grab bag of research material. They struggle to separate reality from romance and, when unable to do so, must acknowledge the dilemma to the reader. History, when handled carefully and correctly, can be more entertaining than legend, but so few people seem to realize it.

The fact remains that women went west by the thousands. They were as affected by the idiosyncrasies of the frontier as were their male counterparts, and perhaps more so. The West was the land of opportunity and pragmatism, and by adapting to it and overcoming the restrictions enforced on them by their own bodies and the cultural precepts of the day, pioneer women, particularly the "eccentric" ones, redefined the social and economic roles of their gender.

1
THE WAY IT WAS

Thousands of women went west during the nineteenth century, usually with husbands or fathers, but often alone. Thanks to the diaries they kept and the letters they sent back home, their journey across an untamed land became the best documented in American history. These writings have been under the scrutiny of frontier historians almost from their inception, but even more so recently. Originally, historical interest focused on women's role as domestic support for the brave men who conquered the frontier wilderness. Lately, the women themselves, in both supporting and starring roles, have gained a great deal of attention. The resurrection of interest in women of the West stems from the mid-twentieth-century feminist movement and revisionist insight into female motivations and reactions.

Early frontier historians, including the renowned Frederick Jackson Turner, overlooked the contributions of pioneer women altogether. Those who mentioned them at all tended to interpret female thoughts and responses according to the romanticism of the nineteenth-century culture in which they lived. Scholars with a single-sex view of history related directly to the social lore of the time–a presumption that the female of the species embodied all that was good, honest, pious, pure, and loyal. They wrote their histories accordingly. Until the 1960s, Americans wrote and read about uprooted eastern women who sadly, but bravely, bore the hardship and isolation of the frontier, having left behind everything dear to them out of loyalty to their men. These were the martyrs of the frontier–the "Saints in Sunbonnets" as historian Glenda Riley called them. When women were mentioned at all in early western history works, they were made to fit that stereotype.

More recently, revisionist historians have imposed a modern interpretation onto the activities and ideas of frontier women. Using a late twentieth-century feminist frame of reference, they write of rough and tumble women who were as gritty as any man. Their women could ride, shoot, and drive cattle with the best of them. They learned to wear pants or hitch up their skirts and were able to adjust readily to the vastness of the landscape and the many extremes that marked the challenges of the wilderness.

Interestingly enough, these distinctly different groups of historians weren't always talking about the same women. One group interpreted its history through the lens of the romanticized patterns assigned to nineteenth-century society. They saw delicate ladies who were out of their natural environments and miserable because of the estrangement. The revisionist historians satisfied the political needs of the evolving feminist movement by examining the nineteenth century through twentieth-century spectacles and finding it less than tolerant by modern standards. It was a matter of selection. Nineteenth-century historians were most interested in the women who "tamed" the trans-Mississippi frontier. Primarily farmers', miners', and ranchers' wives, they toiled uncomplainingly behind their husbands within the confines of the traditionally domestic, devalued female roles. Women who refused to confine their activities to those deemed socially suitable for the "weaker sex" were scorned by these writers as unnatural and even immoral. These historians simply didn't mention such women, or, if they did, they transformed "eccentric" women's stories into melodramas or objects of ridicule.

At first, most Americans were aware of "wilder women" of the West only because of the sensationally fictionalized stories written by the popular dime novelists of the late nineteenth century. The writers' treatment of these rather unique women was more fiction than fact and served to entertain rather than inform their readers. In fact, dime novels and the like badly muddled the historical record of the American frontier and made it even more difficult for ethical historians to seriously research the more daring western characters.

Historian Dee Brown was the first to treat these colorful women with any degree of respect in his 1958 work, *The Gentle Tamers: Women of the Old Wild West.* Brown's readers finally learned that many frontier legends had bases in fact, and that many others existed that had never before been mentioned. Still, Brown tended to treat these delightful women as isolated characters spawned by the low moral standards of the early fron-

tier. He seemed to assume that they were mere flashes in the pan whose lifestyles were curiosities but had no relation to the American culture that followed. Fortunately, history didn't give Brown the last word on the subject.

More recent historians have written of a frontier female who took her assigned, traditional role between her teeth and, with hard work and a refined sense of freedom, carved for herself and all womankind a new position of respect. She developed a disdain for the practices and attire of the "civilized" world and made her way in the wilderness with determination. This woman was the grandmother of the modern feminist movement and is the focus of this book.

Interestingly, both "saints in sunbonnets" and the rough-and-tumble female existed in the frontier West. The liberating force that distinguished one type of woman from the other was a rare combination of the characteristics unique to frontier life and dear Father Time. Many of those female pioneers who crossed the Great Plains with their husbands lived out their lifetimes in nostalgic, silent misery longing for the niceties and friends they'd left behind. A percentage of them learned to enjoy the experience, but almost always within the confines of acceptable womanly behavior. A third group, the thousands of female nonconformists who came west for the opportunity it offered or in search of adventure, lived out their atypical lifetimes as outcasts from acceptable society. The majority of them were or became gamblers, prostitutes, or even manlike individuals who lived out their lives barely touched by the mainstream of American society. The real change came with the daughters of the first generation—women who teethed on individual freedom, shared games and chores with their brothers, rode horses astride "clothespin style," and discovered that pants, not skirts, were the logical attire of the frontier. They found different ways to ply their newfound skills, but ply them they did. They were decidedly less shackled to tradition than their mothers had been and more able to negotiate the uncharted environment they had inherited. They were unique to America because the American frontier experience is unique to the history of humankind.

Relative freedom for women was not new to the American continent. In fact, it originally arrived with early colonists who came to settle a frontier of their own. One out of three seventeenth-century immigrants to the American colonies was a woman. As the gentleman's class that dominated the Jamestown settlement battled the wilderness in generally inappropriate and ineffective ways, work and self-sufficiency became essential to survival. In those early years, the lifestyle of the time and the

severe manpower shortage in America allowed women to contribute to the developing economy in a meaningful way.

The industrial revolution had deliberately been denied to the colonies by the mercantilist mother country. Consequently, Americans generally worked as farmers, manual craftsmen, or tradesmen. In every case, their place of work was in or around the home. Farmers lived on their land, and craftsmen and tradesmen worked out of shops below or adjacent to their residences.

Women, the domestic overseers of the home, were available to pitch in whenever necessary, and it was often necessary. Wives ran shops while husbands crafted goods. Wives fed livestock while husbands plowed fields. Wives sold goods while husbands bargained for the purchase of more. Because these jobs required nearly around-the-clock attention, whoever was available to perform the task generally did just that. The shockingly high mortality rate had its own effect on survivors. Life was unpredictable and longevity relatively rare. In the face of widowhood, women who had, after all, received extensive on-the-job training quite often executed specific crafts as well as had their husbands.

Women took part in the same occupations as men because they were family enterprises, and they were adult members of the family. There were also areas of expertise open almost exclusively to them. Women dominated the field of obstetrics as midwives, practiced law when the need arose, and treated the sick within the family or, if particularly successful along those lines, the neighborhood. Even then, however, women had difficulty earning their keep outside the family. They had no officially recognized existence apart from men, a situation that dramatically limited their options. Single women who had no extended family to care for them were often destitute, and many survived only in servitude.

The fact is that while colonial women who reaped the benefits of marriage were nearly economic equals to men, they were socially and legally inferior. From birth they were ruled by their home's male authority, educated exclusively in the home arts with a smattering of reading and writing, and, once married, retained no legal existence whatsoever. With the 1775 publication of Sir William Blackstone's *Commentaries on the Laws of England,* English and, consequently, American common law accepted the following treatise:

> By marriage, the husband and wife are one person in law; that is, the very being or legal existence of the woman is suspended

during marriage, or at least is incorporated and consolidated into that of the husband; under whose wing, protection, and cover, she performs every thing....A man cannot grant any thing to his wife, or enter into covenant with her; for that grant would be to suppose her separate existence.[1]

By the end of the colonial period, the manpower shortage had eased and industry had crossed the Atlantic to settle permanently in the New World. Families who could afford to do so moved women out of the workplace and into the home in emulation of middle-and upper-class European standards. There, women performed the domestic duties required to operate their homes, or they supervised staffs of servants responsible for carrying out these same duties.

Men, many of whom now worked away from home thanks to the onset of the Industrial Revolution, became the exclusive bread-winners. Mrs. A. J. Graves studied American women at the dawn of the nineteenth century and documented the early isolation of her gender:

> Next to the obligations which woman owes directly to her God are those arising from her relation to the family institution. That home is her appropriate and appointed sphere of action, there cannot be a shadow of doubt; for the dictates of nature are plain and imperative on this subject, and the injunctions given in Scripture no less explicit...."Let you women keep silent in the churches" – be "keepers at home" – taught "to guide the house."[2]

One source of this stereotype was the economic structure that had grown out of the newly industrialized United States. Unlike farming and craftsmanship, jobs in industry were located away from home. Since groups of men, often working in shifts, were responsible for a particular task, time on the job could be limited to set arrival and departure hours. Because men no longer performed their jobs in or around the home as they had as farmers, smithies, printers, or the like, they became alienated from it. Their natural environment quickly became the factory or office, and, since men also served as office support staff at that time, they had little time or need for women there.

Man evolved into a creature of the outside world. Here, in order to be successful, he operated in a competitive and even combative manner. His efforts to prosper in the capitalist marketplace forced him to accept spurious traits that, before long, were seen as God-given. With

time, Americans came to insist that man was a semi-civilized creature of the outside world who was naturally immoral and driven by carnal passions and territorial rivalry–fitting characteristics for the combative business world. He and his gentle woman companion ruled over separate kingdoms and seemed to have little in common.

Woman's realm became, more exclusively than ever before, the home. Here she brought order to the chaos of the dog-eat-dog outside world, but only at the discretion of her man, the titular "head of the household." Her God-given purpose was to serve as guardian of all things good and beautiful: child rearing, religious teachings, education within the home, morals, and gentility. From her sorely limited but perceptually lofty throne, she was characterized as an inherently emotional, submissive, physically delicate, pious, morally pure creature who was disinclined toward, in fact, naturally unfit for, intellectual pursuits.

At home, her paramount purpose was to create for her family an oasis of culture and domesticity founded on the traditional ideals of Judeo-Christianity and the tenets of western civilization. Recent historians have referred to this artificial, stereotypical female role as the Cult of True Womanhood. Revisionist historian Julie Roy Jeffrey described true woman:

> Sheltered from the business world, possessing few material goods,...women lacked resources and the reasons for pursuing selfish goals. They naturally devoted themselves to others. As feeling rather than thinking creatures, lacking egotism and pride, women were uniquely able to perceive and act upon moral truth. Their physical charms and affectionate nature provided them with useful advantages in their encounters with husbands and children.[3]

Thus, the feminine influence would stabilize the vicissitudes of the industrial world, and social order would be ensured.

It only made sense. Americans had traditionally believed in a natural order to the universe. This order was the foundation upon which the Bible had been written, the nation's founding philosophy based, and the continent settled. Rationalism, the eighteenth-century philosophy shared by our founding fathers and the framers of the Constitution, is reflected in the words of the Declaration of Independence, the Constitution, and the Bill of Rights. In essence, it is the belief in the existence of a body of self-evident truths pre-ordained by God for the benefit of humanity. With

a twist here, and a tweak there, such a conviction could be redefined just enough to serve as justification for the newly separate, but, it was believed, naturally determined roles assumed by men and women.

Within the newly established market economy, these separate roles took on an almost immediate air of indisputability. A few exceptional women recognized their loss and fought the limitations of the Cult of True Womanhood. Most, however, not only accepted its tenets but became convinced of its permanent place in the order of the universe.

Indoctrination flowed from every possible source. Sunday sermons glorified the saintly position of domestic women. Novels produced heroines like Fanny Forester's Lucy Dutton, a girl "with a seal of innocence upon her heart, a rose-leaf on her cheek" who was disgraced shamefully by a roving city slicker. *Godey's Lady's Book*, the most popular women's periodical of its day, was first published in 1830. Its July 1854 issue describes a "true woman":

> Wives graceful and affectionate, matrons tender and good, daughters happy and pure-minded.... I defy you to think evil in their company.... After you have talked to her [a wife, matron, or daughter] a while, you very likely find that she is ten times as well read as you are; she has a hundred accomplishments which she is not in the least anxious to show off, and makes no more account of them than of her diamonds, or of the splendor round about her.... Is it not happiness for us to admire her?[4]

Women stepped proudly onto the domestic pedestals provided them by the newly competitive marketplace and surrendered their right to function effectively in the outside world.

Some unfortunates, of course, couldn't be what society demanded of them because they were not part of the one institution whose membership was expected of all women—matrimony. If a woman was a spinster or had been widowed or divorced, she was an outsider, even to other women. Since her role within the home had been obstructed or abbreviated and she had no role outside the home, she generally was dependent on others for support. Sometimes her parents or a sibling would take her in and put her to work caring for children or helping with household chores. Neighbors often talked about "poor Margaret," who was never attractive enough to find a man or whose husband died before his time and left her penniless.

If she had a reasonably good education, a woman might be able to get a job as a schoolteacher or a governess–only, however, if she had nobody to care for her. If she wasn't well educated, she could become a seamstress, a laundress, or a hotel maid or could work as a household servant. The only jobs that were thought to be appropriate for a woman were those related in some way to homemaking or child rearing. Even then, a working woman was regarded with a touch of dismay or even disdain. It simply wasn't natural. Fortunately, by the mid-1800s, there was a way out–the road west–and thousands of women recognized it as a pathway toward a more equal role in the American pursuit of happiness.

2
PIONEER WOMEN

As restless Americans, heirs to the adventurous tendencies of their immi-
grant ancestors, headed west, they carried with them the sexual roles
assigned them in the now settled, more Europeanized East. The artifi-
cial nature of their assignments soon became apparent. No matter how
hard they tried to adhere to those roles, the ordeal of the trail and fron-
tier life rendered it difficult and often impossible. The cost of the now
familiar transcontinental trek by wagon train made it generally available
only to those with money in the bank or under the mattress. Women
who traveled across the Mississippi River to the wilderness beyond were
usually middle-class creatures of a relatively staid eastern culture. Because
they believed themselves to be the missionaries of refinement that soci-
ety expected them to be, they meant to bring culture to the frontier.
What's more, they meant to make the domestic roles assigned to them
in the East fit the less predictable lifestyle of the West. At least they meant
to try.

In the early weeks of trail life, daily duties were assigned accord-
ing to gender, as would be expected. Men drove the Conestogas, hunted
when necessary to supplement the food supply, and stood guard against
Indians and wild animals. Women supervised children, cooked, cleaned,
and washed. In time, accident, sickness, childbirth, or even death might
require one partner to take over the chores of the other. Adjustments
were made with every mile traveled. In time, everyone in the wagon train
came to realize that gender made little difference in the face of neces-
sity. An extraordinary cultural transition had begun.

The trail west took four to six months depending on the destination,
weather, topography, and the degree of good or bad luck. The experi-
ence would be exotic one moment and tragic the next. Golden sunsets

9

would be the backdrop for cholera or diphtheria epidemics. Fabulous waterways could become burial seas for men guiding mules across deep, fast-moving waters. Magnificent mountains too often sported crude crosses marking the spots where children fell from wagons or mothers died in childbirth.

Women, society's guardians of education, documented their experiences extensively in journals and letters home. Some saw the trek west as the experience of a lifetime and reveled in each new adventure. Along the way, they picked up new skills that would have been considered inappropriate back home such as riding astride where side-saddles were useless, shooting small game when men were occupied, and driving the wagon team through miles and miles of dusty trail. "Lydia Waters drove the loose stock and boasted of her recently acquired ability to drive the heavy wagon."[1]

As they left the East behind, most women were able to make adjustments when it became necessary. For the most part, the younger they were, the easier came the adjusting. Their reactions to the adventure were as different as their ages and personalities. Extremes of opinion leap out of the personal writings of these women. Mrs. A. M. Green described the Great Plains as "those dreadful, hateful, woeful, fearful, desolate, distressed, disagreeable, dusty, detestable, homely, and lonely plains."[2] But Alice W. Rollins saw the same landscape and was filled with wonder:

> There is something fine in the great breathing space, and it is the only place in the world where your horizon comes absolutely to the ground in every direction; where the dome of heaven fits perfectly the world it was meant to cover, and the sky shuts down over the prairies as the cover of a butterdish fits its plate.[3]

Once they had reached their destinations, the women's challenge to adapt was even greater. Far from towns, churches, and schools, far even from their nearest neighbor, women were expected to mold for their families an existence as similar as possible to that enjoyed in the East. Most pioneer women had brought with them touches of eastern finery to brighten the dreariness of the frontier. Still, rugs on the floor, curtains in the windows, and geraniums on the table could not disguise the fact that a sod house was, by definition, always dirty.

Mandated by a general absence of trees, "soddies" were built by cutting blocks of tough, grassy dirt from the ground and stacking them, brick-like, to form four walls. These dirt-block igloos offered their

inhabitants far more shelter than comfort. Mrs. George Shafer likened hers to a "prairie dog hole."[4] A Nebraska physician described his home in more detail. "When it rained, the roof leaked the dirty water onto our bed and I would wake up with water running through my hair, and I had to put dishes and water proof buggy curtains on the bed to catch the water."[5]

Towns, when they finally grew out of the prairie dust, were no better. Usually established by young men more interested in excitement and profit than in security or comfort, these towns centered around the local saloons and were generally crude and lawless. Once women and children arrived to inhabit them, however, frontier towns tried hard to recreate the patterns of the East. Within a few years, women who moved to the frontier expected to enjoy once again the refinements and comforts left behind in the East. Unfortunately, it was not to be. Before the railroads crisscrossed the open prairie and connected the frontier to the refinements of the East, western towns were as vulgar as the miners or cowpunchers who peopled them. One description of Cheyenne and Laramie, Wyoming in the 1870s explains the problem:

> Hogs and cows had the run of the dirt streets, which were alternately dusty and muddy. Citizens erected board fences to confine their own livestock and to exclude the animals of others. A woman wrote the *Cheyenne Leader* in March, 1872, complaining that every family had three to five dogs. She often thought she was in an Indian village as the beasts yapped and tore at her clothes. Rusting tin cans and empty bottles littered vacant lots, alleys, and streets.[6]

In a Congregational church sermon in November 1870, the Reverend J. D. Davis appealed to his congregation:

> We ought to mourn and languish at the barrenness of our city and its surroundings....We are all mourning that Cheyenne grows no faster, but what is there to bring people here or to keep them after they are here? A bare, brown, sere, desolate town, with hardly any beauty in it...all the dirt and garbage of the city hauled out on the windward side, and left in ugly heaps to be blown back in our faces.[7]

To make matters even worse, if that were possible, frontier women were frequently alone in their isolated, wind-blown homesteads. Off buying livestock or supplies, selling crops, or working at other jobs during hard times, men were often away from home, sometimes for extended periods. The nearest neighbor was probably two or three miles away. Doctors were rare and hospitals nonexistent. In the face of extreme isolation and even abject deprivation, most first-generation pioneer women gritted their teeth and did what needed to be done, but few of them enjoyed it.

For the older emigrants, and perhaps even more so for the less intelligent or the more stubborn, life on the frontier became a battleground. Many of these women were so bound to the doctrine of the Cult of True Womanhood that they refused to make even the simplest accommodations to their surroundings. They succeeded, instead, in making life miserable for themselves and everyone who came in contact with them.

Woman's rights advocate Margaret Fuller traveled west in the mid-1800s to meet and talk with women who had settled there. Hoping to add a pinch of spice to her upcoming book, *Women in the Nineteenth Century,* with information about a new breed of American woman in the hostile frontier environment, she was dismayed to discover women who insisted they were still "ladies" struggling to live according to eastern expectations. These women had become self-imposed hermits who refused to venture far from their doorsteps for fear of rattlesnakes. They struggled to put away dribs and drabs of money and, as soon as they could afford to do so, sent their daughters back East "to be polished." This well-intentioned but spurious exposure to the dogma of the Cult of True Womanhood had a dismal effect. The pitiful young creatures produced by this tragic misapplication of their mothers' unrealistic feminine ambitions returned home totally useless and as discontented as their mothers. Fuller sadly stated that she had expected life in the West to allow women the opportunity to lead more natural lives.[8] It had, in fact, even though she saw little evidence of it during her visit.

Women who were caught up hopelessly in the cultural roles assigned them in the East were destined to be miserable in the strikingly different environment of the West. Lura Smith remarked to a friend on December 26, 1854, "I am quite glad there is no one to wish me a Merry Christmas. It would have been such a mockery."[9] Still, some women were able to rise to the challenge. They demonstrated their adaptability in their daily lives as well as in emergency situations.

Warren P. Trimm, his wife Susie, his sister Mary, and two small children moved to Kansas in 1877. Together, husband and wife built a small sod house and farmed their 160 acres gained through the Homestead Act. In his diary, Trimm credited his wife with courage and an optimistic outlook despite the hardships they faced: "I knew...that failure would not be her fault," he remarked.

The night Susie went into labor with their third child, Trimm set out to fetch the midwife but became lost in the absolute darkness of the prairie night. When he finally returned home after daybreak, he found Susie had given birth alone and was perfectly composed. "'Come look at your son.' When she turned the blanket down, there lay a twelve-pound boy, as completely cared for as a doctor could have done."[10]

Susie was far from alone. Enlightened information about sex and pregnancy was unavailable to frontier families, and nineteenth-century birth control tended to rely primarily on self-imposed abstinence and impotent, homemade concoctions. What women knew or thought they knew about birth control, abortion, female hygiene, and child care was passed from woman to woman and was as laden with superstition and supposition as it was with fact. Such information tended to be even less available and reliable on the frontier. The typical frontierswoman could count on a birth every fourteen to twenty months and an average of seven or eight children, five of whom would live to adulthood.[11] On the frontier, the chances of finding a doctor or midwife to assist with every birth were slim at best. Women wrote about solo childbearing as if it were routine. Many diaries and letters of pioneer women relate incidences of unassisted childbirth. In fact, in the early days, such births were frequent enough to be considered typical. Not only were most successful, but new mothers cited that they bathed their newborns, rested briefly, and then returned to the chores of the day.

These first-hand accounts also indicate a direct relationship between age and the ability to adapt to frontier life. Matrons had spent much of their lifetimes attempting to conform to eastern ideas of lady-like behavior. They had had time to grow convinced of the God-given rightness of the Cult of True Womanhood. Although their environment rarely justified these beliefs, they were more likely to pass judgment against women who did not behave according to eastern ritual than to conform to the frontier situation. These women were locked into the lifestyle they had always emulated and were unlikely to change in the summer of their lives. After years of struggling with loneliness, the windy wide-open spaces, dirt, disease, back-breaking labor, death, and an evolving new

morality, they realized the futility of their dream. Most mourned their loss but never learned to enjoy their new lifestyles.

Other pioneer women, usually younger, adopted a compromise culture wavering between the preachings of the East and the realities of the West. They, too, had been indoctrinated but were young and strong enough to question those restrictions when confronted with the hardships of the West. As they teetered on the brink of cultural transformation, some gave in and adapted to the needs of the frontier while others could not. Because they were determined to preserve their artificial convictions of gentility and delicacy, most of them couldn't serve as the frontier's changing force. That momentum had to come from their daughters—women who were themselves products of the frontier.

Still, that noble first generation of struggling frontier women initiated the changes that were to come. Simply by doing what needed to be done, they instituted social acceptance for wider economic and legal roles for women. Furthermore, by allowing their daughters a little more freedom than they themselves had enjoyed—a change made necessary by the endless workload they endured—these pioneer women served as the force that instigated transition. Many of them went so far as to assign traditionally masculine chores to their daughters for lack of sons, hired hands, or time. These daughters adapted well to the changes and learned to appreciate their new lifestyle. In time, they adopted a culture less tied to the simulated refinements of the East and more inclined to take advantage of the relative freedoms of the frontier West.

The simple fact is that, whether they did it deliberately or because they were pressured by continuous drudgery, the first generation of frontier women reared children (both male and female) who possessed a sense of pragmatism and self-assurance that guaranteed progress for all the women, and, therefore, all the people, of America.

3
WORKING WOMEN
IN THE WEST

The great majority of women who held jobs, whether in the East or the West, in the late nineteenth century did so because they had no choice. Unmarried or needy women generally worked at menial jobs using the housekeeping and child-nurturing skills they had learned at their mothers' knees.

At first, frontier women who needed the income took in washing or cooked and baked for local bachelors who populated the region in large numbers. As western opportunity knocked, many women began to open boarding houses and hotels. Iowa Territory census records show that by 1856 women in that jurisdiction had become milliners, dressmakers, and midwives. By the mid-1860s, the *Iowa State Gazetteer* listed not only those occupations for women but, in addition, those of music teacher and restaurateur. The list continued to lengthen, and by 1890 the American West had become the only true source of opportunity for women. For that very reason, women from all over the world were attracted to it.

The feminine influence was felt more deeply in frontier regions than elsewhere because there women's services were more in demand. When Nannie Alderson of Union, West Virginia, visited her aunt in Atchison, Kansas in 1880, she was amazed at the cultural changes already affecting those of her gender. Later she commented, "What impressed me most was the fact that a girl could work in an office or a store, yet that wouldn't keep her from being invited to the nicest homes or marrying one of the nicest boys. This freedom to work seemed to me a wonderful thing."[1]

Fortunately, because they were in such demand on the frontier, women's homemaking skills could sometimes turn a tidy profit. Cooks, seamstresses, and laundresses were particularly popular, especially in the

bachelor-ridden mining camps. In 1852, a Boston newspaper printed a letter from a California woman "who reported that in less than a year she had baked and sold $18,000 worth of pies, about one third of which was clear profit." A Missouri woman paid for her western trip by taking along a flock of hens and selling fresh eggs at $2 a dozen all the way to California. She arrived showing a tidy profit.[2] In Wyoming, Martha Maxwell supported herself and her daughter as a taxidermist, an unusual vocation for a woman. The 1870 census indicates that while her neighbors listed property valued at "$0," Mrs. Maxwell claimed real estate worth $500.[3]

Finding loopholes in their domestic assignments, women opened hotels and boarding houses either with their husbands or independently. One entrepreneur of note was Katrina Murat, a German by birth, who immigrated to the United States in 1848 with her first husband. His untimely death soon left her a widow struggling to make her way in a foreign culture. Eleven years later, she teamed up with a Frenchman named Henri who became her second husband, and a certain David Smoke. Together they opened the Eldorado Hotel just outside Denver, Colorado. Despite its glamorous name, the Eldorado was typical of the crude shelters of the day, designed to offer miners a roof and a meal. Murat, the only woman involved in the enterprise, served as cook, chambermaid, and laundress.

Despite her determined efforts, the Eldorado failed, undoubtedly due at least in part to the abundant drinking habits of Murat's two male partners. Their apparent alcoholism soon established for them a tragic pattern, as the three partners moved from one doomed enterprise to another. Finally, in Virginia City, Montana, Murat managed to keep Henri sober long enough to turn their newly opened Continental Restaurant into a success. Murat hid her profits in bags sewn to her petticoats, and the couple returned to Denver but were never able to make another go of it. She died a pauper's death in 1910 under the care of the Pioneer Ladies Aid Society.[4]

Western women soon discovered that the life they'd become used to had developed into quite a sensation back East. Those who had some flair with pen and paper made quite a splash writing accounts of their lives or observations for curious readers back East. Many of these authors won public acclaim: Mary Austin, Helen Hunt Jackson, and Laura Ingalls Wilder were just a few. Wilder had a particularly fruitful childhood. Her father, Charles, was a true wanderer of the-grass-is-always-greener variety. He moved his family first to Wisconsin Territory, then westward to

Minnesota, further west to Iowa, back to Minnesota, and finally to Dakota Territory. His daughter, author of the famous "Little House" series of frontier stories, once commented, "No one who has not pioneered can understand the fascination and the terror of it."[5]

Josephine Donna Smith was born in frontier Illinois and moved with her family to Los Angeles in 1851. She began publishing poems at the tender age of fifteen under the pen name "Ina." Briefly married, she suffered through the death of her only child and moved north to San Francisco.

Josephine's mood often dipped far into depression, a tendency that shaped her poetry and helped to make it famous. She published her work in two San Francisco literary magazines under the name "Ina Coolbrith" (her mother's maiden name). Unable to make a living at writing, she worked as a librarian at the Oakland Public Library from 1874 to 1894. Still, her poetry remained popular, and in 1919 Coolbrith was honored with the title of Loved Laurel-Crowned Poet of California.

Beginning soon after the Civil War, Carrie Adell Strahorn kept a journal of her thirty years of travel with husband Robert as he worked for the Oregon Short Line Railway. His job was to recruit business investors and settle townsites for the expanding railroad, and it required that he virtually live in a stagecoach or on horseback. A dutiful wife with an eye for adventure, Carrie went right along with him. In her journal, she recorded detailed stories about western life in the 1880s, railroad land disputes, and the birth and development of frontier towns.

By 1906, Carrie had reworked her journal into a gem of a book and had it illustrated by the famous "cowboy artist" Charles Russell. *Fifteen Thousand Miles by Stage* told the story of the frontier through the experiences of a comfortable upper-middle-class matron and was an instant hit. It was reprinted in 1911, and then by the University of Nebraska Press in 1988.

Perhaps the lingering message in Strahorn's work is summarized in the first volume, in which she writes:

> The joys of motherhood have often been envied as fond parents watched the budding and maturing intellects of their children and noted their development into men and women of honor and refinement, but it is no small compensation to help make towns

and cities spring from earth in answer to the demands of an army conquering a wilderness as it follows the trail of the pioneer.[6]

Carrie and her husband, whom she called "Pard," crossed the continent so often and for so many years that they noticed the changes migration brought to the frontier. She specified the far Northwest region with this comment: "From season to season, as we crossed again and again the great stretches of sandy lands, there was ever a revelation of progress that made our hearts glad."[7]

Most of Carrie's memories were pleasant, and even the crudest situation was given a cheerful twist. Seeking shelter from an impending storm near Boise City, Idaho, the Strahorns were forced to stay in a stage-line cabin for an evening.

> [It] had but three rooms; the front room was a store where a few commodities were kept for the freighters or possible travellers; the middle room was a sort of catchall for everything and the family bedroom; back of that was the kitchen, with a dirt floor....The dirt was an inch or two thick on everything....Mr. Peck...produced a violin from one of the mysterious dark corners of the room and began to draw the bow across the strings....We danced to the strains of Old Dan Tucker and Money Musk, Turkey in the Corn and Dixie.[8]

Toward the close of volume two, Carrie began a serene appraisal of her documentary efforts, thus producing an insightful observation that may apply to most creative women of adventure.

> To record the heartaches and discouragements threading through the pioneer days would deprive these pages of the romance of the experience, and the reader might lose sight of the marrow of joy....I can always bring a tear to my own eye when my mind dwells on some of the unhappy experiences, but I am not prone to linger on the dark side of life, for I love the sunshine and gladness, and keep myself in it whenever possible.[9]

Creative women found other outlets as well. Grace Carpenter Hudson of California became well known for her oil-on-canvas painting. Her work was in great demand in the drawing rooms of the East. The eccentric artist Elisabet Ney immigrated from Germany to Texas, where she became as

notorious for her sculpture as for her unusual, rather risque lifestyle. Rumors that she and the British doctor with whom she lived were unmarried (quite unfounded as it turned out, although she may have originated and certainly promoted the misconception) would have caused her exile from eastern society. In frontier Texas, such rumors merely made her more interesting. Mary Hallock Foote is known as the "dean of women illustrators of her time." From the 1870s to the 1890s, she illustrated several national magazines and became renowned for her stories and vignettes of the lives of frontier women.

* * *

Opportunity existed on the frontier, and women were making the most of it. As in the East, women were most often in the company of men. The dangers implicit in leaving behind the comforts of civilization caused most of them to seek the protection the men of their time generally elicited. In the frontier West, women who sought employment outside the home tended to work in gray-area occupations tied somehow to domesticity and, therefore, deemed socially acceptable.

Yet, the history of the West is sprinkled generously with more daring women who came to the frontier alone. For reasons of their own, many of them sought adventures that carried them just beyond the perimeters of the Cult of True Womanhood, and, in so doing, left ajar, just a crack or two, the door to women's rights.

4

GOING IT ALONE

According to the law of supply and demand, servant girls were among the most valued components of western life. They were hard to find and even harder to keep. In 1820, Richard Flower wrote, "Marriages here take place so frequently that we are certainly in want of female servants; even our Mrs. C., who lived with us upwards of twenty-five years [presumably before the family moved west], and is turned of fifty, has not escaped; she is married to a Mr. W. having first refused a Monsieur R."[1]

Most women who were hired as servants came west looking for something else. After all, they could have been servants without leaving the safety and security of home. Once out west, most of them sought husbands, but a few hoped to save enough money to go into business for themselves and/or to buy property. It was fairly common for them to spend their days off staking out new homesteads and entering claims in the nearest town. Then, for the next five years, every free minute was spent building shacks on their claims and farming the land or supervising men hired to do the same. After five years, the improved land was theirs according to the requirements of the 1862 Homestead Act, and their servant days were ended. Propertied women had no trouble attracting men.

As settlements grew and more and more families moved in, schools became necessary. Since few securely employed eastern schoolmasters could be persuaded to abandon security for the unknown and uncivilized wilderness, the schoolmarm quickly became a fixture in frontier schools.

Catharine Beecher, one of thirteen children of well-known abolitionist, women's rights advocate, and Presbyterian minister Lyman Beecher and sister of Harriet Beecher Stowe, author of *Uncle Tom's*

Cabin, was responsible for attracting thousands of single women to the frontier. During her travels in the West, she discovered a crying need for teachers that she believed could be quickly and easily fulfilled by unattached young women. Never reluctant to mount a good cause and a strong advocate of education for women, Beecher addressed this need in her 1845 book entitled *The Duty of American Women To Their Country*. Firmly convinced that woman's natural role was that of wife and mother, Beecher, who never married, defined the teaching of children as a woman's responsibility given its dependence on nurturing and gentle persuasion. Beseeching her American sisters to personally take up the cause of the poor, unenlightened children of the frontier as their patriotic duty, she struck a responsive chord. Her written arguments were reinforced by her well-received speaking tours, which found her bewailing the "destitute children" of the West who were unable to get an education due to a shortage of teachers.[2] Her efforts brought hundreds of young, single women, ready for a little fun, to the West.

The teaching conditions that awaited them were certainly less than ideal. Schoolhouses, when they existed at all, were frequently barns, sheds, soddies, tents, or worse. Pay was rarely sufficient to support an independent existence since most students' families were barely getting by themselves. Having no home of her own when she first arrived, a teacher was usually offered boarding arrangements that required periodic transfer from one student's home to another. Nevertheless, these particular women were willing to put up with a great deal in order to satisfy the objectives for which they had migrated–patriotism, a little adventure, and propertied husbands to support them. There was a constant turnover as teachers married. By one mid-century estimate, "about two-thirds of the women of Kansas have taught school."[3]

In 1875, fifteen-year-old Carrie Ayres and her mother migrated to Sterling, Colorado and claimed a homestead. Needing a way to bring in some extra money, Carrie opened Sterling's first school in a fourteen-by-sixteen-foot sod house. There she earned twenty dollars a month teaching approximately twenty students.

When the entire town packed up and moved to nearby New Sterling in 1881 in order to be closer to the incoming railroad, Carrie managed to finance a relatively luxurious frame schoolhouse in the center of town. Her comfort was short-lived, however. One dismal day a tornado blew through town and destroyed every structure. Carrie and her pupils had to make do with a dugout until a new building could be erected.

Reports indicate that the school became the center of society and entertainment in New Sterling. "Even spelling bees attracted a standing-room-only crowd."[4]

Willa Clanton taught in Cedar Creek, Colorado around 1898. Because paper and ink were so scarce, her students worked on small, individual slates with rags and bowls of water for erasing. Like so many others in her frontier profession, Clanton lived with the families of students–first the Diffendarfers and then the Stackhams.

While with her first family, she was obliged to ride to school on horseback with their young son straddling the saddle behind her. The Stackhams offered her a degree of luxury by loaning her a horse and buggy. Willa and the Stackham boy traveled back and forth to school in style.

In her entertaining history of Colorado women, Nell Brown Propst includes a list of women who pioneered the first schools in their particular frontier towns in that territory. They deserve recognition.

Hattie Irwin – Akron, 1882
Mary Pratt – Yuma, 1885
Amelia Guy – Julesburg, 1885
Marion Howard – Grover, 1886[5]

Other women were somewhat less orthodox in their approach to frontier opportunity. Many of them were single or widowed women who needed land to escape dreary dependence on reluctant relatives. Land ownership also had its own way of attracting potential mates. A few particularly hardy souls even threw themselves into the peculiar insanity that surrounded the great territorial land rushes.

Anetta Daisy, a Kentuckian by birth, participated in four land rushes and secured claims in each. She nearly met with a premature death in Oklahoma as she raced headlong across the prairie against the Sooners sprinting for land that had once been Indian territory. Her methods were a bit atypical. On March 23, 1889, Daisy earned her first claim by jumping from a speeding train just ahead of the pack of mounted land rushers tearing across the Plains on horseback. As she staked out the claim that resulted from her rather unique approach, she was shot once by an unscrupulous competitor and again when a claim jumper tried unsuccessfully to take her new-found land from her. It took more

than a couple of bullets to put a stop to Daisy's ambitions, however. Two years later, she was willing to make another go of it, and on September 22, 1891, racing the mob in her second land rush, she was thrown from her horse into the milling hoards. Somehow, she not only survived her own recklessness but was able to keep possession of both claims.

Martha Sabrowsky took part in the Oklahoma land rush of 1893 but moved to Colorado a few years later. There she made her 160-acre claim and lived quietly in a two-room dugout slightly less than five miles from her nearest neighbor. Of course, the fact that she owned property attracted men, but she was in no hurry to take on the role of wife.

Finally, in 1916, she married John Hallett, but the union lasted only about a week. While stringing a fence line, John evidently provoked Martha in some way. She pulled out her pistol and shot him in the leg. John, recognizing a hint when it came his way, left home, never to return.

Martha didn't seem to be the type to keep company too long with anyone. She is said to have once mused that civilization "brings hurt with every joy. I have yet to hear a more comforting sound than horses chewing hay."[6]

One particularly dismal tale also comes from the Colorado frontier. It features a young lady named Christie Payne who, in 1886, at the age of seventeen, came west to visit relatives. She was attractive and in no time had captivated a peculiar brand of cowhand named John Merrell.

According to locals, John was the son of a wealthy eastern family and had graduated from Yale University. A keen sense of adventure brought him west to try his luck on the frontier. When he met Christie, he was working as a hand on the JB Ranch. He married her as soon as he could. He was twenty-six and she eighteen.

Merrell became the ranch's foreman while Christie worked hard as a cook for the JB's cowhands and, in the interim, brought two babies into the world. Eventually they were able to put away enough to homestead a little claim near Abbott, where, in 1894, they built the first frame house in the area.

Four more children were born to the Merrells, and things seemed to be going well. Then John, tiring of the drudgery of homesteading, spent most of his family's savings on a fancy strain of Belgian breeding horses, hoping to fund a more exotic lifestyle. With her husband absorbed by

his new venture, Christie took over the management of all six children plus the homestead. One day John, still dissatisfied with his humdrum existence, left home and never returned.

Christie organized the children, assigned jobs to everyone capable of handling them, and made do. Ten-year-old Frank became the farm's foreman. His sister Hattie was put in charge of the house. When Christie learned that John had sold part of their land and incurred quite a few debts, she simply increased her workload. Saturday became her route day, when she would drive to town and then door to door selling eggs, butter, cream, jelly, and sometimes meat, all produced on her farm. Christie's remarkable determination was interrupted when her infant son died, and, quite understandably, she went through a period of mourning from which she had difficulty recovering.

But recover she did. Christie soon had her debts paid and was married again to a Will Partridge. Since Partridge had a claim of his own, she rented her farm to another frontier family and moved to his. Will had enjoyed a reputation for drinking before he married Christie, and, despite his promises to reform, he was soon back on the bottle. Sadly, when he drank, he abused his wife and her children.

One evening, after a particularly nasty encounter, Will staggered to the door and fell to the floor—dead. Fifteen-year-old Frank later confessed that he had laced his stepfather's whiskey with poison and was sentenced to life imprisonment. The first-degree murder charge was later overturned.

The newly widowed Christie accepted a position as an assistant game warden, an unusual job for a woman at that time. Willing to try again, she met and married Harry Jones, and he, too, deserted her. Turning her homestead over to a son, she moved to Sterling, Colorado, bought a small store, and married a man named Phillips. It wasn't long before he left.

Deciding to take it easy for a while, Christie rented the store. Its income plus that of her rented farms gave her a comfortable living until, apparently the eternal optimist, she married Ralph Baird. He convinced her to move to his farm, and she did. When her children stopped receiving regular letters from their mother, they asked the sheriff to investigate.

The sheriff found Baird at home on his homestead, but no sign of Christie. Suspicious, he had Baird arrested and questioned. When the truth came out, Christie's children were despondent. It seems that the couple had argued, and Baird had settled the disagreement by beating Christie to death with a flat iron. When her body was found, Frank went

to claim it. He wired home, "Will bring Mother home this week.... Have someone clean house up good."[7]

* * *

These eastern women who traveled west on their own were among the most daring of their time. They learned to operate independently but still preferred marriage if the opportunity arose, and it usually did. Even so, the same conditions on the frontier that offered women so much freedom also required that they work harder than their sisters in the East. The effort was more related to the nature of the frontier than to that of western culture. Consequently, marriage offered no relief from this particular burden. In fact, given the quality of manhood often found in the West, marriage itself and the numerous children it tended to produce added to the already substantial burden.

An occasional frontiersman would allude to his own ulterior motive in marrying. A young man riding an Illinois riverboat with his new wife was asked if he had married her because of her rather extraordinary size. The crass young bridegroom, his less-than-dainty wife by his side, commented, "Why pretty much,... I reckon women are some like horses and oxen, the biggest can do the most work, and that's what I want one for."[8]

While this was hardly a compliment to his new wife's femininity, the bridegroom's confession does lend credence to the added economic value men of the frontier placed on their hard-working womenfolk. Because these particular women had dirtied their calloused hands and dared to find ways to develop a degree of influence outside their own homes, frontier women were beginning to see the reforms they deserved.

5
MORE RIGHTS FOR WOMEN

By the mid-nineteenth century, changes were developing throughout the nation that weakened the Cult of True Womanhood. Women's clubs, reform groups, and literary societies became popular at this time. Women's rights groups began to hold conventions in the 1850s. Then, during the Civil War and all across the frontier, the shortage of male workers gave women the chance to acquire jobs previously considered improper for them. What's more, their successes at these endeavors earned them a certain respect from society at large. Novels written in the second half of the nineteenth century tended to give women a stronger, more dominant role than they had held previously. Even *Godey's Lady's Book* included stronger, more capable women in its articles. The delicate female who fainted at the least provocation was becoming outdated. At the same time, western territories, sometimes desperate to add skirts to the stark scenery of their rather bare towns, initiated positive activities to attract women to their borders.

Farming regions populated, as they were, predominantly by families, boasted of nearly as many women as men, but mining camps and cattle ranges were overwhelmingly masculine. In 1860, California, replete with gold and silver boom towns, claimed only one female to every twenty-three males. Colorado, with its similar economy, bore a ratio of thirty-four to one.[1] Washington Territory, which included the present-day states of Washington, Oregon, and Idaho, was a bit more balanced, with four men to every woman.[2]

In a deliberate effort to attract women, a number of western states adopted laws giving women property and a limited number of civil rights. The Oregon Land Donation Act of 1850, one of many political efforts to populate the West, granted a married couple a generous 640

acres of land. Incredibly, the wife was permitted to hold her half of it in her own name. Even more liberal, a single woman was entitled to 320 acres on her own. In a similar act passed for the same reason in 1846, Iowa Territory gave married women the right to own real estate acquired by bequest, gift, or purchase as long as their husbands did not give them the property or the money for its purchase.

Western educational institutions joined the trend toward sexual equality. According to the 1850 census, approximately the same number of girls as boys attended school in the mid-West. Frontier colleges led the way in opening doors to women. Oberlin College in early Ohio became the first coeducational institution in the United States when it was founded in 1833. Antioch College, also in Ohio, admitted women in 1853, as did the University of Iowa in 1855.

Wyoming and then Utah and Colorado were the first territories to give women the right to vote in state and local elections. Such a politically sensitive undertaking could have happened only in an atmosphere of male approval, for men were still the dominant governmental force, even in the new West. Edward M. Lee, the future secretary of Wyoming Territory, presented the territory with a bill for woman suffrage in 1869. Saloonkeeper William H. Bright introduced the bill by succinctly noting, during a time when racism was much too common, that he believed his wife and mother had as much right to vote as Negroes.[3] During the legislative discussion, one popular argument in the bill's favor justified woman suffrage as an effective means of attracting badly needed women to the bleak environs of early Wyoming.

Petitioning for statehood in 1890, Wyoming was bold enough to include a woman suffrage clause in its proposed state constitution. When a much less generous Congress opposed that particular item, a group of Wyoming women wired their delegation in Washington requesting that they withdraw the offending clause rather than be denied statehood. The gentlemen refused, insisting that they would rather remain out of the Union than enter it without the women. Somehow, the bill squeaked through Congress, and Wyoming became the first state to grant women the right to vote. In a 1973 *American Heritage* article, historian Lynne Cheney rightly gave credit where it was due. "Wyoming women did not win suffrage so much as men gave it to them. Men passed the law and set up the tests for it, with some notion that women deserved equality, with the hope that suffrage would stimulate migration by women to female-poor Wyoming, but also with the attitude that pass-

ing and testing the law was a splendid joke, a bit of comic relief in the midst of the anxieties and hazards of frontier life."[4]

Two months later, Utah adopted woman suffrage, followed in 1893 by Colorado, then Idaho, Washington, California, Oregon, Kansas, Arizona, Illinois, Nevada, and Montana, respectively. By 1914, all states in the western third of the nation except New Mexico had fallen into line behind their women. In 1917, New York permitted women to vote–the first eastern state to do so. Clearly, frontier women had won the respect they deserved, partly because they had become much more than mere ornamentation in the early West.

Bill Nye, editor of Wyoming's *Laramie Boomerang*, advertised in his newspaper:

> Wyoming wants women, and wants them bad, but there is no clamorous demand for sentimental fossils....There are few households here as yet that are able to keep their own private poet....The crisp, dry air here is such that hunger is the chief style of yearn...and a good cook can get $125 per month where a bilious poet would be bothered like sin to get a job at $5 per week....We [want] to encourage a class of women to come to this region who would know enough to construct a buttonhole on an overcoat so that it wouldn't look like the optic of a cross-eyed hog.[5]

Yet another view offered by a male homesteader indicated that the Cult continued to have its diehard fans:

> A woman is queen in her own home; but we neither want her as a blacksmith, a plough-woman, a soldier, a lawyer, a doctor, nor in any such professions or handicrafts. As sisters, mothers, nurses, friends, sweethearts, and wives, they are the salt of the earth, the sheet anchor of society, and the humanizing and purifying element in humanity. As such they cannot be too much respected, loved, and protected. But from Blue Stockings, Bloomers, and strong-minded she-males generally, GOOD LORD, DELIVER US.[6]

In a land where marriage was, as often as not, a means of acquiring land and cheap farmhands and where alcoholics were as common as bar flies, divorce became an important issue among women. While the East continued to limit divorce to rare and exceptional situations, the legal

authorities of the frontier, with a more practical approach to nearly everything, responded to the need as they saw fit.

Iowa Territory's first divorce law was passed in 1839. It granted divorce to women in cases of impotency, extreme cruelty, adultery, or willful desertion on the part of the husband for a period of one year. Within just four years, the law had been revised to allow divorce also for bigamy, commission of a felony, habitual drunkenness, and personal indignities. In 1857, the all-male legislature of Dakota Territory granted a landmark divorce to a woman despite the fact that there was no record that her husband even knew that the legal action was being undertaken. Everett Dick, in his memoirs, *The Sod-House Frontier 1854-1890*, noted that, in the West, practically anyone could obtain a divorce by asking for it.

In fact, divorce beyond the Mississippi became so uncomplicated that Easterners sought relief from incurable marital problems amid the more liberal divorce laws of many frontier states and territories. Chicago, a city perched on the very edge of the frontier, adopted progressive laws that caused it to become known as a divorce resort. An observer from equally freethinking Indiana stated:

> Every hotel or tavern had one or more of those bewitching vixens, domiciled with them for ten days, which makes them citizens and residents of the state of Indiana.... At the expiration of ten days, a suit is commenced against some vile husband – if for no other cause than incompatibility of temper. Here are congregated from all states of the Union (except Illinois, who is a competitor for this profitable trade) all the disconsolate grass widows.[7]

Had western divorce laws not been so liberal, a story like that of Elizabeth McCourt, better known as Baby Doe Tabor, wouldn't have been possible. Born on the edge of the frontier in semi-rural Oshkosh, Wisconsin around 1850, Elizabeth married an adventurer named William Harvey Doe in the 1870s and accompanied him to the gold fields of Colorado. It was there that the miners, not accustomed to genuine feminine beauty, took a good look at Doe's wife and nicknamed her "Beautiful Baby." They later shortened it to "Baby Doe," and the name stuck. Depicted by many contemporaries as devastatingly beautiful, Baby Doe was described by a local newspaper article as:

without a doubt the handsomest woman in Colorado. She is young, tall, and well-proportioned, with a complexion so clear that it reminds one of the rose blush [sic] mingling with the pure white lily; a great wealth of light brown hair, large, dreamy blue eyes, and a shoulder and bust that no Colorado Venus can compare with.[8]

Utilizing the newly liberalized laws of Colorado, Baby Doe divorced her flamboyant but undependable husband and relocated to Leadville, the most exciting boom town in the area at that time. It was in Leadville that a fabulously wealthy, middle-aged mine speculator, H. A. W. Tabor, spotted her and was immediately enamored.

The problem was that Tabor was married. His wife was a rather Puritanesque-looking Maine native whose horsey face was influenced less than kindly by the severe pair of pince-nez spectacles she always wore. Augusta Tabor, in her plain, straight-lined, forbidding-looking clothing stood in stark contrast to her husband's gaudy, bejeweled appearance. The rowdier tempered Tabor's tolerance for his wife's prim and proper airs vanished the moment he laid eyes on Baby Doe.

Within a year, Augusta was suing her fifty-year-old husband for support, declaring that he had not only deserted her, but had left her penniless, even though his income exceeded $100,000 a month. She refused to divorce him, pleading that she still loved him. Colorado was shocked by the desertion and, within a few weeks, astounded even more by news of Tabor's two-year-long affair with twenty-six-year-old Baby Doe.

In 1883, Tabor convinced Augusta to file for divorce on grounds of desertion by offering her $300,000—money she badly needed by then. Free at last, he was then able to marry his darling Baby Doe and did so during a glorious ceremony at the Willard Hotel in Washington, D.C. President Chester A. Arthur was in attendance at the dazzling affair, which was pulled off in a timely manner. It seems that Tabor had struck a deal with friends in Colorado's legislature that gave him a senatorial seat for thirty days to fill a vacancy—just enough time to set Washington society on its ear.

Eventually, Tabor's wheeling and dealing led to ruin, as his mines went bust one by one. Appointed as Denver's postmaster in 1898 by sympathetic friends, Tabor was barely able to support the still beautiful Baby Doe and their two daughters. As he lay on his deathbed a year later, he begged his wife to keep the Matchless Mine, the only property still in his possession. She gave him her word.

Baby Doe was as good as her pledge. She returned to Leadville from Denver, established residence in a tool shed near the Matchless, and lived there, hanging onto the worthless, played-out mine until her frozen eighty-year-old body was found dead on the shack's floor in 1935. It was a bitter end for one of Colorado's best-remembered women. The rags-to-riches-to-rags story had come full circle.

Other reforms beneficial to the female gender were pioneered along the frontier. The first state constitutions of Texas, in 1845, and California, five years later, provided protection for married women's property rights. The idea must have seemed like a good one, because it spread quickly. Within just five years, seventeen states, many of them in the West, had granted property ownership rights to women.

In 1869, Wyoming's first state legislators adopted "an act to protect Married Women in their separate property, and the enjoyment of the fruits of their labor." In addition, they adopted a school law that guaranteed that "in the employment of teachers, no discrimination shall be made in the question of pay on account of sex when the persons are equally qualified."[9] This same reform-minded group of men also gave the women of their state the right to vote and to hold office.

Not all men were as understanding, and not all women as well treated. The ancient, time-honored practice of wife-beating was as common in the towns and rural regions of the frontier West as it was in the eastern society of the time. In fact, varying degrees of corporal punishment used as a means of controlling one's wife had been an accepted disciplinary tactic since before biblical times. But western women soon proved they were no longer willing to put up with it.

Esther Morris was a six-foot-tall, somewhat formidable individual who was born in New York in 1813. She ran a successful millinery shop in Oswego until her husband died and left her property in Illinois. Deciding to risk it all for a little adventure, she headed into the frontier alone.

As propertied frontierswomen usually did, Morris married again in no time and became the mother of three sons. When her husband decided to move on to Wyoming, she went with him, but not until she first attended a lecture by Susan B. Anthony.

Inspired, Morris initiated her social presence in Wyoming by hosting a group of Wyoming leaders and legislators at her home for tea or dinner (sources differ). There, with the fervor of Anthony's words still

ringing in her ears, she pitched the wonders of woman suffrage to the gathering. She must have been persuasive. The politicians promised her their support, and they were as good as their word.

It's been said that one of Morris' guests that day was the indomitable W. H. Bright, who later introduced Wyoming's woman suffrage bill to the legislature. Esther, who ultimately became Wyoming's first female justice of the peace, knew how to use the law better than most. Tired of the abuse her husband heaped upon her, she swore out a warrant against him for assault and battery in 1871 and had him arrested. Their marriage persisted for many more years; one can assume the beatings did not.

* * *

The frontier territories were the first in nineteenth-century America to recognize the value of women to the cultural and economic life of the community. While that recognition was far from universal, evidence indicates that it was more commonly extended to the ladies of the West than to those of the East. Perhaps it was the scarceness of women in certain areas that gave them more worth than usual; perhaps it was their contributions as wives, mothers, and helpmates. More likely, it was the fact that these women had begun to step outside of the cultural limitations imposed from the East by the Cult of True Womanhood. They had adopted new roles in the frontier economy and were making a genuine contribution.

Hard-working, ambitious women who were willing to take risks were making their marks in the West. Most of them were married, sooner or later at least, but quite a few of them weren't. Still, there were a few particularly eccentric characters on the frontier. Their contributions to western folklore were as bizarre as they were astounding.

6
THE PANTS IN THE FAMILY

One rare breed of single woman went West deliberately to escape the social conventions back home. Most of these women were nonconforming individuals who, for reasons of their own, sought unconventional lifestyles. They shared the conviction that their atypical individualism might be better accepted or, in some cases, more easily hidden in the less structured society of the West.

A particularly unusual group of women preferred to play the male role exclusively. Those few whose unorthodox activities were documented proved to be single or widowed women from the East who went West as adults or nearly so. In every case cited, they arrived on the frontier having already assumed their new identities. Some apparently lived in disguise because, at least in their opinions, it was a matter of safety or survival, others for the freedom and opportunity it gave them.

Elsa Jane Forest Guerin explained in her 1861 autobiography why she spent thirteen years dressed as a man. According to her testimony, she simply was desperate for a way to support herself and her children after the murder of her young husband left her widowed and nearly destitute.

At the time of Forest's murder, the young family lived in Louisiana on the fringes of the frontier. Forest's untimely death instantly turned Elsa Jane into a penniless, sixteen-year-old mother of two with no family members to turn to for help. Seeing no alternative short of prostitution and being unusually creative by nature, she decided to put her young children into an orphanage and disguise herself as a boy in order to find work. Her costume was convincing enough to land her a job as a cabin boy on a Mississippi riverboat. There she spent the next

four years, regularly sending support money to the children's orphanage to help them out as best she could. Finally, fearing that her true sex was suspected by one of the less scrupulous crewmen, she was forced to move on. By now, however, she had discovered the secret to locating and holding secure employment. Still in disguise, she worked briefly for the Illinois Railroad and then decided to try her fortune, as did so many of her contemporaries, in the West.

Taking the Overland Trail as a member of a sixty-man Conestoga expedition, she traveled the slow, dangerous route to California. She related her reasons in her autobiography. "If I met with ordinary success I might be sure of a competence in a little while, and then I could retire into a more private life, resume my proper dress, and thereafter in the company with my children enjoy life to the full extent that circumstances would permit."[1]

After an unsuccessful attempt at placer mining in the gold-laden creeks of the lower Sierra Nevada Mountains, Forest took a somewhat tamer job in a saloon. Her financial desperation was reflected in her many references to the cost of food and supplies. Still, she knew she could not do as well as a woman. So, continuing to pose as a man, she bought a partnership in the saloon. The decision was a good one, and the saloon profitable. However, it wasn't long before Forest sold out in favor of a visit to her children in Louisiana where she, once again, wore dresses and petticoats. The next time she headed west, she was prepared.

On her second migration, a betrousered Forest drove a herd of 180 cattle but lost 110 of them to the alkali water so common to desert pools. Wounded during an Indian attack, she managed to reach her destination in California's Shasta Valley. Since her past western endeavors had been reasonably successful, she purchased a ranch and a mule train company. This, too, proved prosperous and, once again, her thoughts turned to her children. This time when she sold out in order to visit them, she expressed regret at her return to the lifestyle of a woman:

> I began to rather like the freedom of my new character. I could go where I chose, do many things which, while innocent in themselves, were debarred by propriety from association with the female sex. The change from the cumbersome, unhealthy attire of women to the more convenient, healthful habiliments of man was in itself almost sufficient to compensate for its unwomanly character.[2]

After an attempt at fur trading among the Plains Indians of Nebraska and a second unsuccessful go at mining, this time during the Pike's Peak rush, Forest opened Mountain Boy's Saloon in Denver, Colorado and picked up the nickname "Mountain Charley."

Finally admitting her true gender to her surprised friends and clients by marrying her bartender, H. L. Guerin, Elsa Jane continued to wear men's clothes and to answer to the name Charley—now out of choice rather than deceit. After one last mining attempt, the Guerins moved to St. Joseph, Missouri and settled down. Mrs. Guerin had found a way to comfortably return to life as a woman—a change others like her weren't willing or able to make.

Charley Parkhurst or Pankhurst (records are uncertain) was reputed to be one of the toughest, most daring stagecoach drivers in frontier California's Sierra Nevada Mountains. Charley was, to all appearances, a reclusive man who preferred to sleep in stables and rarely mixed with the other drivers. According to those who knew him, the slightly dandified hermit smoked, chewed tobacco, drank, and cursed with the best of them. Eventually, Charley retired to a small ranch in Santa Cruz County, where life continued quietly for some years before he was found dead in bed on December 29, 1879. The doctor who examined Charley for a postmortem delivered the amazing news to the mourners. Charley Parkhurst, reputed to be one of the toughest drivers in California, was female.

According to local legend that is difficult, if not impossible, to document, Charley is believed to have been born somewhere in the Northeast. Sketchy records indicate that she may have dressed as a boy to escape an orphanage and never appeared as a female again. When the doctor examined her body that December morning, he is reported to have found physical evidence that she had at one time given birth. Little more, other than speculation, can be determined concerning the mystery "man" of Santa Cruz.

"Little Joe" Monaghan was a New Yorker, according to postmortem newspaper accounts, who went west disguised as a male. She may have assumed a masculine identity as a means of protecting herself along the trail. She probably decided to remain in trousers for similar reasons plus, perhaps, the freedom of action they afforded her. The facts regarding her original name and childhood may be forever in doubt due to the secrecy under which she lived and died. Although her assumed name was

spelled as above in her January 12, 1904 *Idaho Statesman* obituary, later writers tended to use "Jo" (perhaps as a means of identifying her true sex) and nearly as often, "Monahan." Due to her small stature, fine manners, and gentle ways, Joe became a favorite topic for legends concocted by the denizens of the West, even during her lifetime. The fine hairs dividing fact from fiction are particularly difficult to discern where Joe Monaghan is concerned.

"Little Joe" arrived in Ruby City (later renamed Silver City), Montana in 1867. She, like Charley Parkhurst, was a loner who won the respect of a community that believed she was a man. Although standing only about five feet or five feet two inches tall (depending upon the source), Joe led the hard life of a silver miner before turning to sheepherding. Romanticized tales concerning the diminutive sheepman's run-ins with cut-throat cattlemen, which appear among later articles featuring "Little Jo," conclude that only her gentility and small stature saved the guileless sheepherder from their sinister wrath.[3]

After a few years, Joe began to hire out to work for local ranchers, performing the difficult chores attributed to cowhands of the day. In particular, she became a talented bronco buster and rarely failed to quiet even the wildest steed. About a year after her death, the *Boise City Capital News* claimed, "No horse was too wild or savage that he could not be brought to saddle and butt under Little Jo's hands."[4]

Using the experience gained working as a ranch hand, Joe claimed and developed a small homestead of her own near Rockville, Idaho. There she lived in a dugout shoveled from the side of a hill. Later accounts refer to her home as a primly neat log cabin. Of course, by that time, everyone knew she was a woman, and they were likely to be more comfortable believing she had lived in a tidy little cabin rather than a squalid dugout.

During the summer, Joe traveled to nearby ranches to perform odd jobs and, throughout the winter, cared for her own horses and cattle. According to her friends, she could rope, shoot, and break horses, but her socializing was limited to singing in her "choir boy" voice with cowhands around the campfire. She generally slept under the stars rather than in the bunkhouse with the other hands and neither drank nor smoked.

"Little Joe" became a respected member of the community and is said to have registered her cattle brand, voted in elections, and served several times on juries (although the poorly kept records of the town don't support this final claim)–all privileges not afforded women. She may have

even worked briefly as a bronco buster in Whalen's (or Whaylen's) Wild West Show and been featured in one of the first films ever produced featuring rodeo performers, if legend and history haven't once more become entangled.

When Joe was found ill in her cottage, a neighbor who knew her well tried unsuccessfully to nurse her back to health. She died in 1903, and, like California stagecoach driver Charley Parkhurst, her true sex was discovered as she was laid out for burial.[5]

The saga continues with extensive speculation concerning the true identity of the tiny cowboy. Two of the keys to her past seem more likely than the others, although they, too, are suspect.

According to a 1952 article in the *New York Post*, a small, black suitcase found after her death revealed that Joe was really Josephine Monaghan, daughter of a prominent Buffalo, New York family. She had been seduced by a passing playboy and forced to abandon her affluent existence for the obscurity of New York City. There she gave birth to a baby boy, turned him over to her sister, and headed west. Letters from that sister and a photograph of Josephine as a debutante were supposedly among the memorabilia in the trunk and have been published on several occasions.

The July 1971 issue of the *Frontier Times* offers a second account. It contends that a curious local rancher, Bill Schnabel, snooped around enough after her death to uncover the fact that Joe actually had been Johanna Monahan of Buffalo. She had been adopted by a family named Walters after the death of her mother and an agonizing period in the custody of a cruel stepfather. After heading west "to make her fortune," she stayed in touch with her adoptive family and mailed them a snapshot of herself dressed as a man and seated on horseback. That photograph and a brief, accompanying story spread quickly through the country after Joe's death.

The *Frontier Times* article goes on to discuss the quest of a young Californian who wrote to the postmaster in Rockville, Idaho asking about the whereabouts of Josephine Monahan, the woman he believed to be his long-lost mother.

There are other, less publicized and far more romanticized versions of Joe Monaghan's early life. Stories like Charley's and Joe's are fascinating not only because of what we do know about them but because of what we may never know.

Women who escaped their social role as the "pure and fragile" sex by pretending to be men were usually native easterners and often, if the stories can be believed, victims of violence or hardship. For a wide variety of reasons, they found themselves desperate to change their identities and make a living, but with neither the means nor the interest to do so in a conventional female manner. Their unusual form of rebellion in the face of the Cult resulted from their own sense of social and economic inferiority.

Once their true identities were discovered, these frontier transvestites did serve the purpose of forcing many of those who learned of their secret to question the essential value of a social system that could be so easily and so completely defied at will. Moreover, the fact that at least a few women could function successfully within the male role for so long a time led to further weakening of the slowly dwindling Cult of True Womanhood. But, because they chose to escape their femaleness rather than challenge its limitations, these tough little women were seen as eccentrics rather than exceptional women, and, consequently, they did little to bring recognition to their sex for their sometimes remarkable achievements.

7
SOILED DOVES

The frequently romanticized western prostitute was, like women who dressed as men, usually an eastern immigrant with pressing financial reasons for pursuing her rather noteworthy career. "Soiled doves" were popular in early, virtually all-male western settlements and managed to keep pace with the advancing frontier. They were often the first women to arrive in an area and the first to leave when civilization finally arrived under the guise of family, church, and culture.

The boom years in mining camps, with their no-holds-barred lifestyle and male-dominated population, created an atmosphere in which prostitution enjoyed great success and occasionally large, if short-term, profits. A Virginia City denizen of the mid-1860s recalled in later life that at one point the city boasted 12,000 people, "but only 20 were women and most of them were trollops."[1] One estimate suggests that in the second half of the nineteenth century approximately 50,000 prostitutes were plying their trade in the trans-Mississippi West.[2] In fact, legend has it that the term "red light district" originated in Dodge City, Kansas, where railroaders who were visiting prostitutes hung their red brakemen's lanterns outside their doors in order to signal their need for privacy.

Saloon hostesses, performers, and dancers, though often assumed to be "loose," were not always ladies of easy virtue. Some were young, single women who, newly arrived from the East or from Europe, were simply trying to support themselves in ways that defied the drudgery that was woman's lot. Others were wives of eternally optimistic but realistically poor miners who were working to supplement the family income. However, the fine line between entertainment and prostitution was narrow indeed. Prostitutes, as well as hostesses and the like, were expected by those who employed them to advance the cause of

alcohol consumption with their customers before retiring upstairs to their rooms. Frequently, one seemingly tireless woman would fill the multi-purpose shoes of hostess, dancer, performer, and prostitute.

As was done in the East, western prostitutes advertised their services and wares by dressing in brightly colored, physically revealing outfits and brazenly sashaying about town. Prostitution, one of the few "professions" dominated overwhelmingly by women, spread through the male-dominated ranchlands and the boom towns of the frontier as a serviceable means of income for women of all ethnicities. No other field of endeavor for either sex indiscriminately employed Mexicans, Asians, blacks, Indians, and whites and offered them all the fringe benefits of low wages, regular beatings, numerous cases of colorful venereal diseases, unwanted pregnancies and, therefore, abortions or attempts at them, plus, too often, an early death. Their lives were romanticized in the garish dime novels that were so popular among curious eastern readers, but prostitutes generally led miserable lives.

Most western harlots were young, uneducated women from poverty-stricken backgrounds whose lack of education and social upbringing gave them few choices if they hoped to improve their desperate lives. To them, at least, their options appeared starkly limited. They could hire on as servants to the more fortunate or join the comparatively glamorous ranks of "Ladies of the Evening." Those seeking excitement and adventure leaned toward the latter endeavor, not fully realizing that the career, and quite often the life, of a prostitute generally ended a good thirty years before that of a servant. As one Denver prostitute explained, "I went into the sporting life for business reasons and no other. It was a way for a woman in those days to make money, and I made it."[3]

Few found the glamour or success they so desperately sought. Prostitutes died younger and in larger numbers than did more restrained women, and their lives, even after retirement, were doomed to misery more often than not.

Despite the women's own dreams of meeting and marrying a pioneer Prince Charming, only the most repugnant frontier men initiated long-term relationships with prostitutes. More respectable men would turn from their bawdy companions at the first opportunity and marry virginal daughters of local miners, ranchers, and farmers. The 1880 census revealed that among Denver's fifty-five prostitutes, thirty-three were single, five married, and seven divorced.[4] Despite their dearly held hopes and dreams, marriage or cohabitation with gamblers, bartenders, pimps, or saloon owners made the lives of western prostitutes even

more miserable. These men often expected their women to continue in their line of work in order to supplement or single-handedly provide the family income. The sad fact is that prostitutes tolerated this sort of treatment because they had rarely, if ever, known anything better. Relationships of this sort tightened the chains of their male-induced bondage and added new chapters of melancholy to the wretched decadence of their lives.

Biographies of frontier prostitutes are colored with the fictionalizing common not only to western history in general but to the lives of prostitutes as well. When interviewed, many of these women, perhaps as a means of justifying their career choice, exaggerated the glamour of their positions and financial condition. Many of the men who had known them daily endured the dangers of underground mining or dust-choking cattle drives and saw these women as diamonds in the rough. Some may have been just that. However, writers, preferring entertainment to information, treated them with more imagination than accuracy.

Young Mollie Forrest married Joe Scott from the Black Hills, and the couple traveled to Helena, Montana in 1880. Their names show up on the court dockets of Helena as a result of Joe having battered a hotel clerk who questioned their marital status.

From there, the Scotts went on to Butte, where she became employed as a bar girl and prostitute at a local dance hall. Joe did a little mining but spent most of his time drinking and gambling. One evening Scott stormed into Mollie's place of business violently angry. Witnesses testified that after a hot-tempered argument, he grabbed his wife, "dragged Mollie to her prostitute's room near the dance floor and shot her. The fatal shot blew away the side of her face and the back of her head." Mollie's miserable life had ended in a manner all too common for prostitutes and their companions.[5]

Annie Morrow immigrated to Atlanta, Idaho and then Boise, as a child. At an early age, she began practicing the oldest profession. When she and a colleague, Dutch Emma, became trapped in a snow storm in the Rockies, the search party found Annie half-crazed and half-frozen beside the body of her friend. Both of her legs were frozen and had to be amputated, leaving Annie walking on stumps and seemingly unemployable. When she recovered, she began work as a laundress for the same miners who had once paid for more personal services.[6]

But Annie wasn't easily daunted. Realizing that her strumpet days were past and preferring not to spend the rest of her life beside a wash-tub, she saved her hard-earned money and opened a boarding house in Atlanta. In no time, she had added to her enterprise a "lively and highly illegal bar."[7]

Years later, during prohibition, revenuers raided her place, although Annie had been tipped off long before their arrival. Always ready for a little fun, she not only hid the incriminating evidence but invited her friends to visit her soon-to-be-raided establishment to watch the G-men at work.

Their search turned up not one drop of liquor, leaving them with no choice but to apologize to the poor old crippled lady for their actions. As soon as they were out the door, Annie "raised her long skirts and clambered down from the big whiskey barrel on which she had been sitting.[8]

Given the confusion existing between fictional renditions of frontier tales and the facts behind them, individuals often become lost in the turmoil. Women of uncertain reputation, more than others, were victimized or celebrated (depending upon your interpretation) by this tendency. Numerous women lived as prostitutes among the overwhelmingly male populations of mining or cattle towns but were respected enough by these same men to enjoy reputations as lily white as any virgin. These, after all, were the same men who coined terms such as "Ladies of the Evening," "Soiled Doves," and "Fallen Angels" to substitute for the harsher, more judgmental "whore" or "harlot."

But the shoe could as easily be placed on the other foot. Women who got in the way of political chicanery or other male endeavors could be blackened with the soot of ill repute as easily as their sisters were purified. In a lawless environment, vigilantes could and did regulate society. If the victim was a criminal, justification for backwoods hangings was easy to come by. If the victim was a woman, prostitution was often the crime of convenience.

The story of Ella Watson exemplifies the difficulty implicit in a historical study of western characters. In her case, the routine romanticizing of "wild west" sagas was complicated by the political wrangling of the range wars. The bare facts of Watson's life are all that can be guaranteed. She was a stocky, somewhat homely woman who came to Sweetwater, Wyoming to homestead a claim next to that of Jim Averell, a small ranch owner homesteading a controversial piece of land. A con-

flict developed between Watson, Averell, and a wealthy cattle baron over ownership of the claims on which Watson and Averell resided. As a result, the luckless woman and her next-door neighbor were hanged together from a tree by a lynching party, none of whom were ever punished for their deed.

The problem was that Ella Watson's life was played out among the violence that, for a time, engulfed the range land and water rights throughout cattle country. Having arrived well ahead of the sheepherders and farming pioneers who followed, the cattlemen of the plains had grown accustomed to open range ranching that allowed branded, semi-wild longhorn cattle to roam, grazing at will across wide spaces of unfenced territory. For decades, they got away with it, until frontier land began to grow scarce and newcomers were forced to challenge the established order.

Cattlemen's associations rose to the challenge by becoming little more than vigilante committees determined to preserve the status quo. The stockmen fought among themselves, with the sheepherders whose animals grazed on the same grass as cattle, and with the farmers whose snaked-lines of barbed wire were beginning to seal up the prairie and whose plows were turning under the grass. The result was more than twenty years of protracted violence that victimized nearly everyone in its path.

The Ella Watson story unfolded during the height of the range wars in Wyoming. The wealthy stockmen who wanted Watson and Averell off the land represented one side of the story. The not-so-wealthy, who sympathized with the two homesteaders against the ranchers, told quite another. Newspaper stories were the only documentation of the episode, and, at the time, they were notoriously prejudiced in favor of the cattlemen. Two markedly different tales evolved from the fiery situation.

In the stockmen's version, Ella Watson was known as Cattle Kate. It was said that she was the oldest of nine children from a poverty-stricken farm in frontier Kansas. By the time she was halfway through her teens, Kate had become a prostitute to escape the dirt-scrabble farm of her Bible-toting parents. She traveled from one frontier city to another plying her trade and, according to some who had known her, was married briefly to a man named Maxwell.

The stockmen's tale goes on to state that she eventually met an equally amoral individual named Jim Averell who offered to pimp for her. In an effort to add a degree of efficiency to the business deal, he had Kate homestead the claim next to his. Here she built a shack-like brothel

that became known by local denizens apparently unimpressed with both the structure and its less than comely proprietor as the "Hog Ranch."

What disturbed the cattlemen was the presumption that Kate often accepted rustled cattle as payment for her favors. One particularly dramatic version of the story even has Jim Averell running stolen cattle through Kate's homestead as a clearinghouse. There he would re-brand the beasts, fatten them up, and ready them for market. Whether or not the tales were true, stockmen believed them. By the spring of 1889, the cattle barons claimed that Kate's corral contained more than one hundred stolen calves that had been marked with her concocted brand, even though records in Sweetwater carried no brand registered to Ella Watson.

A. J. Bothwell, one of the owners of the stolen calves and a leader of the stockmen, organized a raid on Kate's ranch. The vigilantes drove off the allegedly stolen cattle, captured Kate and Averell, and, without benefit of trial, lynched them both from the same sturdy tree. Their bodies hung gruesomely in place for two days to serve as a potent deterrent for other homesteaders.

The version of the story told by Watson's sympathizers is markedly different. According to them, Ella Watson was not a prostitute but either Averell's wife or his lover. She and Averell worked separate homesteads, as did many other frontier couples in an effort to benefit from a peculiar loophole in the laws regarding homesteading. According to the Homestead Act, a man and his wife could homestead only one 160-acre claim between them. However, two single settlers could claim one homestead apiece (320 acres). It was entirely possible that Ella and Jim were secretly married and a bit ambitious. There were even those who said that a young boy named Tom Averell had been born to the couple in 1884 and lived with Ella on her homestead. Others don't mention a child.

Supporters go on to say that Averell and Watson had the misfortune of settling on land once used by Bothwell as pasture for his wide-ranging cattle that he wanted back. In an attempt to save his land from the grasp of so powerful a man, Averell began to organize homesteaders to stand up to the power of the stockmen. He wrote letters to a Casper, Wyoming newspaper asserting that the cattle barons were attempting to "hog one hundred miles of the meadows along the Sweetwater River."[9] In short, Jim Averell was becoming a pain in the neck.

The ending of this version of the story is identical to the stockman's tale, except that sympathizers called it premeditated murder by Bothwell and his compatriots. They also claim that the cattle in question belonged

to Watson and Averell and that stories of Watson's less than moral behavior were invented to justify the cold-blooded murder. As with much of the history of the wild West, the absolute truth probably will never be known.

Under any circumstances, the misery of prostitution had a tendency to perpetuate itself. Surviving children of prostitutes led lives of not-so-quiet desperation. As one might expect, an unusually high percentage of them died of disease or neglect, and those who lived, more often than not, did so like brutes. Their mothers spent inordinate amounts of time away from home–either in jail or following soldiers. The children were dragged from town to town and subjected to poverty, brutality, and extensive physical and even sexual abuse. Most remained illiterate and unskilled, prepared only for a life of pimping, prostitution, and crime. If female, they most often followed their mothers into the family business, where the agony was perpetuated, at least temporarily.

* * *

Prostitution, in a rather twisted way, was a career that could be categorized under a "woman's place." The lifestyle pre-dates written history as a last-chance option for desperate women plagued by spurious cultural constraints. Nineteenth-century men categorized women in two classes–those you took home to mother and those you didn't. "Ladies of the evening" were the unfortunate denizens of the latter group. Prostitution also opened no new doors for women in search of a widened cultural role. In fact, it denigrated women even further, and its tendency to be romanticized in the West supported those who continued to consider women as weak, passive, not altogether bright, and designed by the Almighty to be tools of the stronger, active, far more intelligent male.

The frontier West was an unruly land where vigilantes too often enforced whatever had been substituted for law and prostitutes could become community idols. To further complicate an already confusing situation, early treatment of western history at the hands of those fascinated by the romance rather than the reality of life on the frontier tended to be less than factual. Not only did historians, newspaper editors, novelists, and the like glamorize the often vulgar events of the wild West, but so did the characters who lived them. It's little wonder that coarse miners who spent much of their lives in the bowels of the earth and dusty

cowhands who spent theirs staring at the rear ends of cattle often viewed prostitutes as angels. After all, they were often the only women around, and they could usually be counted on to help in an emergency. The history of the West is replete with outlaws who, with a bit of revision, became heroes, gunmen who became defenders of the common man, and drunks who became celebrities.

Sometimes, however, the trend reversed to create monsters out of good-hearted nonconformists. This tendency was particularly prevalent during the "civilizing" time that eventually affected every town as families came there to live. Attempts by these well-meaning people to reform the rough, tough surroundings could be grossly unfair to those less-structured citizens who preceded them.

Circumstances grow more convoluted when the political concerns surrounding land domination and power are considered. Much of the story of the West is one of greed. Everyone wanted land and a piece of the action. The powerful wanted a great deal of it in order to become more powerful. The common man wanted just enough to live on. In both cases, they were willing to fight for what they wanted. The innocent and even the not-so-innocent who were caught up in the contest usually lived to regret it. Sometimes they didn't.

8
SILVER AND GOLD

Money was there to be made in the West. It could be scooped from fast-moving rivulets descending from mountain sources or dug from the mother lode under tons of earth in the bowels of those same mountains. It shone in the sunlight, could be pounded into powder, and traded for nearly anything. It was silver or gold or any one of the lesser ores that were housed in the ranges of the far West. When a lode was discovered, a boom town sprang up around it as instantly as fire leaps from a match. When the lode was played out, that same boom town emptied just as quickly, leaving behind only the ghosts of memories. Greed was the underlying cause of it all, and women were just as attracted by the ore fields of the West as were men.

Mining, whether of the placer (panning) variety or underground, was considered mentally and physically too difficult for women. Many of those who did try their hand at mining disguised themselves as men to avoid the uproar their presence would invariably cause, but not all of them did. Many of the women highlighted in this research effort were, at least for a time, miners. Elsa Forest, Joe Monaghan, and Calamity Jane Canary were just a few.

In 1864, in Bingham, Utah, the Woman's Lode Mining Claim registered their claim with the following statement:

> We the undersigned "Strong Minded Women," do hereby determine and make manifest our intention and right to take up 'Feet' ore [sic] anything Else in our names, and to Work the Same independent of any other man. We do therefore take up and claim in our own Right '200 Two Hundred feet Each. . . at this Notice and Running in a N.E. direction 1000 One Thousand feet and

S.W. direction from the same 1000 One Thousand feet with all its dips, Spurs, and Angles, and Variations and Whatever other Rights and priveledges [sic] the laws or guns of this district give to Lodes so taken up.[1]

The women making this claim were soldiers' wives, the wife of General Patrick E. Connor being the first to sign the document. All nine of them succeeded their signatures with their husbands' military ranks. Their motives in filing such a claim are unknown, as is information regarding the success or failure of their endeavor, but these women are the only officially documented female mine owners of the nineteenth century.[2] However, they weren't the only women who took up mining.

The February 13, 1850 issue of the *Illinois Republican* reported that two young women came to California with the forty-niners. They were accompanied by an old and trusted slave and staked out a claim about thirty miles from any other mining activity. There they began digging for gold and soon had about $7,000 worth of dust, intending to stay, according to the reporter, until they had $10,000 worth.[3]

Hundreds of other women worked in the mining industry, and many mined land without first filing a claim for it. Many assisted husbands and fathers on their claims. Others invested money wisely in the mining ventures of friends and relatives. Mrs. E. C. Atwood of Colorado was so upset after losing $10,000 in bad mining investments that she took up the study of mineralogy. Within just a few years, she was the reigning vice president and general manager of the Bonacord Gold Mining and Milling Company.[4]

Theora Ailman was raised on the frontier, wandering from place to place behind a footloose father. Her family first moved from Michigan to Missouri, to Illinois and then to New Mexico, settling there in 1877. There Theora married Henry Ailman and moved to Georgetown, California, where her husband owned a mine. She became the enterprise's bookkeeper and one of only four white women in town.

Lillian Weston Hazen, who served as bookkeeper for a mine in Gilt Edge, Montana, described the boom town in a carefully kept journal:

It was wide open gambling, drinking, and fighting in every saloon, and the bartenders were kept busy. Calamity Jane was there one winter, and it was said that she was never the last up to the bar when somebody set up the drinks. Sometimes a thousand dollars was lost on the turn of a card. And many a weird western character wandered through.[5]

Luzena Stanley Wilson's memories were recorded by her daughter and later typed and bound. Luzena was twenty-eight when she and her husband and two children moved to California in search of gold. She opened a boarding house. When they moved on to Nevada City, she opened a hotel:

> I brought two boards from a precious pile belonging to a man who was building the second wooden house in town. With my own hands, I chopped stakes, drove them into the ground, and set up my table. I bought provisions at a neighboring store, and when my husband came back at night he found, mid the weird light of the pine torches, twenty miners eating at my table. Each man as he rose put a dollar in my hand and said I might count him as a permanent customer. I called my hotel "El Dorado." From the first day it was well patronized, and I shortly after took my husband into partnership.[6]

* * *

One of the unique promises of the frontier that was the American West came from the glittery stuff emanating from underground. The record shows that thousands went West in search of quick, easy riches. What they found was filth, miserable working conditions, a good chance of alcoholism, the likelihood of an early death buried under tons of rock, and the probability that they would never, never become rich.

Mining attracted women in nowhere near the same numbers as it did men. The realities of the vocation were simply too negative. Placer mining (panning the waters of rivers and streams) kept one above ground and required less physical prowess, but the payoff was many times smaller than underground mining with all its faults and dangers. The money, if it was to be had at all, was in the great veins of gold and silver beneath the earth. It had to be picked and pried from the bowels of the mountainside by brute force, and few women were up to the challenge.

Those women who were, however, became legendary, in part because there were so few of them. They often acquired unfortunate reputations, perhaps because they deserved them, perhaps because they were the only women among the hundreds and sometimes thousands of men who swarmed about the forbidden gold and silver camps who weren't openly prostituting their wares and nobody knew what to think of them.

The discovery and exploitation of precious metals was essential to the history of the United States. Rumors of precious metals and gems helped to bring the first explorers and settlers to the colonies of the New World. Gold rushes were essential to the settling of the vastness of the frontier West, and tales told about gold in the streets of New York and Boston helped man early American factories with hopeful immigrants at the turn of the twentieth century.

In 1859, prospector William Parsons summarized the impact of greed and the discovery of valuable ore in the Rocky Mountains:

> As the discovery of gold in the mountains of California was the forerunner of an immense emigration, and the immediate cause of the erection of a new and powerful state upon the Pacific coast, so the recent discovery of the precious metal in and around the vast "mother range" of our mountain system, is destined to exert an incalculable influence upon the growth and prosperity of the country. The Atlantic and Pacific coasts, instead of being, as they are now, divided countries, will become parts of a compact whole, joined and cemented together by bonds of mutual interest.[7]

9
JUST VISITING

Army wives were a somewhat unique group of women. They came west with their husbands, tolerated the primitive conditions and extreme weather, lived in one form or another of inadequate shelter, and survived just like their pioneer sisters. Unlike permanent settlers, however, army wives knew from the beginning that their situation was temporary. That knowledge seemingly allowed them to treat their western experience as an adventurous tour and, in many cases, gave them a rather unique sense of abandon.

Thanks to the cascade of migrants headed west and the assortment of hazards awaiting them, the decades surrounding the Civil War saw the U.S. Army assume the role of pioneer protector. In the rush to meet the demand, crude forts were quickly erected, protective stockades raised, and soldiers assigned to master primitive conditions. Little thought was given to comfort or convenience and even less to the possibility that military dependents might choose to accompany these servicemen.

Unfortunately, the army paid poorly across the board and offered few benefits to its troops or their leaders. Enlisted men earned so little that they routinely hired themselves out to senior officers as servants or handymen during their off-duty hours. In search of supplementary income, enlisted soldiers whose wives accompanied them usually found it necessary to put them to work as well. Junior officers also were forced to seek ways to augment their incomes but were more likely to turn to family for assistance.

Even though many soldiers were family men, there were no special provisions made for accompanied tours to frontier posts. Women and children had no more status than common camp followers. In fact,

military law did not officially recognize their existence. When women did have the nerve to accompany their husbands to the frontier, they were expected to live in the same spartan environment as the soldiers. Most of them stuck it out; some stayed for a while and then returned to the more civilized environs of the East. Because of the less than adequate conditions, many died earlier than they might have if they hadn't come west— usually in childbirth.

The wives of enlisted men suffered the most. Since these women had neither the time nor the education to write letters or keep journals, a history of their experiences must rely on the hearsay of others. The War Department preferred that their common soldiers not marry at all, and while it didn't forbid them the privilege, official policies made life for married soldiers as difficult as possible. They generally lived in unheated tents, crude dugouts, or slightly more comfortable sod houses and had less legal status than camp laundresses.

Inside these "homes," dirt floors were damp enough to grow mushrooms, insects and small vermin dashed from point to point, wind whistled through the gaps in the quickly erected walls, and rain poured through the roofs. Yet the inhabitants of these post accommodations were the lucky ones. Because of the limited amount of housing on post, a restricted number of enlisted men had wives and children living on "Soapsuds Row" with the laundresses while they continued to reside in barracks.

Since the rough conditions weren't deterrent enough, the Army issued Circular No. 6 of 1883 stating that married soldiers had no right to separate housing as of June 18 of that year. Circular No. 8 of 1887 discouraged married soldiers from re-enlisting and indicated that the Quartermaster's Department would no longer provide free transportation for soldiers' families.[1]

In addition to these constraints, the wives of enlisted men nearly always had to supplement their husbands' meager incomes. Because they were female and usually semi-educated and semi-skilled, their options were few. Most of them worked as laundresses, cooks, or maids for the bachelors or unaccompanied troops assigned to the post. It was difficult work and served only to aggravate the anguish of life on the frontier. Laundresses, a group of women recognized, paid, and ranked by the army until 1883, were described by one army officer as "industrious, red-armed women who maintained their rights with acrimonious volubility. . .and they were ever ready for a fight."[2]

Although officers' wives were officially recognized by the War Department, no special provisions were made for them. Most were

products of middle-class eastern homes and, often having read the popular dime novels of the time, had romantic misconceptions about life in the West. Since their husbands had been sent west ahead of them in the company of their comrades, women generally made the long, rugged trip alone or with their children, traveling first by train to the railhead nearest the post and then by stagecoach. Wealthier women headed for Pacific coastal areas might sail to Panama and then cross the Southwest by train to their destinations.

The relative quality of post quarters depended upon rank and seniority. Officers' Row was generally a line of tiny log or sod cottages with three or four tiny rooms each. Rugs were often army blankets seamed together, and packing boxes substituted for tables and washstands. Senior officers were able to choose their homes from among all existing quarters. If a junior officer was occupying the home at the time, he was ordered to move out. "At Fort Clark, Texas, a captain forced Lieutenant and Mrs. Oremus B. Boyd to move out of their quarters even though Mrs. Boyd had recently given birth, was still suffering from childbed fever and two of her three children had whooping cough. The Boyds, five in number, then occupied quarters consisting of one room and a detached kitchen."[3]

Many officers' wives were relatively well educated and, perhaps because they viewed the opportunity as an adventure at first, kept diaries or published books concerning their experiences. They had arrived at their destination as conservative women learned in the ways of True Womanhood. They viewed the West as a desolate land devoid of civilization and were often disgusted by routine frontier situations. Terese Viele described the food available in the post store:

> Mouldy flour and rancid pork and a few beans. . . . The butter was always soft and liquid, the water was constantly lukewarm, and the food was flavored with red ants which tasted similar to caraway seed.[4]

Still, these army women, particularly the officers' wives, had a curious way of making the best of things. Their writings reveal a certain sense of adventure that gave them a tourist's determination to see and do as much as possible so that they could learn by the heinous experience. Being military wives, they were products and enforcers of a strict caste system. They expected and received more privileges as their husbands rose in rank and had little interest in or sympathy for those "beneath" them.

Charity efforts usually focused on children orphaned by the Indian Wars and rarely on women of more common origins. In fact, officers' wives had little to do with the wives of enlisted men and avoided at all costs the lusty residents of Soapsuds Row.

Military wives also showed little generosity toward their pioneer neighbors. Ellen McGowan Biddle wrote in her memoirs of her disgust in meeting a Dodge City hotel owner who was "a woman with a hard face, fully six feet tall and of very large frame. She was dressed in a 'bloomer' costume. . . a knife and pistol were in her belt."[5] Even less merciful were the comments of Lydia Lane, who, in her account, reported, "We are told to take in the stranger, as by so doing we may entertain an angel unawares, but I do not think that class of guests often travel in Texas and New Mexico. . . and if they did. . . their disguise was complete."[6]

Conveniences and even necessities were usually rare or completely lacking on frontier posts. Few had schools, churches, or medical care for dependents. Supplies needed to set up housekeeping and deal with growing families were non-existent. Eviline Alexander remembered her first post home as a "large hospital tent" with a small fly that protected the kitchen beneath from the sun and rain if little else. Here she entertained the renowned General William T. Sherman as they sat around a table of planks spread across two sawhorses. He didn't seem to mind.[7]

Elizabeth (Libbie) Custer was the wife of the famous, if short-lived, George Armstrong Custer, or Autie, as she called him. Her book, *Tenting on the Plains or General Custer in Kansas and Texas,* a masterpiece of personal and spousal salesmanship, was first published in 1887. It covers the young couple's experiences on the Plains from 1863 to 1867. While it must be read with an eye toward the Custers' joint predilection to pat themselves and each other heartily on the back, it relates the hardships of the tour as well as Elizabeth's apparently positive approach to the adventure. Traveling by covered wagon to Austin, Texas in the winter cold, Mrs. Custer wrote:

> It was cold at night, and the wind blew around the wagon, flapping the curtains, under which it penetrated, and lifting the covers unless they were strongly secured. . . . It rained sometimes, pouring down so suddenly that a retreat to the traveling wagons was impossible. One day I was wet to the skin three times. . . . Our march was usually twenty-five miles, sometimes thirty in a day. The General and I foraged at the farms we passed and sought good butter, eggs and poultry. . . . We enjoyed every mile of our march.[8]

Because of George's indisputable ambition, the Custers had more experience with the frontier army than most couples—a fact that allowed Libbie to enjoy a sense of superiority concerning her ability to adapt to the environment. The couple was stationed in two Texas posts and at Fort Riley, Kansas. From the latter, Libbie wrote to her aunt Eliza Sabin in 1866:

> I am never happier than when sleeping in a tent. It is so comfortable. . . . There are drawbacks to Kansas, but it is a fine spot to begin life in, with good farming land.[9]

According to Libbie, she and her husband were particularly inventive with her heavily petticoated skirts.

> These seven breadths of skirt flew out in advance of us, if they did not lift themselves over our heads. My skirt wrapped themselves around my husband's ankles, and rendered locomotion very difficult for us both, if we tried to take our evening stroll. He thought out a plan, which he helped me to carry into effect by cutting bits of lead into small strips, and these I sewed into the hem. Thus loaded down, we took our constitutional about the post, and outwitted the elements.[10]

Despite the fact that she apparently was not prepared to surrender her skirts to ride astride, Mrs. Custer became a daring horsewoman, albeit on sidesaddle. She, her husband, and their two dogs often enjoyed the unbounded openness of the prairie. He would carry her hairpins, net, and switch in his coat pocket so that, after their horse race, she could repair her long hair (a point of contention—she wished it could be short) before they returned to the post. She described such a ride:

> The horses bounded from the springy turf as if they really hated the necessity of touching the sod at all. They were very well matched in speed, and as we flew were "neck by neck, stride by stride, never changing our place."[11]

The General wrote to his father-in-law:

> Libbie. . . is now an expert horse-woman, so fearless she thinks nothing of mounting a girthless saddle on a strange horse. You

should see her ride across the Texas prairies at such a gait that even some of the staff officers are left behind.[12]

The general's wife did find a few aspects of the frontier that were not to her liking. While in Texas, she wrote of her fear of scorpions and ants "with such sharp nippers that they made me jump from my chair with a bound."[13] She also had few compliments for the pioneers she encountered. In one observation she reported seeing "small, low log huts, consisting of one room each. . . and the windows and doors were filled with vacant faces of filthy children."[14]

In a very real sense, army wives had the best of both worlds. Products of the East, they were willing to live by its standards while under eastern surveillance. Their journey to the frontier allowed them to visit another culture and to adopt the traditional philosophy of the tourist—"When in Rome...." Fully determined to return to the more cultured refinement they had left behind, these women were reckless enough to accept abandon when it was presented to them. The majority, after all, were young. They enjoyed lives of adventure and travel or they wouldn't have married soldiers. In making the most of a temporary situation, they challenged the boundaries of the Cult of True Womanhood but were always fully prepared to return to it once the adventure had ended.

Katherine Garrett traveled to Fort Lincoln, Dakota Territory, in 1874. Her sister, Mollie McIntosh, met her in Columbia. An army wife from the East with several years of frontier experience under her belt, McIntosh arrived armed to the teeth and served both as escort and bodyguard on the return trip to Fort Lincoln. Garrett later wrote down her observations, noting that, "Mollie's sensitive, musical nerves used to go jittery at a discord struck on a piano or guitar. This country had certainly changed her."[15]

The transition undergone by that first generation of western women was essential to the evolving sense of freedom their daughters would come to enjoy. If their mothers hadn't learned to adapt, however begrudgingly, to the wilderness, the daughters wouldn't have had a chance to take the next, great leap. If the accomplishments of these frontier women had not been observed and respected by the men around them, nothing new would have come of it. After all, men and only men wielded the ballot.

10
FACILITATORS OF CHANGE

Although their mothers struggled against all odds to meet the standards of the Cult of True Womanhood, the next generation was born into a frontier society that had slipped the noose of eastern refinement. Instead of imposing rules of behavior imported from the East and poorly suited to the less structured environment of the frontier West, these daughters of pioneers shaped opportunity in the land of their mothers' trials. In so doing, they changed for all time woman's role in the economy and culture of the United States. They were what historians have come to call the "new women," the grandmothers of modern feminism, and they did what they did not only because they had to but because it made sense.

As girls, quite a few of this generation of women had received the same education as their brothers, thanks to more liberal western schools and their schoolmarms. They had learned to use firearms and to ride astride. Many a corset was relegated to the closet and reserved for use only at parties and dances, if then. Many a floor-length skirt was remodeled to allow for more freedom of movement. Creative female riders tailored long, baggy trousers that resembled skirts so they could straddle a saddle like a man.

Sidesaddles, still used by petticoated eastern women, were uncomfortable and downright dangerous for cutting cattle or riding the fence line and dodging rattlesnakes. These women could be seen racing their steeds across the open prairie at speeds and with a daring previously witnessed in only the male of the species. Some became crack shots and were able to throw knives and snap bolo whips as well. In fact, the changes in lifestyle necessitated by life on the frontier produced thousands of female characters considered eccentric by the average easterner. A visitor to Indiana wrote:

A strange figure emerged from the tall rank weeds into the road before us, and continued to move in front, apparently never having noticed our approach. The figure was undeniably human; and yet at the bottom it seemed to be a man, for there were a man's tow-linen breeches; at top, a woman; for there was the semblance of a short gown, and indeed a female kerchief on the neck and a sun-bonnet on the head....It originated in the necessities of a new country, where women must hunt cows hid in tall weeds and coarse grass on dewy or frosty mornings.[1]

What had happened in the span of a single generation appeared revolutionary but was, in fact, a response to conditions on the frontier. Necessity had become rather quickly the mother of invention, particularly in childrearing.

Children of the frontier were more useful than hired hands–cheaper, too. They were expected to pull their weight on the farm or ranch and did so from the age of four or five. Perhaps because adolescence would not mean cotillion or the possibility of becoming a debutante, or because overburdened parents needed as much help as they could get, girls took on many of the heavy tasks. As time passed and necessity interceded, the separate chores traditionally assigned male and female children became blurred and often entirely reversed. Frontier historian Glenda Riley wrote:

Herding stock was assigned to boys and girls alike. Children as young as six and seven were sent out to follow the sound of the bell strapped around the lead cow's neck and to persuade the herd to stop grazing and return home for milking. In addition to this chore, Matilda Paul remembered that as a child she carried in wood for the cook stove, hauled water, and fed calves...as well as assisting with the more traditional female-oriented household duties.[2]

One change initiated by the first generation had an immediate and lasting effect on their children. Young, single women, "schoolmarms," taught the children of the West. Perhaps even more important, as relatively learned individuals and authority figures, these women also served as superior role models of educated female achievement. Because the teacher wore a skirt, her girl pupils tended to stay in school longer and their prolonged attendance became commonplace. After all, it required

a particularly courageous brand of nerve to tell the lady teacher that one was withdrawing one's daughter from school since she was a girl and need learn nothing more. Many of these students grew up to become "schoolmarms" themselves. Boys, too, grew up with a new view of female capability thanks to the women who had commanded their formal education.

Frances Trollope visited the United States from England in 1829. Of her visit to frontier Cincinnati, Ohio she wrote:

> The method of letting young ladies graduate, and granting them diplomas on quitting the establishment, was quite new to me; at least I do not remember to have heard of anything similar elsewhere.[3]

Quite often, the children themselves were unwittingly the facilitators of change. They acted not from principle but out of a sense of practicality. By making decisions based on their own innate sense of right and wrong, they tended to induce disapproval from their more idealistic mothers quite unexpectedly. In return, these utilitarian youngsters saw near lunacy in their mothers' attempts to inculcate the ideals of eastern womanhood into the realities of frontier life. They preferred to respond to challenges in a more pragmatic way. Once they had tempted providence in childhood and found it rewarding, the pattern for their adult lives was established.

Molly Dorsey's diary tells of a day she was sent to locate a stray cow. Tired of snagging her long skirt in the thorns and brambles of the prairie, she took action and recorded it in her diary:

> It occurred to me how much easier I could get through the tangled underbrush if I were a man! and without letting anyone know of my project, I slipped out into the back shed, and donned an old suit of Fathers' clothes....[4]

Molly's mother was horrified by her lack of refinement. At the same time, her sisters were delighted by her ingenuity. Molly, herself, simply did not understand why her practical approach to performing her task, and incidently saving her dress from snags and tears, was cause for criticism. One can be quite certain that Molly and her sisters adopted more sensible work attire by the time they reached womanhood. The real change in women's lifestyles began when these self-assured, self-

sufficient frontier girls, whose efforts had proved equal to their brothers', became women and fully expected to remain the equals of men. After all, they could ride and shoot; they had repaired roofs, erected fences, hunted, and, in some cases, birthed babies. Many of them smoked and partook of an occasional, or not so occasional, shot of whiskey.

Edith Stratton Kitt was born and raised in Arizona in the late nineteenth century. In describing her lifestyle, she wrote:

> I learned to shoot at an early age. When I was ten years old my grandfather presented me with a sixteen-gauge, single-barrel shotgun....I did much of my hunting on Little Bill. He was almost as good as a setter for pointing out game....Game was not as afraid of him as of me, and I could ride quite close to it, slip off my horse...and use his back as a rest for my gun.[5]

Because these young women had responded pragmatically to the demands of their environment, they had developed skills and qualities quite inappropriate for young ladies on the more traditional side of the Mississippi. Those who traveled to the East for enjoyment or education found nearly everything about it to be foreign to their natures. The refinement and restrictions imposed on young women there seemed unnatural to denizens of the frontier, and they generally longed for a return to their prairie homes. If their stay included an extended period in school, young women could be permanently re-programmed to a degree that commonly produced individuals too coarse for eastern society and too polished for the frontier—aliens in their own land.

Still, those reared on the frontier and able to adapt to their surroundings without prolonged interference developed characteristics not often found among the children, particularly the girls, of the East. Elizabeth McCracken remembered one of her host families in Nebraska:

> Have they not a peculiar power, those men and women who as children helped clear away the underbrush on the Western claims...? Her own home was a stronghold. She did so much, she could do so much with her heart and her mind and her hands; and her children were "joyous children;" they were capable and zealous; they, too, did much, could do much.[6]

Freed from most of the constraints that the Cult of True Womanhood placed on men as well as women, many of the children who matured

on the frontier became competent in fields once considered inappropriate for their sex. Boys learned to care for younger siblings, sweep floors, scour tubs, wash clothes, and churn butter. Girls learned to drive cattle, fire shotguns, mend barbed wire, and, in some notable cases, bust wild broncos. The divisions between sexual roles brought about by the advent of industry hadn't fit the needs of the frontier. By the time western children had matured, these roles were beginning to fade from view.

* * *

Sophia Wyers Bryan (1837-1904) was born and reared in Texas. She married a rancher and worked side by side with him throughout her adult life. "Sophia was not the type. . .to concern herself with social reform or political causes. She was not interested in closing saloons. . .but when the necessity arose, she could shoot straight, cut cattle, and snap a snake's head with the flip of her wrist." She, like her peers, had been born and reared in a world that had neither time nor patience for social niceties. Instead, such women had become accomplished, multi-talented souls who could plow, shoot straight, ride horses, drive mule teams, mend fences, grow their own food, birth their own babies, and darn socks when the need arose.[7]

Bryan's granddaughter was asked about her grandmother many years later. Her reply was simple. "She had quite a reputation for cutting her own cattle into, or out of a herd. Somehow I never heard any of the family say that they thought that was extraordinary. And I'm sure it wasn't."[8]

11
A NATIONAL CALAMITY

Martha or Mary Jane Canary or Conarray or Cannary–Calamity Jane–was probably born on the frontier's edge in Princeton, Missouri in 1848, 1850, or 1852. She may have married or had an intimate liaison with Wild Bill Hickok, but probably not. She wanted folks to believe she had fought Indians with General Custer, mined gold, skinned mules, and driven mule trains, but the facts don't bear her out. Even the date of her death is open to question. What is certain is that she hung out in the rankest saloons, drank like an air-gulping fish, and lied about nearly everything. The rest of her life story is a blend of truth, drunken ramblings, and the stuff of fictional dime novels sold to eastern curiosity seekers eager to romanticize the West.

This outlandish eccentric named Jane (the only part of her name not open to question) was a woman as controversial as her name. The story of her life has been glamorized to such a degree by herself as well as irresponsible sensationalists selling less than accurate "histories" of the West that an unvarnished biography has become absolutely impossible.

One undeniable fact is that Calamity Jane was a daughter of the frontier, and, as such, she added dimensions to the lives of women she would never meet. Few women of her time wandered as far from acceptable behavior and continued to identify themselves as female. Jane was a true product of the West, but a sad one. Despite her tragic childhood and alcoholic binges, Jane was a pioneer. Only in the freedom offered by the frontier could such a woman become legendary, even in the imagination.

She was, according to legitimate sources, the daughter of a drunken dirt farmer, gambler, and part-time preacher and his wife. Jane's mother sometimes supplemented the meager family income by

practicing prostitution. Jane wrote in her autobiography that she was born on May 1, 1852, the eldest of four girls and two boys. A little research proves this tale to be as fictitious as other accounts of her life.[1]

The Mercer County, Missouri census of 1860 lists a J. T. Canary, his wife Delilah, five girls, and three boys.[2] The contradiction in numbers can probably be blamed on the fact that many frontier children, particularly those of the poorer classes, died young. When Jane was approximately twelve years old, the family moved from Missouri to Alder Gulch, Montana, where their already difficult life rapidly deteriorated. The December 31, 1864 *Montana Post* reported that the little Canary girls spent that first blustery, sub-zero winter on the streets of town begging for food.[3]

Hard times drove Delilah, a crude and cursing woman shunned by most of the neighbors, to take in washing as well as the occasional stray man. She died of "washtub pneumonia" in 1866, an illness often contracted by red-armed laundresses who worked out of doors, elbow-deep in sudsy water, through the hard north prairie winters. The surviving family members moved to Salt Lake City, where J. T. died in 1867. With few ties to bind them, the Canary offspring went their separate ways. Thus, Jane Canary, an impoverished, semi-educated, uncultured, and decidedly unattractive girl in her mid-teens, was suddenly on her own.

Perhaps due to the fact that she possessed few of the characteristics and skills needed to be a successful woman of her time (she wasn't meek, genteel, religious, or even the least bit pretty), she was innovative. The fact that women were not permitted inside saloons probably caused Jane to dress like a man. Later, she proved there was little she wouldn't do for a drink, but even in trousers she never claimed to be male. By the time she was in her early twenties, Jane was a fun-seeking, cigar-smoking, cursing alcoholic who could be violent when drunk. For obvious reasons, she preferred the world of men and kept to it by circulating among the mining towns and railroad camps where men were most prevalent. A contemporary described her as a "good-natured camp trollop cruising with the timber bands, handling a pick, hoisting ties on her shoulders, and cracking a bull whip."[4] She quickly developed a reputation as rowdy but usually friendly.

In Deadwood, Dakota Territory, Jane is said to have joined a band of men led by Bill Hickok, and, although she was the only female, she was regarded as the wild one. The five men would ride into town with dignity as Jane "screamed,...waved her arms and leaned over from the

saddle to bestow enormous hugs and buffets."[5] Hickok probably toler-
ated her as a colorful, pitiable character and that was all. Possibly Jane
invented the story of her intimate relationship with Hickok after his death
in order to play on the sympathies of barflies and earn herself a few drinks.
She may have come to believe it herself as she gradually drank her way
to fame and a relatively early death.

From Deadwood, Jane traveled to Cheyenne, Billings, Rawlins, and
Rapid City, where she became little more than "a peculiarly engaging type
of town bum."[6] The fictional Jane, so well known by eastern readers, was
born as a heroic army scout on the pages of Horatio Maquire's *The
Coming of Empire* and lived on in any number of popular dime novels.
Jane loved the attention and the free drinks her image brought her as
she traveled from town to town and bar to bar embellishing the stories.
During the 1880s, newspapers often reported the presence of "Calamity
Jane" at the same time, but in different places. According to historian T.
A. Larson:

> Some people assert that there were three Calamity Janes, because
> the name appears so often in the press, and over such a wide
> area that there must have been more than one girl so designated.
> The best-known Calamity Jane was the one who died and was
> buried in Deadwood, South Dakota, in 1903. There are those
> who think she was a beautiful and romantic heroine. On the
> other hand, several scholars who have looked closely at the
> facts of the career have concluded that she was a mannish,
> hard-bitten prostitute whose sordid life has been glamorized
> beyond recognition.[7]

By 1885, Jane had settled down long enough to marry a man named
Burke. In fact, she wrote her strangely stylized, largely fictionalized
autobiography, *Life and Adventures of Calamity Jane,* under the name
Burke. Within ten years, however, she was back in Deadwood drunk and
begging for shots of whiskey. Rumors spread that she had a child or two
by Mr. Burke, but there is little evidence to support them.[8]

By 1895, Jane had been reduced to selling photographs of herself
in buckskins and six-shooters that had been taken during the height of
her fame. Kindly citizens of Deadwood threw a benefit for the penniless
Jane, perhaps out of a sense of duty to their notorious resident. As a way
of thanking them, she used the donated money to buy rounds of drinks
for the house. A witness wrote that "she continued to do this for the rest

of the evening until she became howling drunk and someone rescued what remained of the money."[9]

Jane made an effort to pull herself together in 1896 when she was hired to tour in her fancy buckskins for the Palace Museum. But try as she might, liquor won out, and she was fired for repeated drunkenness. In 1901, she accepted a job to appear at the Pan American Exposition in Buffalo, New York. Again, alcohol reaped its perverse victory. Jane, soused once again, pulled out her polished pistols and shot up the midway. She had been given her last chance but couldn't fight off demon rum long enough to enjoy it. This time when Jane was released from her contract, she returned to the frontier an even more broken woman.

Storekeeper William R. Fox recalled seeing Calamity Jane:

In early June 1903 there drifted into the town of Sundance, Wyoming, a nondescript woman who had the appearance of great age. When it was discovered that this woman was the notorious Calamity Jane of Pioneering days, those who had known her could scarcely believe her identity. All traces of her former vitality and aggressiveness were gone. She was fifty-two years old, but looked eighty.[10]

Jane died either August 1 or 2 of that year, a woman who had lived according to nobody's standards except her own and those of the addiction she couldn't shake. Even then, those who knew her expressed differing opinions. According to historians James D. Horan and Paul Sann, Dr. W. A. Allen of Billings, Montana said simply, "She swore, she drank, she wore men's clothing. Where can you find a woman today who doesn't do such things? She was just fifty years ahead of her time."[11] On the other hand, L. R. Chrisman of Deadwood in a letter to Earl Jones was less charitable.

[Calamity Jane] was a tramp prostitute, always broke and sponged money and whiskey of[f] any one she could. Deadwood was always having someone like her for publicity to attract tourists....I was told by one old Seventh Calvary man...that Calamity Jane, with two of her women, followed along the Calvary, that they had a light wagon and team of ponys and set up there tent out side of the soldiers, sponged there food of[f] the supply wagons and picked up any money the soldiers had on pay day.[12]

In the same letter, Chrisman described Jane's funeral.

> All Deadwood turned out, that is all of the saloon element. Her
> pall bearers, were bar tenders....The Geni Theater had a band
> also some of the other dance halls, they all played for the funeral,
> and after the funeral the bands marched down [?] St.—and they
> would play in front of a Saloon until they would set up free drinks
> and then march to the next saloon and play....by the time the
> band had made all of the saloons, the crowd was thoroughly
> drunk, and there was a wild time.[13]

Jane would have approved.

* * *

Martha Jane Canary, or whatever her true name was, was a woman
at the crossroads. Having been reared in the lax society of the frontier
West, she felt free enough in her prairie existence to cast aside the
accepted ways of cultured womanhood, if in fact she had ever been aware
of them. Although she worked and played exclusively in the world of
men and usually wore trousers, she never denied being a woman. Jane's
contribution to history was her legend rather than her life. She was unique
enough to gain the attention of a media hungry for tales of unrefined,
eccentric western characters. Her coarse, primitive image was scrubbed
squeaky clean and sensationalized. Still, those who read the dime nov-
els knew nothing about the genuine, far less glamorous Jane.
Consequently, they found themselves intrigued by the thought that a
woman could do so much so bravely. The story was not true, of course,
but the important thing about Calamity Jane was that so many people
wanted it to be.

12
OUTSIDE THE LAW

There were times and places when the sheer, bone-wearing drudgery plus the slackened moral and social codes of frontier life led to recklessness. The tendency to rear children with few standards, but plenty of self-confidence, was particularly prevalent in the early years of the frontier West when isolated pioneer parents were most overwhelmed by the effort to survive. Add this to the presence of thrill-seeking easterners and ambitious publishers, and the legendary wild West emerged to allay the inquisitiveness of the more mundane society east of the Mississippi. Among the hell-raisers roaming the boom towns, the most infamous among them had either been born in the West or carried there as youngsters. Examples include: William Bonney (Billy the Kid), Frank and Jesse James, the Dalton brothers, and John Wesley Hardin, just to name a few. The urge to rebel was just as marked among females.

Although prostitutes, showgirls, and gamblers were generally immigrants to the West, women desperadoes were nearly always born and raised on the frontier, apparently products of their loosely knit society. They not only sought adventure wherever they could find it but demonstrated little respect for social principles and less for the law. The most renowned among them was Myra Belle Shirley–Belle Starr.

Belle Shirley was born on February 5, 1848 on the Missouri frontier. She was the youngest child and only daughter of John and Elizabeth Shirley, who operated an inn in Carthage and owned 800 acres of land ten miles northwest of town. The dignified Shirley owned an impressive, multi-volume personal library, and it was rumored that he had been born into the distinguished Virginia aristocracy.

Belle, a child of relative privilege, was enrolled at the age of eight in the Carthage Female Academy, where she studied basic academics, the

classics, and deportment. Life for the Shirley family seemed secure until the Civil War broke out. First, Belle's brother Edward (Bud) was killed while fighting for the Confederacy. Then, in 1863, the Shirleys' inn burned to the ground, probably as a result of a kitchen fire, and the family moved to Scyene, Texas. Here Shirley bred horses and teenaged Belle began to consort with outlaws.

Photographs of Belle Starr define a painfully thin, dark-haired woman with a long, rectangular face, a pock-marked complexion, and a drastically receding chin. Given her relatively privileged childhood, one must wonder if her homeliness bore any blame for Belle's decision to seek out the company of thieves. Then, as now, a woman's intelligence and talents tended to be overlooked as the world judged her on the basis of beauty or lack thereof. Could it be that only the crudest of men could truly appreciate an ugly woman who happened to have exceptional brains and energy?

In 1868, Belle defied her parents and married a horse thief named Jim Reed, probably because she was pregnant.[1] Her daughter, Pearl, was born in 1869, but there is some question concerning her paternity.

As a child, the little girl was known as Pearl Reed, but at some point Belle began to call her Pearl Younger, claiming that she was the illegitimate progeny of famed outlaw Cole Younger. In his autobiography, however, Younger vehemently denied fathering Pearl and stated that he had met Belle only twice—first when she was fourteen years old and again in 1868 when she was six months pregnant with Pearl.[2]

With the law in pursuit, the young Reed family ran first to California, where a son, Edward, was born, and then back to Scyene, where Jim was killed on August 6, 1874. The facts surrounding Jim's death are obscure. Depending on the source, he was either shot by a member of his own gang or by Deputy Sheriff J. T. Morris. Whatever the cause, Belle was a widow.

The next six years are something of a mystery to those interested in Belle's life. She seemed to drop from sight altogether. Some say she was busy leading a band of male cattle rustlers, others that she spent her time in the saloons and gambling halls of Dallas, Texas. History didn't catch up with her again until June 6, 1880, when she married a Cherokee Indian named Sam Starr and settled down on his spread in Indian Territory (later settled by whites, who renamed it Oklahoma). Interestingly, she christened their ranch "Younger's Bend."

In 1883, Belle and Sam Starr found fame when they were tried as horse thieves by "Hanging" Judge Parker. The trial made all the newspapers, and Belle became the "Lady Desperado" in the *Police Gazette*, the

most popular fictionalizer of western history at that time. Parker sentenced her to six months and Sam to one year in the Detroit House of Correction. Displaying her splendid education, Belle wrote reassuringly to her fourteen-year-old daughter:

> Now, Pearl, there is a vast difference in that place and a penitentiary; you must bear that in mind and not think of mamma being shut up in a gloomy prison. It is said to be one of the finest institutions in the United States, surrounded by beautiful grounds, with fountains and everything nice. There I can have my education renewed, and I stand greatly in need of it. Sam will have to attend school and I think it will be the best thing that ever happened for him. And now you must not be unhappy and brood over our absence. It won't take the time long to glide by and as soon as we come home we will get you, and then we will have a nice time.[3]

Shortly after returning to Younger's Bend in 1886, the Starrs were arrested again, but charges were dropped for lack of evidence. However, it wasn't long before Sam Starr was shot to death in a dance hall brawl, and Belle was a widow once again.

Never one to be without male companionship for long, Belle moved in with a Creek Indian named Jim July. In 1889, while returning home from Fort Smith after convincing July to turn himself in under the assumption that the government had no case against him, Belle Starr was shot and killed from ambush by an unknown assailant. Her daughter, Pearl, a second-generation frontier native, went on to become an outlaw and, according to western lore, a prostitute in her own right.

Just before the turn of the twentieth century, while the Doolin Gang was busy terrorizing Oklahoma Territory and nearby localities, a couple of young ladies decided to step out of their feminine roles and their voluminous skirts. They caused quite a stir in local newspapers and probably among Doolin's boys as well.

Emerging from a boyhood spent on a hardscrabbling Arkansas farm, Bill Doolin first had plied his outlaw trade with the notorious Dalton Gang. Having gained criminal as well as management experience at their hands, he hired some thugs of his own and set about making quite a living leeching off the profits of trains and banks in Arkansas, Missouri,

eastern Texas, and, of course, Oklahoma. In no time he had gained a reputation as the "King of Oklahoma Outlaws" and had a posse on his trail.

One night Bill attended a dance near Guthrie, Oklahoma. Two young ladies, about marrying age (sixteen and seventeen) but apparently not of a marrying inclination, spotted him from across the room. When the starry-eyed groupies were told that he was the famous Bill Doolin, they, like adoring fans before and since, decided they wanted more than a glance.

That night, Annie McDougal, a sweet-looking bit of a girl, and Jennie Stevens, who stood about a foot taller than a Winchester rifle and looked innocent enough to make the heart ache, went home, stole two pair of trousers, and rode off to join Bill and the gang. Initially, the outlaws turned them away, but a few nights later the girls were back, once again in trousers. Admiring their persistence, the outlaws agreed to give them a chance.

For several months, the girls, nicknamed Cattle Annie and Little Britches by the outlaws who came to admire their spunk, rode with the Doolin Gang. Throughout their short-lived criminal careers, they wore masculine clothing and participated in robberies disguised as boys. In July 1896, Bill Doolin was shot to death by Deputy U.S. Marshal Heck Thomas, and the girls found themselves unemployed fugitives from the law.

Two of the posse members, Marshall Bill Tilghman and a colleague named Burke, pleased to be seeing an end to the chase, traced the young desperadoes to a local cowboy who had befriended them. Tilghman's men were closing in on a farmhouse where the girls were hiding when he spotted Little Britches crawling out a back window and mounting her horse. According to the *Daily Oklahoman*, Tilghman gave chase as Jennie turned repeatedly on her galloping horse and fired her pistol at him. He put an end to it by shooting her horse, confiscating her pistol and putting her across his knee for a good paddling. Meanwhile, his comrade had overpowered Annie back at the ranch, and he bore the scars to prove it.

Because of their ages and, no doubt, their innocent demeanor, the two girls received light sentences of two years each at Boston's Farmington prison. After their release, Annie married and settled down back home in Oklahoma. Jennie preferred to stay in Boston, where she worked first as a domestic servant and then as a social worker at a settlement house until her rather early death. She is said to have died of consumption (probably tuberculosis).

Other female products of the West were equally cavalier. Laura Bullion, also known as Della Rose, was born in Kentucky but reared near San Angelo, Texas. Her widowed mother unveiled her harassed state when she readily admitted that all ten of her children were wild. Laura's name first appeared on the police dockets of St. Louis, Missouri as a prostitute. By 1889, she was riding as a regular with the Hole in the Wall Gang and dressing as a man during robberies.[4] Within a few years, her criminal ambitions had promoted her to membership in one of the most renowned gangs of her day. Led by Butch Cassidy (born Robert LeRoy Parker) and Harry Longbaugh (the Sundance Kid), it was appropriately called the Wild Bunch.

In October 1901, Laura and her lover, Ben Kilpatrick, also a member of the gang, were arrested in St. Louis during a post-robbery spending spree. After serving her five-year prison sentence, she disappeared from sight. Little more factual information is known about Laura, although legends persist. Perhaps her near anonymity can be credited to her more glamorous successor.

Sundance, or the excitement he represented, attracted an unlikely female accomplice. Longbaugh's long-time lover was Etta Place–a tall, beautiful, articulate, seemingly gentle woman, rumored to have been a schoolteacher but best known for her male costumes, sharpshooting, and horsemanship during robberies. Running from the law, Harry and Etta visited New York City in 1902 and registered as man and wife at a boarding house. Before hopping a ship to Argentina, the lovers had a formal portrait made of themselves. The Broadway photographer remembered their formal attire and high society manners.[5] Butch, Sundance, and Etta spent a few years outside the Argentine law before Etta mysteriously returned to the United States. Rumors as to the reason for her return included a bout with appendicitis and an illegitimate pregnancy, but the ethereal Etta had vanished, never to be heard from again.

One of the last notorious outlaws of the waning frontier was Pearl Hart, who was born Pearl Taylor on the Canadian frontier in 1878. Married, thanks to an unplanned and unwanted pregnancy, Pearl was a genuine victim of the times and culture. As a married woman, she had no choice but to follow her ne'er-do-well husband as he roamed the North American side show circuit as a carnival barker between drinking and gambling binges. When she finally tired of that exhausting routine, Pearl fled to Trinidad, Colorado,

gave birth a second time, and one year later sent her young son and infant daughter home to her rather surprised mother in Canada.

Freed from maternal responsibilities, Pearl drifted about working the more routine female occupations as cook, servant, dance-hall girl, and prostitute. Looking for something better, she eventually joined a handsome vagabond named Joe Boot. The two worked a scam together that victimized drunk miners as they staggered from camp saloons. Pearl would serve as alluring bait for the lonely inebriates while Joe crept up behind and mugged them. They then shared the privilege of rifling through their victims' pockets. The results were penny ante, since most of the miners had spent their money on liquor and other amusements before they encountered Pearl.

Pearl's desire for income increased dramatically when she received word that her mother was ill and needed money. Rising to the occasion, Hart plotted what turned out to be the last stagecoach robbery ever committed in the history of the American West.

Going to great lengths to disguise herself, Pearl cut her hair short and dressed in men's clothes. Even so, she was recognized. The pursuing posse easily nabbed the two when they lost their way on the escape route and very nearly rode back into the arms of the law.

Perhaps because she reminded the nearly civilized West of the good old days, Hart became an instant celebrity. She was jailed in Tucson, where she played to a tee her role as an old West desperado. Wearing cowboy attire, complete with boots and a Stetson hat, she received many of the hundreds of visitors who were drawn nostalgically to the spot. Fame and her tendency to flaunt it without reservation made her more of a nuisance than a celebrity at Arizona's Yuma Prison. It had been built as an all-male prison, a fact Pearl turned to her advantage. From her private cell, she bellowed repeated claims of mistreatment, rape, and, eventually, pregnancy, even though only the warden and his wife possessed keys to her cell.

At the request of the harassed warden, Governor A. O. Brodie pardoned Pearl on December 19, 1902. The only provision was that she leave Arizona immediately. Two years later, Hart was arrested in Kansas City for "complicity with thieves." That may have been the last of her wild oats, for she simply disappeared. Periodic sightings were rumored for decades afterwards, but Pearl Hart, the last of the legendary female outlaws, had vanished with the frontier.

* * *

In the early days of the West, living outside the law may have been easier than living inside the socially accepted, womanly role of gentility. Outlaws had little interest in home, motherhood, morality, purity, or piousness, and they were certainly far from delicate. Female outlaws were almost exclusively second-generation (or third) frontier natives. They had been reared with far fewer rules and regulations than eastern women and reacted accordingly. Even those like Belle Starr and Etta Place, who apparently were well educated and reared with some degree of structure, felt little commitment to artificial principles of behavior that had been established in the East.

13
NATIVE AMERICAN WOMEN ON THE WHITE FRONTIER

Some frontier women had more to struggle against than their gender. These hard-pressed women belonged to one of the racial groups whose skin color and cultural behavior were disparaged by "white" Americans. Many were native to North America, and the frontier life changed them, too, usually in ways that were detrimental. The frontier experience that brought opportunity and prosperity to many people of European descent ultimately brought disease and defeat to those who had been there before them.

On the other hand, these women possessed certain advantages over the middle-class whites who came west. In a perverse sort of way, social and economic discrimination may have prepared them for the rigors of frontier life. They had never been subjected to the doctrine of the Cult of True Womanhood simply because they were considered to be an inferior species of human to whom it didn't apply. Since they possessed no artificial sense of gentility, they were able to adapt more readily to the hard-bitten conditions of frontier life. This was particularly true of western Native American women who, in the days before whites invaded their land, had been reared in an environment that offered them a sense of racial superiority and a great deal of self-esteem.

Native American women had lived on the trans-Mississippi frontier for thousands of years before white incursion. They belonged to any of the hundreds of primarily nomadic tribes that made up the original human population of the North American Great Plains. Their traditions were as different from those of the European conquerors as tepees are from brick mansions.

From infancy, these original Americans lived intimately with nature and were fully conscious of their absolute dependence upon it. They lived

every moment of their lives aware that "the natural environment...was the source of life and death and of reward and punishment."[1] Surviving Native American chronology includes a prayer commonly uttered over animal prey by a wide range of Native American peoples. In it, the hunter asks forgiveness for the slaying and explains the necessity that justified the animal's death. The widespread existence of prayers of this nature suggests a sense of intimate unity between hunter and hunted that is unknown among European cultures.

This same sense of gentleness influenced childhood among the Indians. Children were highly valued and were treated with great affection and permissiveness by virtually every member of the tribe. Activities that fostered selfishness, competitive spirits, or egocentric behavior were discouraged in favor of those that encouraged cooperative, team-player attitudes and self-control. Children enjoyed large extended families, all of whose members encouraged and disciplined them from birth. Discipline rarely resulted in corporal punishment, however, as ridicule and shame achieved the same results.

Even as adults, Indians sought to relate peacefully to other members of their tribes. A successful tribal member was one who did not anger others or break his pledged word. When he disagreed with the will of the majority, his reaction was most frequently to retire from the group rather than speak up and cause unnecessary discord. If an Indian failed to understand the complexities of a given situation, he would sit silently and listen, hoping to gain understanding rather than disturb the proceedings by asking questions.

In eastern tribes, women were valued for their agricultural as well as their domestic roles. Many women achieved authoritative positions on tribal councils, were honored with official titles such as "Beloved Woman," and assisted in the selection of tribal leaders.

The non-agrarian, wandering tribes of the Great Plains, however, treated women with a different kind of respect. The reasons were twofold. Because of the lifestyle of these great warring tribes of buffalo hunters, and the number of male deaths on the battlefield and hunting grounds, women greatly outnumbered men in virtually every community. Polygamy was common—in fact, necessary—if women's essential reproductive capacity as well as their skills as gatherers and manufacturers were to have significance within the tribe. Because these communities were so often on the move following the great buffalo herds as they migrated from feeding ground to feeding ground, agriculture was minimal and, given the semi-arid climate, difficult.

Indian girls were generally brought into womanhood through a formal puberty rite. The rite differed from tribe to tribe, but, in every case, it was initiated at the onset of menstruation and symbolized the young woman's readiness for courtship and marriage.

Most western tribes honored chasteness and expected a woman to be a virgin until she married. A marriage was generally arranged with neighboring tribes by the two fathers of the young couple. The groom's family generally honored the family of the bride with gifts of horses, skins, or ornamental jewelry. The value of the gift depended on the groom's status within his tribe and the worth he placed upon his bride.

The intra-tribal warfare so highly prized by the mounted warriors of the Great Plains gave men a more exalted status than did mere hunting. While hunting was essential to survival, warfare provided opportunities to demonstrate courage. Men who succeeded on the battlefield were greatly honored by the tribe, and women rarely were allowed to perform this function.

Plains women were constantly occupied. They cleared the land for camp (not difficult among the nearly treeless tall grasses of the Plains). They manufactured and erected tepees and often the more permanent lodges used in winter camps. They gathered firewood (or lacking wood, buffalo dung) for cooking and warmth, toted water, cleaned and processed the prey from each hunting expedition, made clothing, cooked, cleaned, cared for children, and much more. Hard-working women, particularly those from esteemed families, were valued in ways difficult for traditional European society to understand. Often, lower-class women were sold for profit and more prized women granted to a valued friend or powerful chief to settle a quarrel. A husband trying to make an impression might offer a wife to a distinguished visitor for an evening's pleasure, not out of disrespect for the woman's importance but out of recognition of it. The extention of such a gift was a great honor to both the guest and the chosen wife. And there were other traditions involving women that were often misunderstood by pioneer Americans who viewed women as physically weak and needing male protection:

Indian women...often were substitutes for pack animals. At Fort Mandan, Lewis and Clark (leaders of the famous expedition) reported that She-he-ke brought to the fort a quarter of beef on his wife's back. On another occasion, a woman carried a canoe three miles on her back. When Clark's "whale party" was returning from Tillamook Head, he tried to help a Chinook woman

whose load of blubber had slipped, but he found the load so heavy that he could barely lift it.[2]

White men found it impossible to correlate the term "female" with adjectives such as "strong," "capable," or "powerful," even when they witnessed such scenes among Native American cultures.

Yet, records indicate that certain women, perhaps born into elite families or brighter, braver, and more energetic than most, became warriors or chiefs. Older women were often members of tribal councils. Some younger women were permitted to participate in raids on the enemy and, from time to time, were honored throughout the tribe for their deeds. The Crow tribe revered warrior women to such a degree that they would not allow men to court or marry them. These exceptional women carried titles indicative of that honor and assisted in the governing of the tribe.

Many women were skilled artisans who produced jewelry, blankets, clothing, baskets, and pottery. A particularly talented artisan was highly regarded by the tribe and given special status among them. Still, since most tribes had no written language, little is known about individual Indian women unless they came in contact with white men and, by doing so, became part of recorded history.

Charlotte Small was the fourteen-year-old wife of David Thompson when she first came to Idaho. Her father had been white Canadian and her mother a Cree Indian. David was a somewhat prudish British trapper and "one of the world's great mapmakers."[3] His quiet nature gave him a reputation for being far more subdued than the raucous French Canadians who usually traversed the territory.

Charlotte followed her husband through the dust, mud, heat, and blizzards that are the trapper's lot, performing the normal toil that was woman's lot, and bearing and tending four children along the way. Thompson retired in 1812, and the two settled in Canada to rear thirteen children in relative poverty, despite the fact that he had added 43,000 miles of unknown territory to the maps of the world.[4]

A Crow woman from the Wind River country of Idaho Territory, Batchika Youngcault, married mountaineer Caleb Greenwood in 1827. For years she traversed the Snake River country with him,

doing the slave-like drudgery so often required of the Indian women, sharing her knowledge of how to live off the land, how

to read its signs and avoid pitfalls, and almost incidentally produced two daughters and five sons.[5]

As an old man, Caleb began to lose his eyesight. Batchika, convinced that the white physicians in more civilized St. Louis could help him, showed an incredible determination. She marched her entire family through more than a thousand miles of hostile Indian territory to reach Missouri. At one point along the way, a band of Sioux accosted them as they traveled by riverboat. The Sioux stole everything they had except the kettle of meat Batchika had hidden under her skirt. When one of the more observant members of the band grabbed for that, she knocked him out of the boat with a well-aimed oar. According to the story, the marauding Indians returned all the stolen goods out of respect for Batchika's gumption.

Joe Meek took to himself three Indian wives before it was all over. He treated each one with respect and consideration. Mountain Lamb was the first. "She rode a dappled grey horse whose harness was decorated by tinkling bells, porcupine quills and glass beads, and whose bridle was faced with Mexican silver coins."[6] To add to her elegance, she wore a bright red silk scarf with leggings and blouse to match. Joe is supposed to have told people, "She was the most beautiful woman I ever saw."

Mountain Lamb had been acquired in 1834, when her first husband, an aging mountain man, headed east in search of medical treatment and gave her and their child to Meek. Joe acknowledged his good fortune and treated her almost like a queen, a most unusual relationship for the time and culture. When Mountain Lamb was accidently killed by a stray Bannock war party arrow while crossing hostile territory, Joe mourned painfully. According to all accounts, he had truly loved his stunning wife and wasn't ashamed to let her know. Few Plains Indian women could wish for such respect.

Meek apparently recovered from his broken heart by marrying a Nez Perce woman whose name has been lost to history. This time he'd found a proud woman. The Nez Perce reputedly treated their women with more respect than most tribes, and the strong family structure she had enjoyed gave her alternatives many Indian women never knew. Her objections to Joe's womanizing and heavy drinking ways were expressed, Indian-style, with silence, a stiff neck, and a hanging head rather than with the carping so common among white women. When Joe failed to recognize

her dissatisfaction, she simply packed up their baby daughter and went back home to her family.

Wife number three was the fifteen-year-old daughter of Nez Perce Chief Kowesote. Virginia was neither as beautiful as the first nor as obstinate as the second, but she benefitted greatly by marrying Joe so late in his life. The two of them retired to Oregon, had seven children, and somehow endured the mindless prejudice of the white settlers around them against Indian women. This time, Meek was faithful to the end. Rather than abandon his Indian woman as so many trappers did in the face of "civilized" white disapproval, he treated her with respect until the day he died. Recorded history loses track of Virginia after that.

Interracial marriage between Indians and white trappers and traders was commonly accepted in the early nineteenth century. As civilization moved west, however, and the pressure to control the remaining land increased, there was decreasing tolerance of that practice and of Native Americans in general. Missionaries preached on the inferiority of the Native American and shamed white men who lived with Indian women. And as the status of Indians decreased throughout the century, their problems increased.

Sarah Winnemucca was a Paiute Indian born around 1844 in Nevada Territory and named Thocmetong (Shell Flower or Small Rock Flower) by her family. Her grandfather, Truckee, was head chief of the Omahas, and her father, Winnemucca, a lesser chief. For a time, she and her sister Elma lived and attended school with Chief Truckee's white friend, Major Ormsbey, and his family. Their three years at St. Mary's Sister of Charity Catholic School in San Jose, California gave them the English fluency and understanding of white culture that allowed Sarah to become one of history's primary advocates of equal justice for her people.

Chief Truckee was a patron of the white man who moved much of his tribe to California in the summer of 1847 to live and work among the white people of Sacramento and Stockton. Men took jobs as cowboys and women as domestic servants. Sarah, a small child at the time, accompanied them on this trip. After a year of cultural immersion, the tribe returned to its ancestral home on what was to become the Pyramid Lake Reservation.

When bands of Mormons moved onto their tribal lands, the Paiutes attempted to ease the situation by accepting paid positions on their farms and ranches. But when that same homeland was invaded by more

insensitive whites during the 1859 Gold Rush, the Indians were over-whelmed. Unable to defend themselves against the white man's abuse, the Paiutes were badly mistreated. Many of the men were all but enslaved by miners.

When Chief Truckee died, Sarah became the voice of calm within her tribe. She urged her people to adapt to the new challenge. At the same time, she made an appeal to the whites. She, her father, and her brother, Natchez, rode to Carson City to beg the governor to eject the white settlers from Paiute land. The same three later traveled to San Francisco to explain the Paiutes' plight to U.S. Army General Irwin McDowell. Both gentlemen made verbal promises to the Winnemuccas that they failed to keep.

When the cavalry killed eighteen Paiutes on a fishing expedition, including Sarah's younger brother, there seemed to be no controlling the tribe's warriors. The possibility of an uprising led the commander of nearby Fort McDermitt to summon Winnemucca and her brother to a meeting. There the two served as leaders, not merely interpreters for their people. They convinced the commander to provide food for the starving Paiutes and to send soldiers to protect them from white attack.

Believing that the white man's laws could be used to aid her people, Winnemucca made repeated appeals through government channels for schools, food, and clothing. For a time, the tribe lived happily at Fort McDermitt under the protection of its commanding officer, and the Paiutes enjoyed a period of relative plenty. The reservation received so many tents and rations that Winnemucca was able to convince a band of tribal renegades to rejoin the tribe.

Sarah's personal life wasn't going as well. Against her family's advice, she had married Lieutenant Edward Bartlett, a young cavalry officer, in 1871. The arrangement lasted only a few weeks because, according to the bride, "he was nothing but a drunkard."[7]

Following her brief marriage, Sarah rededicated herself to helping her tribe. Firmly believing, as had her grandfather, that her people could survive the powerful onslaught of white civilization only by assimilating, Winnemucca wrote to the Commissioner of Indian Affairs and requested instructions on farming the reservation land. Her idea to turn warriors into farmers was ahead of its time but may have led ultimately to the Dawes Severalty Act of 1884, which divided reservations into individual agricultural allotments. Still, at the time of her suggestion, neither the U.S. Government nor the members of her tribe could be convinced of the rightness of her project. Attempting to gain support for

the effort, Sarah traveled to San Francisco and Gold Hill, Nevada, where she spoke to local and regional authorities, but to no avail.

While she was gone, Reverend Bateman, then the Indian agent for the Pyramid Lake Reservation, tried his best to defame the young woman who had become a thorn in his side. Using regional newspapers, he set about spreading vicious rumors concerning Winnemucca's identity, morality, and the number of her failed marriages (he claimed there were seven).

Despite the attempts to blacken her name, Winnemucca was able to land a job as interpreter for Sam Parish, the agent of the Paiutes' Malheur Reservation in Oregon. Under her influence, Parish not only implemented Winnemucca's farming project at Malheur but opened a school for Native American children with his wife as teacher and Sarah as her assistant.

When Parish was replaced by a more avaricious agent named Rinehard (or Rinehart), the experiment failed. The replacement quickly turned independent Indian farmers into little more than sharecroppers and charged them for provisions designed for free distribution. Still working within the white system, Winnemucca began to file reports with the authorities concerning Rinehard's behavior. In fact, an infuriated Sarah was headed for the District of Columbia in 1878 to complain about Rinehard when she was stopped by army troops who reported that the neighboring Bannock tribe was instigating an uprising. She instantly offered her assistance.

Working as personal interpreter for General O. O. Howard and as a spy for the army, Winnemucca moved along the front lines among the Bannocks gathering information. By assisting the whites during this crisis, she hoped to earn a degree of justice for her people but was disappointed once again.

Her determination to repair the breach between the Paiutes and the government led Winnemucca further into the fray. Dissatisfied with the slow pace of reform and not understanding the United States bureaucracy as well as Winnemucca, many of her tribesmen began to blame her for their troubles. Despite the Paiutes' declining allegiance, Sarah loyally appealed an exile enforced upon her by reservation authorities in an attempt to quiet her. The more sympathetic territorial authorities to whom she pled her case returned her to the reservation.

By then, other tribes in the region had begun to seek Sarah's assistance. Realizing the Paiutes weren't alone in their misery, she wrote letters to the authorities on the behalf of these tribes as well, but the Indians were beginning to want more than letters. She remembered in

her autobiography that "day after day my people were begging me to go east and talk for them."[8]

When the army notified the Pyramid Lake Paiutes that they would be relocated to the Malheur Reservation, more than half of them, including Sarah, went peacefully and unwittingly became part of a conspiracy. Instead of traveling to Oregon, the Indians were escorted to Yakima Reservation in Washington Territory, where they were imprisoned. The journey couldn't have been timed more poorly. As the Paiutes crossed the Sierra Nevada Mountains in January, nearly half of them died of starvation and exposure. Those who survived reached Yakima only to be locked into unheated sheds at the reservation.

Winnemucca wasted no time. When her requests for food, heat, clothing, and blankets fell on deaf ears at the reservation, she visited the authorities at Fort Vancouver near San Francisco. She also spoke upon request to a small audience in the area. A gentleman in attendance noted that she was "speaking with zest, expressing herself perfectly in good English, able to translate quite naturally the most intimate feeling of her soul...[so] that many people were moved to tears."[9]

Hoping once again to quiet her, authorities of the Bureau of Indian Affairs invited Winnemucca to the national capital in 1879. Accompanied by her brother Natchez and her cousin Joe, she was kept busy touring every nook and cranny of the city. Unable to find time to grant interviews or make speeches, the trio did finally meet with Secretary of Interior Carl Schurz. During their brief exchange, Schurz granted the Paiutes release from the Yakima Reservation, canvas for tents, and 160 acres of land to each adult male in the tribe. Thrilled by their apparent success, they prepared to meet President Rutherford Hayes.

> We were shown all over the place before we saw him....At last he walked in and shook hands with us. Then he said, "Did you get all you want for your people?" I said, "Yes sir, as far as I know." "That is well," he said and went out again. That is all we saw of him. That was President Hayes.[10]

Of course, Shurz's promises never materialized, and Winnemucca was completely disheartened. For the next three years, she withdrew to her tribe, is said to have been briefly married to a Native American, and avoided whites altogether. In 1882, while visiting her sister Elma in Montana, she met and married a civilian employee of the army, Lambert Hopkins, and ended her isolation from the white community.

Interest in Indian reform was growing among the upper classes of the East, and, in response, Mrs. Horace Mann invited the Hopkinses to conduct a speaking tour of the Northeast. Understanding the whites perhaps better than they understood themselves, Winnemucca toured much of New England, New York, and Pennsylvania dressed in deerskin and leather leggings and speaking the truth as she saw it. Under a headline reading "The Indian Bureau Alarmed," a newspaper article included in the back of Winnemucca's autobiography begins:

> Sarah Winnemucca, the Piute [sic] princess is lecturing in Boston on what she knows about Indian agents. She is throwing hot-shot into the camp of the "peace policy hypocrites," who plunder the red man while professing to be his best, truest, and only friend.[11]

When the old rumors regarding Sarah's identity and morality resurfaced, aristocratic Boston flew to her defense. Her hostess convinced Winnemucca to write her autobiography and served as its editor. Her Boston friends helped Sarah write and circulate a petition demanding land for the Paiutes, and a Massachusetts senator introduced the bill into Congress in 1884 where, surprisingly, it passed almost immediately. Sarah Winnemucca returned jubilantly to her tribe, but her triumph was short-lived.

It soon became apparent that Secretary Schurz had no intention of enforcing the new legislation, and his contrariness was supported by the newly elected Congress. In despair, the Paiutes escaped from Yakima and returned to Pyramid Lake, and Sarah Winnemucca retired permanently from her life of advocacy. She died of tuberculosis, probably complicated by a broken heart, on October 17, 1891, at about forty-eight years of age.

In her 1883 autobiography, she had written:

> Since the war of 1860 there have been one hundred and three of my people murdered, and our reservations taken from us; and yet we, who are called blood-seeking savages, are keeping our promises to the government. Oh, my dear good Christian people, how long are you going to stand by and see us suffer at your hands?[12]

But she may have summarized the recent history of her people best in the opening paragraphs of that same work:

I was a small child when the first white people came into our country. They came like a lion, yes, like a roaring lion, and have continued so ever since, and I have never forgotten their first coming.[13]

Nearly half a century passed before Winnemucca's contributions to her people were recognized. Although she died believing she had failed to mediate her people's problems, she had taught them well. Today's Paiutes continue to live on the ancestral land along Pyramid Lake that has remained theirs thanks to a series of court battles and government agency actions initiated and won by the tribe. In the 1940s, they recovered more than 2,000 acres of land that had been claimed by squatters eighty years earlier. They have forced legislation preserving the natural condition of their lake and its trout on several occasions. Thanks to the teachings and persistence of their ancestor, the Paiutes are today one of the most prosperous tribes in the United States.[14]

Inshtatheamba (Bright Eyes) was an Omaha Indian born in 1854, just ten years after Sarah Winnemucca. As Susette LaFlesche, she graduated with honors from the Elizabeth Institute in Elizabeth, New Jersey in 1875. Her father Joseph, or Iron Eye, son of a Frenchman named LaFlesche and his Indian wife, was head chief of the Omaha Indians.

By 1879, Bright Eyes was teaching her people on the Omaha Reservation in present-day Nebraska when she heard about the plight of the Ponca Indians, a tribe whose people had been close to hers until they were removed to Indian Territory (Oklahoma). As was common among new arrivals, malaria had killed nearly half the tribe, including Chief Standing Bear's sixteen-year-old son. Responding to the traditions of his tribe, the grieving chief and a small band of loyal tribesmen left the reservation on January 2, 1870 to return to Nebraska to lay his son's bones to rest on hallowed ground. They took with them a few wagons and horses, some food, and about twenty dollars.[15]

No sooner did the band of thirty reach the Omaha Reservation than they were met by an army division. Still carrying the child's bones, the chief and his followers were arrested for leaving Indian Territory. Sympathetically, Bright Eyes rushed to their rescue.

Teaming with Thomas Tibbles, an Indian rights crusader and reporter for the *Omaha Herald*, Bright Eyes stirred up enough public sympathy for the Poncas to arrange their release. She, her brother Frank, Tibbles,

and Standing Bear then headed east for a lecture tour designed to strengthen their support base.

In an effort to project the dignity and tradition of her culture, Bright Eyes wore elegant deer skins and moccasins and projected an image that Boston's *Woman's Journal* described as "refined, of great intelligence, and with singularly sweet, graceful, and simple manners. There is an unusual dignity and elegance in her talk in private, and a sense of the value of words that is remarkable."[16]

The quartet traveled first to Chicago and then to the East Coast. Bright Eyes translated for their audiences while the equally striking Standing Bear told and retold his tragic story to sympathetic listeners. In Maine, the group met Helen Hunt Jackson, who had traveled from her home in Denver to join in the seventieth birthday celebration of Justice Oliver Wendell Holmes. According to Mrs. Jackson herself, it was the presentation of Bright Eyes and her entourage that inspired her noteworthy Indian rights campaign. Wanting to know more, Jackson accompanied the speakers around New England and began to research Indian history. Her lobbying efforts as well as her books, *A Century of Dishonor* and *Ramona*, were instrumental in assisting the Indian cause.

In *A Century of Dishonor,* Jackson quotes a western artist who visited the Ponca Indians:

> The chief, who was wrapped in a buffalo-robe, is a noble speciman of native dignity and philosophy. I conversed much with him, and from his dignified manners, as well as from the soundness of his reasoning, I became fully convinced that he deserved to be the sachem of a more numerous and prosperous tribe. He related to me with great coolness and frankness the poverty and distress of his nation—and with the method of a philosopher predicted the certain and rapid extinction of his tribe, which he had not the power to avert. Poor, noble chief, who was the equal to and worthy of a greater empire! He sat...overlooking the little cluster of his wigwams mingled among the trees, and...shed tears.[17]

Alarmed once again by a Native American woman willing and able to speak out against federal policy, the government reciprocated. But while attacks against the Omaha spokesmen issued from Washington, Thomas Nast, the famous political cartoonist, championed their cause and the *New York Times* reported:

Bright Eyes is a little woman about twenty years of age, not over five feet in height, of tawny complexion, pleasant features and has a very feminine voice and manner....She speaks English fluently and seemed to be possessed of considerable information and intelligence.[18]

By this time, Bright Eyes had begun to develop opinions of her own concerning the welfare of the Indian people. During the mid-1870s, she first advanced the idea that the granting of American citizenship to the Indian people was the only way to free them from the afflictions of government charity. Her efforts led to a nationwide demand to reform the laws regarding the treatment of Indians. As a result, new federal laws were designed to protect them.

In 1880, Bright Eyes and her party testified before a special Senate committee investigating the removal of the Poncas to the reservation. While in Washington, they were invited to the White House to meet President and Mrs. Hayes and Senator and Mrs. Dawes of Massachusetts. The senator was chairman of the Senate Committee on Indian Affairs and a long-time advocate of Indian reform. Perhaps having learned a lesson from the recent, unpleasant visit of Sarah Winnemucca and her party, the governmental hosts were charming.

On February 16, 1880, Senator Dawes introduced a bill before the Senate confirming the Ponca Treaty of 1869 and allowing the tribe to return to their land in Dakota Territory. But the government's promises proved to be no more reliable when offered to Bright Eyes than they had been for Sarah Winnemucca. The bill was buried in committee for more than a year and, after adoption, instantly rendered ineffective by the Department of Interior. Nevertheless, change was in the wind.

Determined as Winnemucca had been to make warriors into farmers, Dawes campaigned hard to promote his allotment act. When the Dawes Severalty Act was formally signed in June 1884, all Indian reservation land was divided into individually owned, agricultural entities. The legislation's naive and clearly paternalistic intention had been eloquently expressed the previous January when Dawes spoke to the members of the Board of Indian Commissioners:

If he [an individual Indian] be one who hitherto has been permitted to grow as a wild beast grows...,a savage, take him, though grown up and matured...by the hand and set him upon

his feet, and teach him to stand alone first, then to walk, then to dig, then to plant, then to hoe, then to gather, and then to keep. The last and best agency of civilization is to teach a grown up Indian to keep.[19]

Tibbles and LaFlesche (now Mrs. Tibbles, having married T. H. on July 23, 1881) counted the Dawes Act as a personal victory. They allowed their speaking schedule to wane and sailed for England in May 1887 for a sort of triumphal tour, during which they were wined and dined by a broad spectrum of British society. Unfortunately, their sense of achievement was founded in quicksand.

Historians have castigated the Dawes Act for the resulting breakup of tribal life and dissolution of the Native American cultures. By attempting to assimilate these communities in a manner so foreign to their heritage, the act did little more than alienate them from their own identity and make them wards of the state. Its repercussions were much like those predicted by the 1880 Minority Report on Land in the Severalty Bill of the Committee on Indian Affairs of the House of Representatives. It had stated in part:

> The idea of separate possession of property by individuals is as foreign to the Indian mind as communism is to us....Why should we be so vain as to expect that the Indian can throw off in a moment, at the bidding of Congress or the Secretary of the Interior, the shackles which have bound his thoughts and action from time immemorial....The main purpose of this bill is not to help the Indian...so much as it is to provide a method for getting at the valuable Indian lands....When the Indian has his allotments, the rest of his land is to be put up to the highest bidder, and he is to be surrounded in his allotments with a wall of fire, a cordon of white settlements, which will gradually but surely hem him in, circumscribe him, and eventually crowd him out.[20]

Unaware of the tragedy they had helped inflict on their people, the Tibbles considered their job done and turned their attention elsewhere. T. H. became an avid populist and ran for vice president on the ticket with William Jennings Bryan in 1896. Bright Eyes briefly considered an invitation from Frances Willard, president of the Women's Christian Temperance Union, to tour and speak on behalf of prohibition, but decided against it.

Like her sister campaigner, Sarah Winnemucca, Bright Eyes lived a relatively short life, dying in 1902 at the age of forty-eight. Her gravestone read, "She did all that she could to make the world happier and better."[21]

* * *

The opening of the American frontier led to nothing but trouble for those who first populated it. Perhaps partially because Indian women had never been exposed to the Cult of True Womanhood, they were regarded by American pioneers as ignorant savages. But there was more to it than that. White Americans had never taken an interest in Native American culture, preferring instead to disparage these individuals they considered to be less than human. They failed to understand the position of women in Native American tribal life because they refused to examine the complexities of Indian justice, communal property, governmental systems, nature-oriented religion, or even family life.

Discrimination against Native Americans, male and female, was unrestrained, their "inferiority" attributed to their culture and race. Even those women who married into the white world, wore the clothing of white women, and bore half-white children were treated with disdain. Often, in a strange reversal of social trends, their white men treated them better than did the rest of the white world.

Courage and desperation led a few exceptional Native American women to arm themselves morally and speak out on behalf of their people in a last chance effort to compel authorities to render them some small degree of justice. These women were able to reach the consciences of both those in power and those interested in reform, but their reviews are mixed. Interestingly, the two featured in this chapter failed to understand the full ramifications of the Indian issue.

Sarah Winnemucca, the brave and intuitive woman who retired in depression and defeat, actually did bequeath to her people a legacy of legislation within the United States governmental system that has lasted more than a century. Bright Eyes LaFlesche, the soft-spoken, well-traveled advocate, retired in victory and died before the calamity of her efforts became apparent.

Native Americans were caught helplessly in a tidal wave unlike any other in history. Their stubborn determination to hold onto their culture, and their inability to defeat the armed, migrating hoards engulfing them, transformed these proud people into tragic victims of Manifest

Destiny. Their warriors could not save them in combat, nor could their women in diplomacy. The situation might best be described by Roxanne Dunbar Oritz as she summarizes the treatment of Native Americans at the hands of Euro-Americans:

> American Indians within the U. S. have suffered from genocidal policies, from colonial-like conditions, from racism and discrimination, from the most extreme kinds of economic and social deprivation including malnutrition and disease, from extremely high unemployment, and from the super-exploitation of their labour.[22]

Dr. Bethenia Owens-Adair.
Reprinted by permission of
the Oregon Historical
Society, #OrHi 3.

Below: George and
Elizabeth Custer.
Reprinted with permission
of the Kansas State
Historical Society, Topeka.

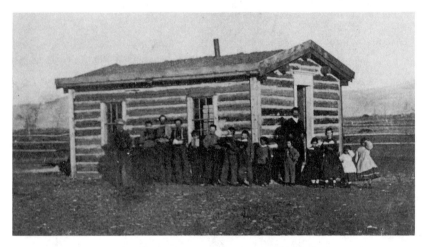

First schoolhouse in Montana, Deer Lodge, Montana,
1865. Reprinted with permission of the Montana Historical
Society, Helena.

Schoolteacher in early schoolhouse. Photograph by L. A. Huffman,
reprinted with permission of the Montana Historical Society, Helena.

Clara Brown. Courtesy, Colorado Historical Society, F21,164.

Mary Fields, stagecoach driver. Reprinted with permission of the Montana Historical Society, Helena.

Sarah Winnemucca. Reprinted with permission of the Nevada Historical Society.

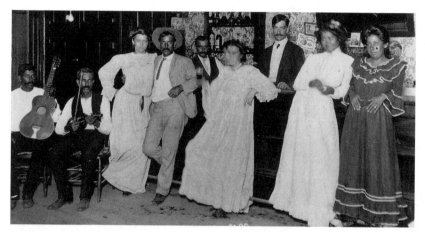

Saloon. Courtesy, Colorado Historical Society, F43,379.

The Big Casino. Reprinted with permission of the Nevada Historical Society.

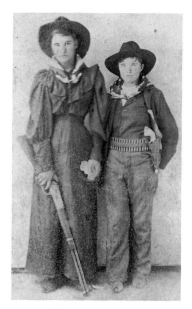

Annie McDougal ("Cattle Annie") and Jennie Stevens ("Little Britches"), members of the Doolin gang. Photograph from the Joslyn Collection, courtesy of the Archives and Manuscripts Division of the Oklahoma Historical Society, 7964.

Belle Starr. Reprinted with permission of the State Historical Society of Missouri, Columbia.

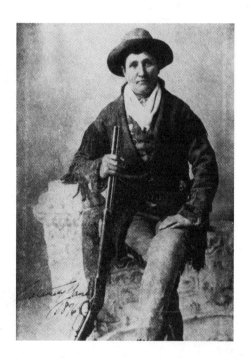

Calamity Jane. Reprinted with permission of the State Historical Society of Missouri, Columbia.

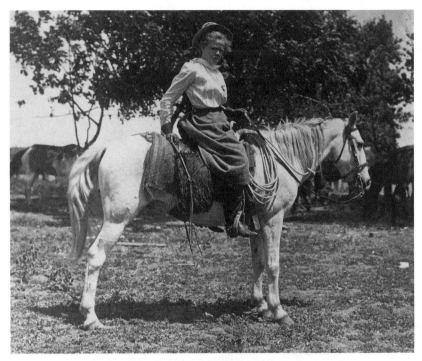

Lucille Mulhall. Photograph by North Losey, Oklahoma City, Abe & Vicky
Conklin Collection, courtesy of the Archives and Manuscripts Division of the
Oklahoma Historical Society, 20630.1.

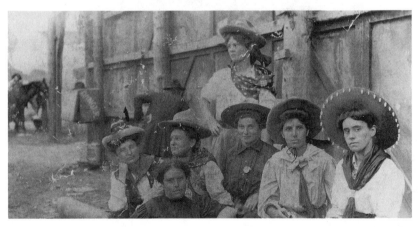

Mabel Tompkins (left) with cowgirls in 1907. Photograph from the
Mabel Tompkins Collection, courtesy of the Archives and
Manuscripts Division of the Oklahoma Historical Society, 19439.3.34.2.

The Colorado Antelope.

—A PAPER DEVOTED TO—

THE INTERESTS OF HUMANITY, WOMAN'S POLITICAL EQUALITY AND INDIVIDUALITY.

"COME LET US REASON TOGETHER."

VOL. I. DENVER, COLORADO, OCTOBER, 1879. NO. 1.

POETRY.

"HE KNOWETH THE WAY THAT I TAKE."

I know not—the way is so misty,
 The joys or the griefs it shall bring,
What clouds are o'erhanging the future,
 What flowers by the roadside shall spring;
But there's One who will journey beside me,
 Nor in weal nor in woe will forsake;
And this is my solace and comfort—
 "He knoweth the way that I take."

I stand where the cross-roads are meeting,
 And I know not the right from the wrong;
No beckoning fingers direct me,
 No welcome floats to me in song;
But my guide will soon give me a token
 ty wilderness, mountain or lake;
Whatever the darkness about me,
 "He knoweth the way that I take."

And I know that the way leadeth homeward
 To the land of the pure and the blest,
To the country of fair summer,
 To the city of peace and of rest;
And there shall be healing for sickness,
 And fountains, life's fever to slake;
What matters beside? I go heavenward,
 "He knoweth the way that I take."
 —Galveston News, Aug. 10, 1879.

"Write on your doors the saying wise and old,
'Be bold! be bold! and everywhere be bold;'
Be not too bold!' Yet better the excess
Than the defect; better the more than less;
Better like Hector in the field to die,
Than like the perfumed Paris turn and fly."

MISCELLANY.

The Way the Future Historian will Write up Leadville.

Romeo had stolen an interview with Juliet and was being entertained in the summer house. A young brother of Juliet, called a Capulet, came that way. The boys in that country were called Capulets until they were grown to man's estate and wore men's hats and were no longer in the sophomore class. When Juliet saw the young Capulet advancing she secreted Romeo in a bunch of passion vines and took up her kitten, well knowing the peculiarities of boys of his age in regard to helpless little kittens. The boy, seeing Juliet, his sister, intent upon petting her cat, said to himself, I will now have some fun; so he took the kitten from Juliet, pretending to be suddenly converted in regard to the beauty and merits of cats, but boy-like gave the cat's tail a twist and threw her over the garden wall, a very high stone enclosure. Juliet was much displeased and chased the young Capulet entirely out of the enclosure and barred all the gates. She and Romeo then wandered up and down the garden until the lark arose to let the sun dry the dew upon its wings. Then Romeo said that he must go home and sweep out the store before customers began to come in, for Romeo's father was the Merchant of Venice.' Juliet said that she regretted his early departure but that she wished he would look for her kitten and place it upon the wall. Romeo then took an affectionate farewell of Juliet, was let out of the gates, and went blundering through the chaparral to find the kitten; at last he found her, nearly dead with fright at being obliged to remain all night in such a wild place; she was afraid the owls might eat her. The kitten was placed upon the wall and easily found her way back to the garden. But Romeo was lost, his head was so completely turned that he did not know his way. He found a little path that appeared to have been made by swine, but it afterward proved to have been made by donkeys or burros, a species of an animal supposed to be a cross between a rabbit and a horse, and used for carrying small packages from one place to another. This species is now extinct but its fossil remains are frequently found in the ruins of lava-covered cities, where it perished with its pack upon its back. Well, Romeo followed this path until he came to a city in the mountains. It was a queer looking city, built mostly of logs, and shaped like a bird flying southward for warmer sun. The wings spread east and west and were a mile or more each way from the breast. The city, he thought, contained about thirty thousand inhabitants and was said to be only about eighteen months old. The first houses at the end of the wings did not appear to be larger than turkey coops or large parrot cages; and Romeo observed that the men who lived in those cabins were Lilliputians, but was told that they were subject to sudden growth, which inflated them wonderfully; or gradual growth, like other men in other places. Sometimes these people were like the frog that tried to be as large as an ox and burst in the inflation. Some of these men wore a night shift and some of them wore a day shift and they worked for the most part in holes in the ground, digging for metals which Romeo had often seen, but he had never before dreamed where this metal came from. He learned that the city was called Leadville, a heavy, unpoetical name, but he thought perhaps it was as good a name as the place deserved; and he thought he would wander around and discover what peculiarities the place had before trying to reach his native city. Romeo was much amused at the taste manifested in building the log houses and slab residences; some of them had bay windows and some of them were ornamented by having the slabs cut bias, same as women cut cloth for ruffles or other trimming; these houses he called the van-dyke cottages. There was another peculiarity which he observed, that the men and women grew larger as they came near the centre of the city; this was a peculiarity entirely confined to this place; he was informed that it was owing to the growth of the place. The men who wore the night shifts were engaged in various ways; some were sleeping in day-time, some were smoking pipes with holes clear through them, some were engaged reading a paper called THE COLORADO ANTELOPE; those who were reading sat with their feet higher than their heads and Romeo supposed this was done in order to incline the strength of the system towards the brain. As Romeo wandered towards the centre of the bird-shaped city he noticed his boots were getting fearfully soiled, and that the dust made him cough and sneeze in a most uncomfortable manner; then he noticed that everybody else coughed and sneezed, and he thought it really very wonderful. When near the centre of the city he discovered the booth of a bootblack with white lace curtains and he thought he would have his boots blacked. He noticed that the boy who blacked his boots wore a beard something like a man but was yet small in stature, so he concluded that he was one of the end wing men who had strayed into the big part of the city and had not yet become inflated; but when Romeo learned that he was expected to pay twenty five cents for having his boots " shined " he concluded that perhaps the growth of this Lilliputian would soon commence. Romeo found that the natives never had their boots blacked but once, that there was no use of trying to be fastidious because of the immense depths of the dust and the state of agitation in which it was kept by the passing vehicles and the occasional mountain zephyrs.

[TO BE CONTINUED.]

Carry Nation. Reprinted with permission
of the Kansas State Historical Society, Topeka.

Abigail Scott Duniway writing proclama-
tion for women's suffrage in Oregon,
November 29, 1912. Reprinted by per-
mission of the Oregon Historical Society,
#OrHi 4147.

14
RELATIVE OPPORTUNITY
FOR SOME

African American women were manifoldly handicapped by the society around them. Not only did they have to deal with the overwhelmingly racist attitude of nineteenth-century America and the devastating heritage of slavery, but the bias against female ability as well. Most of these pioneers had been slaves at one time in their lives and, therefore, had been indoctrinated from infancy to believe that they were inferior and lacked intelligence. This prevailing attitude generally doomed them to servitude of one sort or another. The fact that they were women made it worse. In the words of historian Gerda Lerner, "The black woman was exploited as a worker, as a breeder of slaves, and as a sex object for white men."[1] She also had to deal with the culture of the slave work ethic that was prevalent throughout the plantations of the Old South.

An inside-out sort of black culture evolved from the institution of slavery and its more dehumanizing aspects. Because of the advantages implicit in a nation possessing nearly 3,000 miles of unsettled frontier, the average white American had learned through experience that a functional formula for success required hard work, honesty, thrift, and piety. Slaves had found advancement in none of these. Hard work did not earn them their freedom. Indeed, the sweat of their brows had served only "the man" and earned the slaves nothing but the loathing of their own people. The intelligent slave learned quickly to do just enough to avoid the lash and no more. Honesty kept extra food that could be snatched from the master's fields or larder out of the mouths of his children. Thrift was an absurd notion for those who had nothing to save.

The one cultural underpinning shared by slave and master was piety, but for different reasons. Most whites believed that a disciplined religious life led to rewards in this life as well as the next. Blacks had learned to

remove their current existence from the equation. They had been introduced to Christianity in white America and listened carefully to biblical teachings concerning their rewards in heaven. At least that gave them some hope, and they needed hope. The Negro spirituals drifting from the exhausted throats of those relaxing briefly in the slave quarters of the great plantations are evidence of that.

History indicates that the post-Civil War South was a particularly fine place to be from. If one were black, the prewar South would have been equally unpleasant. After Appomattox, thousands of dispossessed southerners left what remained of their homes and moved west to begin again. Hundreds more, perhaps stimulated by the violence that was the Civil War, were attracted by the lawlessness that characterized the West. Some even went west to escape the racial hatred that boiled up from the still smoking battlefields.

The South became a bubbling caldron of racism after the slaves were freed. Partly out of fear, partly out of anger, and partly out of a twisted sort of pity, southern whites were determined to keep newly freed blacks "in their place." This meant menial labor, not unlike that performed by slaves all those years before. It meant tying supposedly freed men and women to the land as sharecroppers by making sure they remained painfully poor and forever in debt. It meant turning freed women into domestic servants who were paid with food, cast-off clothing, and an occasional dollar or two.

To ensure that this revised system of bondage would work, first the Black Codes and then the Jim Crow Laws were passed throughout the South. Blacks were forbidden to work at jobs above the lackey level. They could attend school only a few months out of the year–to free them for planting and harvesting–and then only for a few years. These schools were racially segregated. They quickly deteriorated physically and academically and by 1880 were little more than a cruel hoax. Blacks couldn't appear inside public facilities such as hotels, restaurants, or theaters unless they were there to clean them. In some places, they couldn't leave their residential areas (commonly called "Nigger Town") after dark without fear of reprisal, and reprisal was vicious.

"Enforcement" organizations bloomed in the postwar South like fraternities on a college campus. They ranged from the Knights of the White Camellia to the Ku Klux Klan, and they meant business. If black men or women dared step outside their assigned role, they could count on a visit from the "Kluxers," who weren't likely to be friendly. Leaders of the black community suspected of organizing the slightest resistance

were found at dawn swinging grotesquely from the tallest tree. Lesser sins were punished in less permanent ways. A black man who had failed to tip his hat to a white woman or who had sought an increase in pay or privileges could expect a terrorizing visit by a band of white-sheeted marauders on horseback. Attempts to teach or improve the status of the black community met with the flames and smoke of the guilty party's home as it burned to the ground. Many decided life might be better elsewhere, and they headed north or west as soon as they could.

The severe labor shortage on the frontier caused blacks to be readily accepted as freedmen and freedwomen, but they were still considered an inferior race of people designed for servitude rather than enterprise. Legal restrictions on the civil rights of black citizens were adopted in many western states after 1850. Section 394 of the California Civil Practice Act stated:

> No Indian, or Negro, or persons having one-half or more Indian blood and Negroes or persons having one-half or more of Negro blood, shall be allowed to testify as a witness in action in which a white person is a party.[2]

California further limited the rights of these minorities with Section 14 of its Criminal Act, which provided that "no Black or Mulatto person or Indian shall be allowed to give evidence in favor of or against a white man."[3]

Often, western territories and states intentionally disenfranchised blacks and excluded them from homestead laws, a fact that badly handicapped the ambitious. The effect was devastating. Blacks could not earn free land in most of the West just by living on it for a time, as could whites. Even if a black man purchased property, a white man could claim it, and the black, who had no right to testify against the man who had wronged him, was left with no legal recourse.

In 1864, African Americans were barred from riding San Francisco's new streetcars. Numerous protests erupted, including a lawsuit. Charlotte Brown and her father's court action against the state government concluded when "Judge Owens in his decision was very severe and settled for all time the rights of colored people to ride street cars in any part of California."[4]

Because slavery was outlawed in most western territories before it was in the South, and because of the back-breaking labor required of all frontier settlers, servants were in great demand by those who could

afford them. The type of work required of these servants was more varied than that of eastern plantations but just as difficult.

Fortunate blacks, relatively speaking, worked as house servants on large cattle ranches or in evolving frontier cities such as San Francisco or Sacramento. There they cooked, cleaned, and cared for the children of the household much like their colleagues in the East. The overwhelming majority of house servants were women. Others, usually better educated and more determined to make a difference, became pillars of developing black communities in the larger towns and cities of the West. There they opened retail businesses, provided a variety of services, and learned to organize their people in their search for social justice. African American women became strong advocates of black education and fought long and hard to desegregate the schools of the frontier. By the turn of the twentieth century, a black middle class had developed. It included intelligent, educated individuals who had the ability and self-confidence to confront the white community. Following the successful example of their white sisters, middle-class black women began to form clubs that allowed them to develop and promulgate a feminist consciousness of their own.

More learned black men and women weren't in the least satisfied with the slight boost in status awarded them by replacing slavery with servitude. Tossing job security and social acceptance aside, these adventurers sought lives of action and, if things went right, opportunity. When the adventurer was a black woman with some education, she might hope for more, but it was still an uphill climb. Fundamentally, she was still considered a servile entity who "shared the low status, the economic exploitation, and the educational, legal and social restrictions based on race discrimination experienced by their group."[5]

For women of little means and less education, just as with white women, career selection was generally limited to servitude or prostitution—valued commodities in the male-dominated boom towns that erupted after every bonanza. After all, white men had been sexually exploiting black women for centuries. It may be that, now freed from the demands of their masters, some black women saw the chance to turn this perverted slice of their history to their advantage. They were better prepared than most to suffer the hardships fundamental to the oldest profession, and they knew there was money in the gold camps of the West.

Mollie Severe was a freed slave who left postwar Virginia for the relative freedom of the frontier. Because she was poor, illiterate, and female,

she had soon eliminated every other field of endeavor and had become a prostitute who plied her trade in a variety of western towns as she traveled about.

While sojourning for a while in Nebraska, she gave birth to a daughter, Hattie. As Hattie grew older, Mollie decided it was time to settle down and began to seek a permanent location for her business. The two settled in unruly Cheyenne, Wyoming in 1880, when Hattie was nine years old.

Since Hattie had no more opportunity than had her mother to earn an education, her options were just as limited. When she was old enough (about ten years old), she joined her mother's trade. Her response to such an existence reaches out of Cheyenne's police docket, where Hattie's arrest for prostitution and disturbing the peace was recorded in 1882, when she was only eleven or twelve years old. She was arrested for the same crime twice–in 1888 and again in 1890.[6] Hattie had found a way to express herself, even if its sense of propriety was open to question.

In San Francisco, the city of choice for many prostitutes of all races, one black "lady of the evening" hawked her wares with business cards. Each card carried a border of printed flowers (some say they were forget-me-nots) and the words: "Big Matilda. Three hundred pounds of black passion. Hours: all hours. Rates: 50 cents each: three for $1.00."[7]

For all the reasons related above and even more that one can imagine, prostitution was an easy solution for freed black women who had little education, less self-respect, few economic options, and fewer rights as human beings. The profession did give them a certain amount of independence, but it also caused them a great deal of grief. There were black women who wanted more.

In the West, a little schooling and a lot of cunning did open a door or two. Many black women set their teeth, squinted their eyes, and somehow managed to travel a higher road during their times in the West.

Born a slave in or near Gallatin, Tennessee around 1802, Clara Brown was sold to families in Spottsylvania County, Virginia and then Russellville, Kentucky while still a child. She grew up on the farm of hatter George Brown, whose three daughters came to love and respect her. There, she married Richard, another of the Browns' slaves, and bore four children. Gradually her family was sold away from her, although she tried her best to keep track of them through church connections and gossip chains.

With the support of the Brown daughters after their father's death, Clara was able to purchase her freedom when she was in her mid-fifties. Complying with a law requiring newly liberated blacks to emigrate from Kentucky within a year of their emancipation, Clara moved to St. Louis, Missouri in 1857 and then to Leavenworth, Kansas a few months later. In 1859, she joined the rush resulting from the gold strike in Gregory Gulch, Colorado, where she was relatively prosperous as a cook and laundry woman for local miners. Later, she moved her enterprise first to Auraria and then, in 1860, to Mountain City (later known as Central City), Colorado. She was so successful that she began investing in mining operations and property around the Denver area. In 1866, Clara traveled back to Tennessee and Kentucky, gathered up a number of her newly emancipated kin and compatriots as well as some orphans, and returned with them to Colorado.[8] For years, she served as patron to these people as they struggled to reach various levels of independent living.

Clara wisely invested her money in gold mines, grubstaked black miners, and was known for her generosity when it came to making charitable donations. Tradition has it that Clara was one of the largest donors to the effort to raise St. James Methodist Church in Central City. She also contributed heavily to the establishment of a Catholic church in that city. Clara is reputed to have spent more than $10,000 helping other blacks find homes and work in Colorado, and she launched a successful search for the daughter sold away from her while they both were enslaved in Kentucky.

Brown still had to deal with the implications of her dark skin, even in the West. Despite her relatively impressive financial standing, she had difficulty traveling from place to place. When she decided to relocate her business to Mountain City in 1860, Brown had to pay a white prospector not only to drive her there but to pretend she was his servant. Even out West, blacks weren't permitted to ride in public vehicles, and a black woman traveling with a white man would have been subject to a range of unpleasantries.

"Aunt Clara," as she was commonly called, developed a statewide reputation as a wealthy mine owner and philanthropist. In the 1870s, she became one of the first blacks of either sex to be elected to membership in the Colorado Pioneer Association, a highly prestigious organization. At her death in 1883, the mostly white members of the Pioneer Association saw to it that she was buried with full honors.[9]

"Black Mary" Fields was born a slave around 1832 in Tennessee. She lived for a while in Mississippi and told folks that she had been aboard the Robert E. Lee during its famous steamboat race against the Natchez in June 1870.[10] According to those who knew her, Fields was six feet tall, weighed over 200 pounds, and wore a .38 Smith & Wesson strapped under her apron.

When freed by Union victory in the Civil War, Fields decided the frontier was the place to go if she was to make something of herself. She first traveled to Toledo, Ohio, where she found work with the sisters of the Ursuline Convent. When her mentor, Mother Amadeus, headed west to open a school for Indian girls, Fields followed and settled in Cascade, Montana in the 1860s.

Fields worked for Mother Amadeus at St. Peter's Catholic Mission hauling freight and serving as a jack-of-all-trades. According to local legend, a wolf pack spooked her horses one night as Fields was returning with supplies for the mission. Thrown from the wagon along with most of the supplies, she spent the night guarding her inventory and walking in circles to stay warm.

Sadly, Fields' loyalty to the sisters was accompanied by a tendency toward violence. She was constantly fighting with the hired men. Their complaints against her finally reached the ears of the bishop, who ordered the nuns to "send that black woman away."[11]

Mother Amadeus helped her to open a restaurant in Cascade and rescued her from two battles with bankruptcy. It wasn't Fields' feistiness that caused problems, for the restaurant was an immediate success. Mary was just so generous that she insisted on feeding penniless travelers, down-on-their-luck miners, and hungry sheepherders who promised to pay later.

Finally, Mother Amadeus solved Fields' financial problems by landing her a job hauling mail for the U.S. Postal Service. Driving the route between Cascade and the mission, Fields met the sisters daily, sitting upon her mail wagon dressed in her standard attire—a man's hat and coat accompanied by a woman's skirt and apron, a cigar clenched between her teeth.

Fields was the second woman to drive mail coaches for the government, the first to earn a degree of fame while doing it, and she didn't have to pretend she was male to accomplish it. She proved to be "swift and unstoppable," and her daring deeds as a driver led to public admiration. In honor of her reputation, an early Cascade mayor, D. W. Monroe, made her the first woman allowed to drink in the town's saloons, a great tribute in the early days of the West.

One day she found that the town's graciousness and the friends she had made in saloons were not always able to protect her. Having had a few drinks, Mary encountered a barfly who was less than pleased to see a black woman inside "his" saloon. The man's name-calling drew her into a gunfight. Although Mary survived to drink again, the fact that she had participated in such a contest raised the hackles of her employer, and she was fired. By the 1870s, Fields had been reduced to the type of servitude she had worked so hard to escape.

Fields, now aging, but still loyal to St. Peter's, was convinced by the sisters to "return to God." A high mass was celebrated in honor of the occasion, and "Black Mary" attended church draped in the long white dress and veil that the nuns had made for her.

Despite her financial reversals and her way with her fists, Fields' big-hearted attitude won her the admiration of Cascade's citizenry. For years after her death in 1914, Cascade schools were closed twice annually to commemorate her birthday, the date of which she was uncertain.

Biddy and her daughter Hannah were owned by a Mississippi Mormon named Robert Smith. Between them they had twelve children. After moving to Utah in 1851 and to San Bernardino, California in 1852, Smith decided to move on to Texas by 1855. Realizing that they'd be leaving a free state to enter a slave state, Smith's clever slaves convinced a white woman named Mrs. Rowen to carry a petition to Los Angeles authorities requesting asylum. Late in 1855, they were taken into custody and a petition was filed for their freedom before the Honorable Benjamin Hayes, judge, California district court.

During their testimony, Hannah, probably fearing retribution, hesitated to express her desire for freedom, but Biddy's affidavit was clear enough to convince the judge that none of those involved wished to go to Texas. On January 19, 1856, Judge Hayes set the lot of them free after castigating Smith for his attempts to re-enslave his servants, particularly the children who had been born free in California.

Biddy took Mason as her surname and moved to Los Angeles to work as a housekeeper and then a nurse/midwife for a Dr. Griffin. She was soon making a good living as a nurse and midwife and was so successful that her client list included some of the best families in the city.

Saving her money frugally, Mason's first goal was a home of her own. Upon moving in, she entreated her children to "always retain this homestead."[12] Realizing the importance of owning property, Mason bought several lots in what is now downtown Los Angeles. She also spent much of

her time promoting the education of black children and other benefits for her race. She was renowned for her visits to city jails to cheer up the prisoners and her tendency to buy badly needed supplies for the town's poor, both black and white. In fact, she was nicknamed "Grandmother Mason" by Los Angeles citizens in recognition of her many acts of mercy.

Mason died on January 15, 1891, with little recognition from the white community. However, on February 12, 1909, the *Los Angeles Times* reported:

> Biddy Mason was well-known throughout Los Angeles County for her charitable work. She was a frequent visitor to the jail, speaking a word of cheer and leaving some token and a prayerful hope with every prisoner. In the slums of the city she was known as "Grandma Mason" and did much active service toward uplifting the worst element in Los Angeles....During the flood of the early eighties she gave an order to a little grocery store....By the terms of this order, all families made homeless by the flood were to be supplied with groceries while Biddy Mason cheerfully paid the bill.[13]

Despite her generosity, or maybe because of it, Biddy became one of the wealthiest black property owners in Los Angeles and, at her death, left an estate worth over $300,000.[14]

San Franciscan Mary Ellen Pleasant (or Pleasants) was reportedly born into slavery in Hancock County, Georgia in 1818. Her impoverished beginning took a decided turn when she was still a girl. According to her story, a Mr. Price stopped by her plantation "to ask directions and was so impressed by her bright answer that he purchased her freedom for $600 and sent her to Boston to be educated."[15] Instead, the Boston family put the girl to work and generally mistreated her. Finally, for reasons she never disclosed, Mary Ellen was taken to a plantation in Cuba by Alexander Smith, a Cuban merchant. According to one version of the story, she worked for Smith until his death a few years later. Then, free at last, she married John Pleasant, who had been an overseer on the Smith farm. According to the other story, she first married Smith, inherited more than $50,000 from him, and then married Pleasant.

In any case, the Pleasants sold their Cuban property and moved to California in 1848 or 1849. Mary Ellen opened a restaurant in Octavia

and, with the profits, bought real estate and operated a successful loan brokerage, lending money at the rate of ten percent per month.

Pleasant sold her restaurant and moved to San Francisco, where she worked as the household manager of Thomas Bell's home and then opened a profitable boarding house. In 1853, Mary Ellen, now fondly called "Mammy" by those who admired her, helped provide financial backing for a group of black leaders who opened an enterprise known as the Atheneum.

The Atheneum Saloon and Institute was a two-story structure with the saloon on the first floor and the institute on the second. Its purpose was to provide a place for area blacks and their leaders to socialize and to organize to deal with the needs of the black community. It periodically issued public statements concerning the economic success of San Francisco's black community. One such report indicated that:

> Blacks in San Francisco owned two joint-stock companies with a combined capital of $16,000, four boot and shoe stores, four clothing stores, eight express and job wagons, two furniture stores, twelve public houses, two restaurants, two billiard saloons, sixteen barber shops, two bathhouses, one reading room and library with eight hundred volumes, one Masonic lodge, and one brass band.[16]

Rumors spread that Mary Ellen Pleasant donated $30,000 to radical abolitionist John Brown to help fund his slave uprising at Harpers Ferry, Virginia (now West Virginia). Nobody has offered proof of the connection between Pleasant and Brown, and Pleasant herself denied the allegations. Most historians discount it altogether. Still, the fact that the rumor was so widely known goes a long way toward explaining the racial climate of the time as well as the financial status of this particular black woman.

At her death, it was discovered that Mary Ellen wasn't as wealthy as people had believed her to be. Still, she was far from destitute. Pleasant owned property on Sutter Street near Octavia, California and an interest in a law suit over jewels. The total of her estate was a bit less than $190,000.[17]

In 1858, a situation in the schools of San Francisco brought unwanted notoriety to a bright young black girl. Light-skinned Sarah Lester had been attending a white primary school in her neighborhood. When she was about fifteen years old, she took the examinations for entry into the

area high school. Sarah's scores were the second highest in her school for general studies and the highest in music and art.[18] She began high school without a worry.

Soon, however, the pro-slavery *San Francisco Herald* printed an anonymous letter requesting that the board of education remove Lester from her current school to the all-black one nearby. For reasons of its own, the press kept the issue alive for months. Its feature stories implied that the community was divided between those who wanted her expelled immediately and those who would allow her to graduate but bar the entry of additional black students.

Because of the notoriety, Superintendent of Schools Henry Janes received applications from other black students. Pressed for a decision, he turned the situation over to the school board. While they deliberated, the tension grew.

The *San Francisco Herald* continued to harass the community about the case. Other city newspapers were less involved, and some even came out on the side of Sarah, if not the black community at large. White people from Sarah's primary school petitioned the board of education to allow her to remain and graduate from the high school with her class. Some of Sarah's friends in the high school even threatened to withdraw if she were forced to leave.

Finally, the board supported a policy of segregation that would have moved Lester to the black school, but Superintendent Janes, hoping for a way out, delayed the action. The racial convictions of the times were reflected in an article that appeared during the crisis in the San Francisco *Daily Evening Bulletin*:

> We hold it to be wise and true policy to maintain the social distinctions between the white and inferior races in our State, in all their strength and integrity....Nothing could possibly have so powerful an effect in destroying these prejudices as educating the two races together; for if children are taught together and allowed to play promiscuously, the whites will lose their natural repulsion to blacks, and grow up with a feeling of equality and fraternization.[19]

Sarah's parents rescued her from the fray. They withdrew their daughter from the high school and moved their family and successful boot business to Victoria, British Columbia—out of the country altogether.

Another San Francisco resident, Mary Frances Ward, was more aggressive in her efforts to desegregate the city school system. Indeed, her methods were similar to those used in the early 1950s that led to the *Brown v. Board of Education of Wichita, Kansas* Supreme Court decision and the outlawing of segregated facilities throughout the nation.

In 1872, the black community decided to challenge the laws allowing racial segregation in San Francisco schools. When a group of black leaders, with the legal assistance of John W. Dwinelle, started hunting for a case to take to court, they found Mary Frances.

Ward had applied for admission to Broadway Grammar School, an all-white school. Her application was denied, as she expected, with the stated reason that blacks had schools of their own. Dwinelle fought her case for two years before the California Supreme Court. The justices, sensitive to the racial tension of the community, delayed a decision as long as possible. Finally, they ruled against Ward since she did have a black school available to her. They added, however, that black children with no all-black schools available to them must be admitted to the white schools of their neighborhoods. Strangely, this near afterthought offered Ward the opportunity she sought.

In 1875, the San Francisco school board closed the black school as a money-saving endeavor, and by blaming their decision on the depressed economy, they got away with it. Mary Frances Ward enrolled in a newly desegregated school less than a year after the state supreme court had denied her that privilege.

Another black reformer was Sadie Cole. In 1916, angered by being charged fifty cents for a five-cent glass of buttermilk, Cole initiated a campaign to remove signs reading "Negroes Not Wanted" from the streets of San Francisco. She, like Ward, lost her case, but, again like Ward, her point was made, and some of the more caring merchants in town removed the signs voluntarily.

* * *

Black women who moved west with the tide had to be even tougher than most if they were to overcome the twofold discrimination directed at them because of their sex and their race. At the same time, slavery, the institution that had exploited them in every possible way, had saved them from the preachings of the Cult of True Womanhood. This was hardly an advantage, however, given the bigotry suffered by a race

of people who were considered inferior in nearly every way. Nevertheless, slaves, male and female, had been workers. Their physical efforts had been essential to the economy of the South for centuries. Black women had never held even the tiniest toehold on the cultural pedestal occupied by their white sisters. Seen first as blacks and then as women, they were expected to perform the most menial and demeaning forms of labor. Their exploitation at the hands of white culture was both wide-ranging and rabid. This overpowering racial bias followed them west but failed to impart the same depth of torment it had in the South.

Unlike their white sisters, who were expected not to work but often did, black women were expected to work and had little choice. Those who became prostitutes chose a socially easier trail but led lives of misery, poverty, and desperation. The braver, more intelligent, or more educated found numerous ways to make a living on the frontier, despite the efforts of those who would exclude them.

While the road west did not remove blacks from the bigotry of the East, it did protect them somewhat. On the frontier, people tended to be recognized more for their deeds than for their appearance. Because of this limited degree of justice, a few black women were able to gain the respect and even admiration of their communities, both black and white. Most were able to lead independent lives of relative serenity. The western tendency toward social justice didn't make black men and women socially equal to their white compatriots, but it gave them a boost in that direction.

15
HOME ON THE RANGE

The cattle kingdom originated in Texas before the Civil War, but by 1876 it stretched all the way across the Great Plains. It was the grass that attracted these particular entrepreneurs, and there was plenty of it. Ranching this magnificent steppe was a lifestyle different from any other.

The sheer numbers of the cattle and the technique used to manage them sharply distinguished western ranching from eastern stock farming. In the West, the horse, rather than the fence, became the primary management tool. Herding, driving, and roping from horseback through the almost treeless Great Plains allowed a relatively few hardy individuals to control a vast collection of bovines. Early cattlemen learned their skills from Mexican caballeros who, in turn, had learned them from early Spanish settlers. They plied their trade in south Texas, spread to Colorado and Nevada, and eventually extended the cattle kingdom as far north as the Dakotas, Montana, Wyoming, and Idaho.

The land was wide open except where polka-dotted with occasional stands of scrubby trees and shrubs–just enough to offer a little shade on a hot day. Grass was everywhere, and in the south it was green all year. Except for the extreme north, the climate was mild and rarely subject to snow or ice. On the other hand, the Dakotas, Wyoming, and Montana challenged the hardiest creatures with their extremes in temperature, brutal winds, and snow as deep as a cow's shoulder. In those areas, many a cattleman lost entire herds to the worst of the cruel winters.

Still, the plains were ripe for the type of open-range ranching these frontiersmen established there. The earliest cattle subjected to this lifestyle were of a particularly durable Mexican and Spanish origin known as longhorns. They were so tough they could live on range grass alone and required little attention. With no fences to stop them, the cattle roamed

at will, often many miles from home. One man's steer was distinguished from another by the brand burned into its rump or shoulder. To avoid confusion or duplication and to enhance classification, brands were registered in the nearest town and were required to be unique.

In the springtime, the round-up served the ranchers as inventory for the previously existing members of the herd as well as branding time for newcomers. Calves (or dogies) and any wild cattle that might have wandered in over the winter were cut from the herd, roped, "bulldogged," and branded. Once the branding had been accomplished, the fattest and strongest of the lot began the long drive to the railhead for shipment to the meat-packing plants of Chicago. Longhorns could handle it all, but while they were tough in their survival skills, they were equally tough in disposition and meat texture. Ultimately, these great horned herds of the early West either gave way completely to other breeds or were interbred with them.

The target for most cattle drives was Abilene, Kansas, where a clever Texas drover, J. G. McCoy, had established a depot linking the railroad tracks of the prairie to the great city of Chicago. According to McCoy himself:

> Abilene in 1867 was a very small, dead place, consisting of about one dozen log huts, low, small, rude affairs, four fifths of which were covered with dirt for roofing; indeed, but one shingle roof could be seen in the whole city. The business of the burg was conducted in two small rooms, mere log huts, and of course, the inevitable saloon, also in a log hut, was to be found....Abilene was selected because the country was entirely unsettled, well watered, excellent grass, and nearly the entire area of the country was adapted to holding cattle. And it was the [farthest] point east at which a good depot for cattle business could have been made.[1]

Because it was founded as a railhead in which brash young men, with little education and less refinement, would be carousing after eating many miles worth of trail dust and cattle manure, Abilene became one of the most turbulent towns in the West.

> Life was hectic, raw, lurid, awful. But the dance hall, the saloon, and the red light, the dissonance of immoral revelry punctuated by pistol shots, were but the superficialities which hid from view the deeper forces that were working themselves out round the

new town. If Abilene excelled all later cow towns in wickedness,
it also excelled them in service–the service of bartering the beef
of the South for the money of the North.[2]

With time, thought, and the onset of civilization, the crude cattle
industry gained some smoother edges. Pioneer farmers moved into the
area, established their borders, and kept the marauding cattle out of their
crops with some of the fanatically artistic versions of barbed wire that
were available at that time. In response, free-grass men, intent on pre-
serving open range ranching with its semi-wild herds of unchecked, wan-
dering cattle, quickly learned about wire cutters and used them without
reservation. Despite their efforts to preserve them, the days of the open
range were numbered.

Once scrub cattle and longhorns had been replaced with a better
grade of beef cattle, fences took on a different definition. Instead of
restricting the wide-ranging, self-sufficient longhorns, the detested
barbed wire now served to protect and control these gentler beasts. The
haphazard methods of open-range ranching gradually gave way to big-
pasture ranching and a more business-like approach to the entire ven-
ture. With time, railroads penetrated throughout the area, and the
need for the long drive dissolved altogether. Despite the time and the
place, cattle ranching was difficult, and while it clearly was considered
man's work, it didn't keep the women out.

The cattle industry required a financial commitment, strong deter-
mination, and a more permanent home than many adventurers were able
to muster, but it was a way to make a living on the frontier plains. Quite
a few women found themselves saddled with ranches against their wills
when husbands or fathers died, but others deliberately set their hopes
and dreams on the strong back of the longhorn steer. Most were wives
and daughters of ranchers, but many were ranchers in their own right.
They traveled the dusty, dangerous cattle trails because they had a stake
in the enterprise.

Historian Sandra Myers noted that "Texas ranchwomen Margaret
Borland and Lizzie Johnson Williams accompanied their own herds to
Kansas and negotiated their own sales."[3] Mary Meagher owned one of
the largest ranches along the coast of Washington Territory. In 1855, a
newspaperman described Meagher as a "tall, majestic woman about
thirty years old who liked to play poker; she traveled to markets by train
with her cattle, riding in the caboose with ten cowboys."[4] They wore men's
clothing on the job because it made sense. Before long, these ranching

women wore trousers regularly, and they kept right on doing it for no reason other than practicality and comfort.

Eulalia Bourne, an early twentieth century, trousers-wearing female rancher, spoke for her predecessors in her brief autobiography, *Woman in Levis:*

> Whatever I am, the West produced me. And I was not trying to make a spectacle of myself. I had nothing but business on my mind. With trade as my purpose I was not dressed to pass inspection by style-conscious bystanders. I was dressed for a long night ride in an unheated pickup....[I] learned to be comfortable and the heck with fashion.[5]

When Englishman Anthony Trollope visited the American West in 1862, he reported that ranchwomen were "sharp as nails and just as hard. They know much more than they ought to. If Eve had been a ranch woman, she would never have tempted Adam with an apple. She would have ordered him to make his [own] meal."[6]

Ranchwomen found fringe benefits to their unusual way of life. Working outdoors allowed them to escape the drudgery, loneliness, and isolation that were common to women of the plains. Daughters of cattlemen generally learned early to ride horses astride and handle firearms. Some had ridden in roundup wagons or had broken horses as children. As young women they hired themselves out as cowhands. A twentieth-century rancher, Frances Bently, probably expressed the thoughts of her nineteenth-century colleagues when she said, "It's hard on you, I know, but I'm happy working outside. And my horse don't care about the wrinkles. He knows who I am, anyway."[7]

Jean Heazle was another who found the skirts of the time to be a handicap. Unlike most of her sister ranchers, Jean had to learn the trade the hard way. She had crossed the Atlantic from her native Ireland in 1893, when she was fourteen, dressed as a boy for safety purposes. Settling in Idaho, she began her American life as a teacher but longed for something less restrained. Soon she was cutting timber to support the fragile ceilings of nearby mines. After a wagon load of logs turned over and pinned her voluminous skirts to the ground all night, she vowed never to wear them again. For fifty-six years, Jean worked in mining towns, on the ranches of others, and then on a small ranch of her own.

She wore trousers religiously, preserving her feminine identity by wearing skirts "on Sundays, or whenever she happened to feel like it."[8]

When Jean was able to put aside enough to establish her own business on Louse Creek near DeLamar, she didn't settle for cattle for long. She branched out into breeding and training racehorses and was enormously successful at both. Jean had proven herself to be an exception to the rule in a variety of ways.

Sometime around 1875, a woman who signed her name M. A. Mason, but may have been called Jane, settled with her husband and three children as a squatter in Idaho Territory. After becoming established, she disposed of her spineless husband by ordering him off the land and took over the family cattle herd. Her brand was PTOR, "with the letters so closely connected that people suspected her of wielding a fast and fancy branding iron on the other ranchers' brands."[9] Later, the *DeLamar Nugget*, a local newspaper, referred to her as a cattle rustler, but apparently none of these suspicions stuck. Oblivious to it all, Ms. Mason went right on raising and perhaps rustling cattle.

Kitty Wilkins became known far and wide as Idaho's horse queen. She had been raised on ranches and often joined her father on his visits to stock sales and horse markets. Preferring the handsomer of the hoofed species, she started her own business by selling horses to the army and gaining a reputation as a wily, honest dealer. "A Union Pacific station agent said she and her crew sometimes loaded as many as 26 stock cars at one time at stockyards in Mountain Home. Each stock car held 26 horses, a total of well over 500 horses."[10]

At a time when such things were considered unwomanly, Kitty became a successful contractor, guaranteeing six train carloads of broke horses twice a month. The burden on her crew to tame that many horses in so short a time made them some of the best rodeo bronco busters of the time. Two of them were the notorious "Death Valley" Scotty and world champion Hugh Strickland.[11]

Kitty's fame spread throughout the region. The celebrity attached to her unofficial title of queen was coupled with the fascination regarding her diamond brand. The two led to her second nickname–Queen of Diamonds. Both titles were nourishing fodder for newspapers and were used regularly. Idaho historian Arthur Hart noted that she was a "genius at getting her story published in newspapers across the country."[12]

Probably finding neither the time nor reason for marriage, Kitty remained single throughout her life. In her later years, she retreated into her home and became reclusive. Her neighbors indicated that she habitually fraternized with the children who lived around her but never with adults.

These enterprising women found that they could overcome any fears by getting up and getting out. Agnew Morley Cleaveland expressed this point when she wrote about her childhood:

> Not many of our women neighbors got about as did my mother and her daughters. Not many had reason to, with the menfolks to carry the responsibility of looking after their cattle. It was this deadly staying at home month in and month out, keeping a place of refuge ready for their men when they returned from their farings-forth, that called for the greater courage, I think. Men walked in a sort of perpetual adventure, but women waited—until perhaps the lightening struck.[13]

The most adventurous of these cowgirls found other ways to display their skills.

Rodeos developed as a competitive sport for male ranch hands, but it wasn't long before women became involved. In the 1850s, Mary Ann Whittaker gave public exhibitions of riding talent described as "The First Female Equestrian Artist in America." She specialized in performing pantomimes on horseback. The first female bronco buster was reportedly Annie Shaffer, who rode in Fort Smith, Arkansas in 1896. A few exceptional women became celebrated rodeo contenders.

The first cowgirl to enter an organized rodeo was Bertha Kaepernik, who insisted on riding a bucking bronco in the rain in order to persuade male participants not to cancel the show. A spectator described the spectacle:

> Part of the time he [the horse] was up in the air on his hind feet; once he fell backward, and the girl deftly slid to one side only to mount him again as he got up. She rode him in the mud to a finish, and the crowd went wild with enthusiasm. Result—the cowboys thought if a girl can ride in the mud, we can too, and the show was pulled off. The real active idea of Woman Suffrage was thus demonstrated in Wyoming at a Frontier Days show.[14]

Bertha was three years old when she first came to Atwood, Colorado in 1886. She first mounted a horse two years later and more or less stayed there. Her "gentling" abilities with wild horses became legendary, as did her fearlessness in the saddle.

In 1904, Kaepernik read a poster about the annual Cheyenne Frontier Days, which for the first time invited women to compete. Rodeo competition was pretty tough in those days. Not only did you have to provide your own bucking bronco, but you had to transport him to Cheyenne, Wyoming. Twenty-one-year-old Bertha accomplished this by borrowing a wild white stallion, eerily named Tombstone, from horse trader Len Sherwin. On the trailless journey from Atwood to Cheyenne, Bertha rode her horse and led Tombstone. She had saddlebags full of food for herself and the horses as well as a bedroll.

When she finally got to Cheyenne, she discovered she was the only woman planning to compete. That didn't stop her. "A *Denver Post* reporter wrote that Tombstone was a bronc that 'few would have mounted in fun,'...that throughout the ride Bertha 'sat straight in her saddle while she rode him to a standstill.' Failing to buck her off, Tombstone reared on his hind legs. Once he fell backwards, but Bertha simply slid to one side as the horse went down and was 'aboard' again as he exploded to his feet."[15]

Soon Kaepernik was a name to be reckoned with on the rodeo circuit. Bertha finished out 1904 by riding in two more shows. The next year, she teamed with brothers Len and Claude Sherwin and Joe Baker to organize the Sherwin Wild West Show. Bertha was still the only woman competing in these rodeos. In 1911, Bertha won the title for the women's bucking horse championship along with a new saddle at the Pendleton, Oregon rodeo. She took that same crown again the next year. "In 1914, she came within twelve points of capturing the men's title. The following season, women competitors were placed in a separate category."[16]

Bertha didn't limit herself to broncos. She participated in barrel races and the two-horse Roman relay. Each foot balanced on the back of a different horse, she would stand upright with only the two sets of reins to steady her. She was so good "that she finally accepted a handicap of turning her horses backward at the starting line–and she still won!"[17]

Kaepernik rode with some of the biggest rodeos of her time, including the Pawnee Bill Show and the Miller Brothers' famous 101 outfit. While at Millers', she met and married world champion bulldogger Dell Blancett. She was twenty-six.

The couple teamed up to present an especially exciting act that included trick riding, roping, and bulldogging. In 1910, they made one of the earliest western films for the Bison Movie Company. It starred Tom Mix and Hoot Gibson, a former world champion rodeo rider.

Dell, whose rodeo-ravaged body had failed the physical required of men volunteering to fight in World War I, enlisted in the Canadian Cavalry and was killed by a German sniper. Bertha neither married nor competed in rodeos again, although she continued to work support jobs for them until she was nearly sixty years old.

Bertha finally retired to Portersville, California. At the age of seventy-five, she served as grand marshall of the Portersville Roundup Parade. That same year, she was selected as a charter member of the National Cowboy Hall of Fame in Oklahoma City. She died in 1978 at the fine old age of ninety-five. All that strenuous exercise hadn't hurt Bertha Kaepernik.

Other feminine rodeo competitors in the late nineteenth century included Prairie Rose Henderson, Prairie Lillie Allen, Lucille Mulhall, and Tillie Baldwin. Mulhall's spectacular specialty wowed the crowds as she roped eight horses with a single lariat toss. Theodore Roosevelt, a tireless rodeo fan, once saw her rope a coyote from horseback. Tillie Baldwin was the first woman to bulldog steers. Adding more elegance to the show, it was the feminine influence that produced the bright, bangled costumes and trick-riding exhibitions that are common to today's rodeos. These include stands on the backs of racing horses, drags accomplished as the rider hangs from the sides of speeding steeds, and vaults onto the backs of running horses.

* * *

Most of these daredevils were products of the cattle ranching environment of the high plains. Lucille Mulhall grew up on her family's 80,000-acre ranch in Oklahoma Territory and learned to ride, shoot, and rope as an everyday survival technique. Women ranchers worked on family spreads when money or ranch hands were scarce and sometimes just because they enjoyed it. They threw out the impractical, dangerous sidesaddle and rode astride, often in trousers, a practice considered scandalous in the East. As usual in nearly primitive conditions, necessity was the mother of invention.

A California miner broadly exaggerated when he complained about the influence of women on western society, but it was obvious that they had made an impression on him. He told a visitor:

And the women haven't only took charge of the politics here, they've got the business too. They run the City Hotel, and the express office, and the water company, and practically all the stores. Why, even the Stage Drivers's Retreat–Jack Douglass' fine old saloon–even that belongs to a woman. Us men, the few that's left of us, we're making our last stand at Fallon's Hotel. It's the only place now where a man can go and set in a broad old bar-room chair and spit at a stove and express his feelings in just as strong language as he wants.[18]

16
TEMPERANCE IN EVERYTHING, MY DEAR

The lifestyles of female outlaws and rodeo competitors may have been exciting, but they didn't attract the average woman, even in the West. Yet, more traditionally minded women along the frontier did begin to reach beyond their homes for positions in the outside world as technology reached their doorsteps. For support and assistance, they, like their eastern sisters, turned to long-standing women's clubs for help. Railroads, mail-order catalogs, schools, and early technological advances in home appliances had granted them the blessings of a little free time. Those who worked at home far from their nearest neighbors had discovered that they required periodic adult company and projects to enliven their lives. Many of them developed diversions such as literary and social clubs. Others leaned more toward avocations, including volunteer work with churches or schools and any of a wide variety of reform movements. Historians often credit these women's clubs as the soil in which the seeds of feminist consciousness were planted. Whatever they were, the important thing was to get out of the house and share some part of their lives with other women. The clubs gave them a means of sticking together in the face of adversity. This was particularly true along the frontier, where women doubly appreciated the company of other women.

The moral and religious burdens placed on women by nineteenth-century eastern society had prompted the founding of these women's clubs. The clubs were linked to a variety of female responsibilities: church, literature, and/or community service. They had one trait in common–they organized women into power groups that were sometimes formidable. Women's clubs formed the basis of the reform movements that grew up in the nineteenth century. Their earliest attempts had been tied to abolitionism. Hence, the nationwide success of the anti-slavery

movement gave crusading women good reason to seek out additional areas in need of reform.

Interestingly, conventional women of the nineteenth century, even those on the frontier, were more likely to meet quietly in one another's homes to discuss the likes of alcohol abuse, prostitution, and woman suffrage than they were to do anything about it. Ideas about women hadn't changed very much since the 1830s. "Because they lived in an age of male domination, women were expected to leave it up to the men to take action. Before the turn of the century, the very existence of prostitution was so unspeakable that many women could not bring themselves to talk about it in public until the spread of venereal disease spurred them to desperate action."[1] Still, there were ways for even the more refined women along the frontier to address injustices and remain ladies in the eyes of the world.

Historian and journalist Betty Penson-Ward remembers a story told to her by her grandmother on the "ladies" of Atlanta, Idaho. It seemed that the town had a bath house—a rough lumber building that sat beside natural hot springs and contained about six wooden tubs for bathing or laundry. Atlantan women enjoyed a sort of informal weekly convention at the bath house and began to think of it as theirs. Their lack of proprietorship became obvious each time their attendance followed that of area miners, freighters, and others of the male persuasion who not only wouldn't wash the tubs but left behind four-lettered obscenities on the bath house walls. The women were outraged and their husbands too amused to respond. So the Ladies Decency League (LDL) was formed:

> They had only one meeting, the day they toted their scrubbing equipment instead of their dirty laundry, as they went uphill to the bath house. Grandmother could never bring herself to be explicit, but she said the LDL spent all day cleaning what was painted and pencilled and chalked on those walls. Much later, as a ten-year-old, I spent part of every bath time trying to decipher some of those words that were still almost legible.[2]

Women operating within their domestic roles employed other methods as well. In Kelly Hot Springs near Boise, an old bath house that apparently had become a brothel suddenly and mysteriously burned to the ground one night in the late nineteenth century. Rumor blamed the blaze on a woman's activist group.

The story of the Blaine County saloon leaves behind a few unanswered questions. One day in 1898, the building was under construction and nearing completion. The next day it was gone, its boards spread all over the valley.

Women had been operating in the shadows for centuries. They had been protesting behind closed doors for even longer. But by the end of the nineteenth century, they were beginning to be seen and heard in a wide variety of ways. It was still a rare woman who took public action, but rare women predominated in the West and were beginning to show up everywhere. Furthermore, the frontier was quickly becoming the battlefield of all the late nineteenth-century reform movements, including an effort by farmers to reform the currency standard so they'd have more money in their dusty pockets, railroad regulation, tariffs, populism, woman suffrage, and prohibition.

The temperance movement, with its war against alcoholism and its resulting violence, was the first formally organized effort to enlist the energies of frontier women. Women had been concerned with alcoholic temperance since the 1840s, primarily because married women had no legal recourse to the abuse that so often rained upon them from the drunken fists of their alcoholic husbands. This was no small matter. At a time when information concerning alcoholic addiction was unavailable, indeed unknown, and medical and psychological therapy nonexistent, masculine recreation too often focused on barhopping. This was particularly true for men whose work was especially strenuous and almost constant–men like those inhabiting the frontier. Their extravagant drinking habits too often ate up the butter and egg money and produced guilt-ridden inebriates who staggered home to terrorize their families.

Many of the women caught up in the emotions of abolitionist fervor were equally as passionate about temperance. Unfortunately, they had little money of their own and encountered great difficulty recruiting men to a cause that was almost exclusively a woman's concern. Desperately seeking a broader social program and political influence, temperance supporters were working against the odds.

The National Woman's Christian Temperance Union (WCTU) was founded in November 1874 in Cleveland, Ohio to fight the adverse effects of alcohol consumption and to encourage the passage of laws to protect women from its effects. Uniting a wide variety of smaller temperance organizations, the WCTU quickly became the largest woman's organization in the world. Men also joined, although in much smaller numbers, perhaps because they could be only honorary members or

because they preferred drinking to abstinence. Though the site of this powerful league's origin had ceased to be frontier territory by then, the WCTU's long-time president (1879-1898) was a product of the West.

Frances Elizabeth Caroline Willard, born September 28, 1839, had moved by covered wagon from Churchville, New York to Oberlin, Ohio in 1841 at the age of two. She was the fourth born and second surviving child in a family that eventually included Frances' older brother Oliver and younger sister Mary.

The senior Willards, Josiah and Mary Hill, had gone west to seek educations at the newly established co-educational Oberlin College and then moved on to Janesville in Wisconsin Territory. There Frances was reared, enjoying the same activities as her brother. Josiah built up a prosperous farm and was active in his community, despite a chronic lung condition and an uncompromising religious perspective.

Frances was an incurable tomboy–to such a degree that she wore her hair in a short bob, even in adulthood, and insisted on being called Frank. At sixteen, her mother coerced her into wearing long skirts, even though Frank was convinced that doing so meant an end to her years of freedom.

According to Willard, her childhood was exceptional, although not so much for frontier girls:

> Mother never said you must cook, you must sweep, you must sew, but she studied what we liked to do and kept us at it with no trying at all....I knew all the carpenter tools and handled them, made carts and sleds, cross-guns and whip handles....But a needle and dishcloth I could not abide–chiefly because I was bound to live out-of-doors.[3]

Frances became jealous of male advantages early, never quite understanding why her brother's life was less restricted than hers. When Oliver entered Beloit College, Frances became determined to earn an advanced education of her own, despite the fact that nearly all her knowledge to that point had been bestowed upon her by her mother, a young neighbor girl who had briefly served as her tutor, and her Aunt Sarah.

At a time when higher education for girls was discouraged, Willard attended Milwaukee Female College, where her Aunt Sarah taught, and then graduated as valedictorian of Northwestern Female College in Evanston, Illinois. Because she enjoyed the academic world and was an

advocate for women's rights, she decided to devote her life to the education of women.

Willard accepted her first teaching position in 1860 in Harlem, Illinois and her second back home in Janesville at the Grove Street School. She was there when her beloved sister Mary died of tuberculosis in 1862. Seeking a way to honor her sister's memory, she wrote and published the biography of young Mary Willard, entitled *Nineteen Beautiful Years.*

Tuberculosis struck the Willard family again, as contagious diseases are prone to do, and Frances' father died on January 24, 1868. Needing an escape, Frances joined her friend Kate Jackson on a tour of Europe at the request and expense of Kate's father. To help with the expenses, she wrote travel articles and submitted them for publication. Most were rejected.

In 1878, after working with a woman's group to found a quality woman's college in Illinois, Willard was selected as president of the new Evanston College for Ladies and became the first woman in the nation to serve in such a position. When Evanston was annexed by Northwestern University, Willard was appointed dean of Northwestern Woman's College and professor of aesthetics.

She soon found that working with an all-male board of trustees was disagreeable, so much so that she resigned after only three years following a dispute over social rules for female students. Kate Jackson, then an instructor at Northwestern, resigned as well.

Willard immediately took up the temperance scepter as corresponding secretary of the recently founded WCTU and in 1879 was elected president. Under Willard's leadership, the organization evolved into an international movement and broadened its range of activities by encouraging its members to become active in a wide variety of reform movements. In fact, according to her biographer, Mary Earhart, her decision to work in the temperance field had less to do with

> an overriding interest in that cause itself than from a belief that it could be the means of drawing large numbers of women hitherto not receptive to the issue of greater rights for women, into activity which could lead them in that direction. Like the earlier temperance leaders, she saw that political influence would be a determining factor in achieving their goal, and she decided to combine the two.[4]

Willard's gentle touch was perceptive. She understood that most women of her day were of a moderate inclination that alienated them from the strident aggressiveness inherent in the Susan B. Anthonys of the world. Instead of demanding their support, temperance advocates made women aware of the threat that alcohol and other vices held over their homes and families and then softly urged them to enlist, almost as an afterthought. From that point, they could be led to a realization that a voice in public affairs was essential to the ratification of reform. Willard's tactics were effective, as the *Washington Post* indicated in its coverage of the 1881 WCTU Convention:

> This convention is essentially respectful and intellectual....These women are not, as is generally supposed, female suffragists...."Not one sixth of us," said an elderly delegate, "are anxious to wield the ballot. We are, as a rule, domestic women, wives and mothers....We are not anxious to vote but if by wielding the ballot we can better accomplish our aims, then welcome the female franchise, and the sooner the better."[5]

In fact, because the overwhelming majority of American women of the period felt that home was their natural place, a successful leader wisely would advocate the protection of that home, its family members, and its religion. By adopting the phrase "For God and Home and Native Land" as the WCTU's motto, Willard demonstrated her keen understanding of the culture of the time and was able to gradually guide her followers into the more rugged environment of other women's rights movements.

Willard also had a special talent for sloganeering. The success of her first "Home Protection" drive was impressive:

> A combination of the broad appeal carried by the slogan and Frances Willard's formidable talent for organization produced such results that when the petition reached the lower house of the Illinois legislature it carried 110,000 names (about half of them women), and by the time it got to the state senate it had picked up 70,000 more. Women involved in such a project gained a new consciousness of their potential strength, and press and politicians alike were profoundly impressed.[6]

Willard's motto for the WCTU was "Do Everything," and so saying, she set about reforming the nation's moral climate as well as the obscene

character of the male of the species. To fulfill that goal, she departmentalized the organization and assigned to each a specific project. In no time, the WCTU had chapters in every state and more than 200,000 members. Because of its impressive effectiveness, this sort of organization was quickly adopted by other women's clubs and reform movements.

In 1883, Willard launched a monumental tour of the West, during which she kept a daily journal. She noted that Idaho was a particularly tough nut to crack. While in Lewiston, she remarked, "This former capital of Idaho is the only town ever quarantined against us."[7] It seems that the town's male leadership had read of her tour and, rather than have her "infect" their town, they drummed up a timely diphtheria epidemic that forced them to cancel all public meetings.

As usual, Willard was up to the challenge. Despite the fact that the local, anti-temperance newspaper hadn't breathed a word of her stay, she organized an ice cream reception at the home of a Lewiston supporter and invited the town's women to visit. They did and, right under the noses of the duped town fathers, formed a local chapter of the WCTU, adopted its constitution, and elected its officers.[8]

Finally prepared to show her hand, Willard urged those attending the WCTU's 1891 annual meeting to initiate a special drive for suffrage in the coming year. Because of her efforts, Willard's announcement corresponded with the efforts of the Equal Suffrage Association to unite with the WCTU and the establishment of a Prohibitionist Party.

Despite Willard's creativity, however, the WCTU couldn't develop the broad base she coveted. Although her efforts won the prohibitionists a place in national politics, Willard's broad view of reform cost her the personal support she deserved. Men still controlled the politics of the land, and men were almost universally opposed to the goals of the temperance movement. The more realistic leaders of related reform movements recognized the predicament and were reluctant to combine efforts with the WCTU.

Her attempt to link the prohibitionist and populist parties was defeated soundly at the former party's national convention in 1892. The July 1 issue of the *Chicago Inter-Ocean* recounted:

It is reported on many sides that Miss Willard will not come out of the convention with flying colors. In several respects it is stated that her influence is greatly injured since her espousal of the fusion of the Prohibition and People's [Populist] Parties.[9]

Willard's defeat was humiliating enough to send her to England, where she spent the greater part of the next four years. Her growing liberalism stood out according to a review of her address to the 1895 WCTU Convention published in a *Chicago Inter-Ocean* review.

> The address...was a curious piece of patchwork. So far from being confined to the cause of temperance, it branched out into general politics in a grotesque way. Socialism supplies the material of a large patch of this quilt. The truth is Miss Willard is the victim of a radically wrong theory of reform.[10]

During her final years, Willard sank into the extremes of socialism, spiritualism, and related convictions, estranging her from former friends and associates. She founded the World Union as a last attempt to unite a wide range of reform movements on an international scale and served as its president until her death.

Willard gradually retired from active leadership of the temperance movement and died in 1898, leaving the WCTU to once again narrow its focus. Its newly concentrated effort resulted in the ratification of the Prohibition Amendment in 1919. However, it's equally significant that Willard's universal approach to women's rights permitted the WCTU to influence more women than any other nineteenth-century organization.

There was a hysterical wing coupled to the temperance movement, perhaps made up of women who had been directly involved with alcoholic behaviors. They expressed themselves with threats, axes, and hymn singing rather than well-chosen words. The queen of these saloon smashers was a sturdily built woman who stood nearly six feet tall and whose name has become forever linked with turmoil.

Carry Amelia Moore was born in Kentucky in 1846 and spent her adolescence on the Missouri frontier. When she was nineteen, her family took in Dr. Charles Gloyd as a boarder, and Carry fell in love. Their passionate love letters were exchanged through the pages of the family's edition of Shakespearian plays until they were finally married two years later. The good doctor proved to be a drunk, who died just a few months after his young, pregnant wife left him.

Carry than married David Nation, an itinerant lay preacher who had served in the Union Army during the Civil War. In 1880, the young family moved to Texas, where they ran a hotel for about ten years. Sometime

during that period, Carry began to hear voices. Convinced her voices were religious revelations, she focused her interpretative efforts on the church community of Richmond, Texas. Her pious renditions went unappreciated, however, and she was soon banned from the Methodist Episcopal Sunday school.

In 1890, the Nation family migrated to Medicine Lodge, Kansas, where Carry helped organize a local chapter of the WCTU. David, more in tune with his wife's eccentricities than the good people of Richmond, once again took up the ministry. Certain that Christ was talking to her, David began writing his sermons around his wife's visions. The resulting church presentation could be stimulating. "If David deviated from the text, [Carry] would rise and correct him from the front pew, and if she thought he was wandering too much, she would order him to stop the sermon for the day."[11]

Although Kansas was legally a dry state, laws prohibiting the sale and consumption of alcohol were rarely enforced and, consequently, routinely ignored. The men of Medicine Lodge drank openly in the streets and consumed liquor in back rooms of pharmacies for "medicinal purposes." Although interested in temperance and an early member of Kansas' WCTU, Carry tolerated the situation for nearly ten years.

Carry's campaign began innocently enough. One day just before the turn of the century, Carry and a small band of women stood up in church and recited the names of local liquor salesmen. The same women then took to the streets to address each and every one of the accused with the sarcasm of "Good morning, destroyer of men's souls! Shame on you, you rum-soaked ally of Satan!"[12]

Carry's next strategy took her inside the dens of iniquity. Her temperance army would march into a saloon singing anti-drinking songs and hymns. The effect was devastating. One by one, the invaded saloons emptied of customers and closed their doors. By 1900, the job in Medicine Lodge was done.

Carry, now fifty and seduced by her own success, moved her efforts to nearby Kiowa under the direction of her voices. This time she and her troops carried brick bats and rocks wrapped in newspaper. They accompanied their singing with the clatter of smashing liquor bottles, glasses, and mirrors. Again, the saloons closed down. Truly inspired, she marched into Wichita, where the devastation she had wrought and the relative sophistication of the town earned her a prison term and newspaper headlines.

While Carry strategized her next attack, David, unsuccessful in his attempts to talk Carry back to home and hearth, closed out his bank

account and filed for divorce on grounds of desertion. Barely pausing in response to her newly single state, Carry added the sins of tobacco consumption to her list and walked the streets snatching the offending objects from between the lips of smokers.

Nation moved her campaign to Topeka and points beyond, lecturing, raving in the streets, smashing saloons, and, incidentally, publishing two magazines, "The Smasher's Mail" and "The Hatchet." The climax of her frenzied campaign occurred at Topeka's Senate Bar, a hangout for members of the Kansas legislature. There, Carry took out a hatchet, destined to become her favorite doomsday weapon, and lit into everything that didn't move.

Finally, May Maloy of Butte, Montana chased the sixty-four-year-old Nation out of her establishment, the Windsor dance hall. Perhaps shocked that a woman would react so vehemently against her, Carry hung up her hatchet and left town. She retired to Arkansas, a nearby state barely touched by her feverish crusade, and died there just eighteen months after she had unexpectedly been vanquished by the fearless Ms. Maloy.

* * *

Reform-minded women were, nearly always, responsible individuals seeking ways to correct the injustices of society. Those committed to the temperance movement were no different. In a time when men reigned supreme, regardless of the make-up of their characters, women were learning to protect themselves, despite a legal system that refused to help them. Recognizing that strength lay in numbers, women organized the first predominantly female reform movement to have any impact on the larger society—the temperance movement.

Founded, managed, and funded by women in a day when women enjoyed few economic and almost no legal privileges, the temperance movement was something of a miracle. It was also a product of the westward-moving frontier. Its leaders as well as one of its most fanatic members were women. Each had a way of grabbing headlines, and headlines often led to support.

While Frances Willard organized her way into the hearts and minds of thousands of women and even a few men, Carry Nation smashed her way in. These women achieved a notoriety that helped endow the movement with the power it needed to reach its goals. One was methodically eccentric, and the other was maniacally erratic, but they both achieved worthwhile goals in their own ways.

17

WOMAN SUFFRAGE
IN THE WEST

Though conceived in the East, woman suffrage was born in the West. There, the leadership and financial support of women such as Susan B. Anthony and Elizabeth Cady Stanton quickly brought results. Western women relied heavily on the support, encouragement, and frequent visits of suffrage leaders from the East. But, western women, responding to a greater sense of freedom and the patronage of their men, made the greatest headway.

The politics of the West hadn't yet reached the sophistication of that in the East. Its more flexible structure made liberal reforms possible at a time when the sedate politics of the East did not. It should be remembered that, while large blocks of women wrote, spoke, and lobbied in favor of woman suffrage, many other people, both men and women, worked against them. Historian Lynne Cheney quoted the *Cheyenne Daily Leader:*

> We look forward to see the day when the tedium of every trial
> will be lightened by instrumental music, an occasional song or
> anecdote from the bench, and perhaps reading or recitations from
> the female members of the bar, and the introduction of a baby
> or two to be passed around about lunch time.[1]

One should also take into account that the mid-nineteenth century was a time when universal suffrage was undergoing radical changes. Less than thirty years before women first brought national attention to their already energetic movement at the 1848 Woman Suffrage Convention in Seneca Falls, property requirements had been dropped as a voting requirement for white men throughout the nation. It wasn't until after

the Civil War that the Fourteenth Amendment to the Constitution eliminated race as a criterion for voting. It was about the same time that American women, realizing that former slaves could now vote (at least according to the letter of the law), decided in large numbers that it should be their turn to have a formal part in the democratic process.

Still, it required an eighty-year-long national outcry of women across the nation to make the right to vote truly universal. Unlike in European nations, a national campaign wasn't enough. American suffragists were chained to the tedious task of winning the vote at the state level before they could effectively address the nation at large. A movement that was predominately middle class and urban in the East gained widespread support in the more rural West. There, the cry for voting rights encountered a society in which women owned and operated clubs, schools, businesses, ranches, and the like. It also confronted territories seeking a means to mature into statehood. To do so meant attracting more people to settle its lands, even female people.

That fact didn't escape observers in the East who noted Wyoming's landmark decision to allow the few women inside its borders to vote. A writer for *Harper's Weekly* placed tongue in cheek to offer the following commentary:

> Wyoming gave women the right to vote in much the same spirit
> that New York or Pennsylvania might vote to enfranchise angels
> or Martians if their legislatures had time for frivolous gaiety.[2]

Adoption of woman suffrage bills by territorial or state legislatures wasn't always a preamble to female participation in government. The women of Wyoming learned quickly that their presence in the halls of the statehouse would not be well received. Not that they didn't try. Three women were nominated for the state constitutional convention when it came time to draw up the statehood papers. None of them were elected. Esther Morris, Wyoming's first woman justice of the peace, served one term and wasn't reappointed.

Women selected for jury duty tended to be sticklers for legality. Perhaps intending to bring a touch of civility to their frontier towns, they found long-ignored statutes on the books forbidding saloon operation on Sunday, and they demanded their enforcement. "Laramie became known as the puritan town of Wyoming" until the legislature had time to repeal the Sunday laws nearly a year later. Women jurors proved to have no mercy for criminals either. A jury of six men and six women found them-

selves temporarily hung when the men voted for acquittal and the women for some type of murder conviction. The defendant was ultimately convicted of "manslaughter in the first degree" and sentenced to ten years at hard labor. Local men spread a dollop of poetry in response:

Baby, baby, don't get in a fury; Your momma's gone to sit on the jury.[3]

Voting polls and courtrooms did undergo some transformation with ladies present, but they could hardly be called devastating. Poker cards and liquor vanished from the courtroom, and laws long ignored by men were enforced by women. When nearly every newly franchised woman in Laramie turned out for their first election in September 1870, "the polls were reported to be much more pleasant places, since the rowdies, intimidated by the women's presence, stayed away."[4]

Even so, after 1871, women were excluded from jury service in Wyoming, by practice if not by law. The authorities apparently believed that suffrage and jury duty had no particular correlation. Sadly, women didn't serve on Wyoming juries again until 1950.

Not every state was so sexist. Kansas, perhaps feeling a bit more ready for some gentility than the comparatively crude settlements of Wyoming, adopted woman suffrage a bit late, in 1887. However, it took its new responsibilities more seriously. Between that year and 1900, the following women were elected to serve as mayors of Kansas cities:

Annie Austin of Pleasanton (1892)

Bell Gray of Canton (1890)

Antoinette Haskell of Gaylore (1895-1896)

Mrs. W. H. Kelly of Edgerton (1890)

Mrs. A. L. King of Elk Falls (1889)

Mary Lowman of Oskaloosa (1888-1889)

Mrs. H. H. Miller of Rossville (1889)

Wilhelmina Morgan of Cottonwood Falls (1889)

Dr. Rachel S. Packson of Kiowa (1891)

Susannah Medora Salter of Argonia (1887)

Anna M. Strain of Jamestown (1897)

Lucy M. Sullivan of Baldwin (1889)

Elizabeth Totten of Beattie (1899)

Elizabeth Vedder of Haddam (1891)

Mrs. M. A. Wade of Ellis (1896)[5]

Thousands of perfectly ordinary western women clambered to the ranks of the suffrage movement. An Idahoan named Carrie Young attended the Pacific Coast Suffrage Convention in San Francisco in 1870 and was one of the first in the Boise area to speak out for women's right to vote. She had to leave it to Mrs. J. H. Beatty to organize the first Boise suffrage group, however. Beatty headed the Idaho Equal Suffrage Association starting in 1895. Nevertheless, it was an uphill battle. Of the approximately 15,000 adult women living in Idaho in 1886, only about 1,000 were members of the Equal Suffrage Association.[6]

Women seemed rather confused over the issue. Around 1900, Elizabeth McCracken traveled through the United States observing the various lifestyles of American women for a planned book on the subject. A relatively liberated woman for her day, her comments on the West revealed a typically conservative nineteenth-century attitude as she confronted the enfranchised women of Colorado. By the time of her visit, Colorado women had had the vote for more than ten years, and McCracken found them to be no ladies. She felt that "political power had intoxicated her; she reveled in it, not as a means to an end, but as an exhilarating indulgence."[7] Even though Colorado women were quick to point out the fair treatment of shop girls in Denver and credit it to their increased political power, McCracken's convictions were fixed:

> The possession of the ballot, and the employment of that possession have hurt the women of Colorado as women can least afford to be hurt. Her ideals have been lowered; the delicacy of her perception of right and wrong has been dulled. Whatever good she may be able to render to her State and to the Nation by her vote, can that good, however great, compensate for the injury which she has wrought to that State and to the Nation by reason of the blow she has dealt her own womanhood?[8]

Indeed, the power and stridency of the woman suffrage opposition is often dismissed by historians concentrating on the successful results of the long campaign in 1919. Yet, the opposition was powerful and well populated by women, particularly in the East, where many expressed the fear that winning the vote might lose them their femininity, their religion, and their station in life.

Organizations such as the Woman's Protest Against Woman Suffrage and the National Association Opposed to Woman Suffrage sought to bring order and commitment to what they repeatedly vowed were the vast majority of American women—those against taking on masculine attributes by casting ballots. Magazines such as *The Reply* and *The Woman's Protest* cited a wide variety of reasons why woman suffrage was not only foolish but devastating. One article argued the pointlessness of woman suffrage:

> When the family is represented at the polls by the father it would seem to a reasoning mind that the family interests were given sufficient expression by vote....The mothers' votes would merely double the number cast without in any way altering the result.[9]

An article in a later issue of *The Reply* satirized the ambition of the woman suffragist with an article entitled "Bills to Be Presented Before the First Woman's Legislature." The article exposed a bias as spiteful toward the Irish-American as toward liberal women in the decision to call one of the quasi-bills the "Bridget Bill," Bridget (or Biddie) being used along with Paddy (or Patrick) to ridicule immigrants from the Emerald Isle. While other bills (such as the "Sarah" Bill and the "Daisy" Bill) poked fun at middle-class female jealousy and vanities, the ersatz "Bridget" bill spotlighted servants by stipulating that

> all cooks, housemaids, laundresses, and other female help, shall have every afternoon and evening off, shall be provided with hot and cold baths, electric light, manicure, shampoo, and massage; shall have a dance once a week in a ball-room exclusively their own....Violations of this law are to be made punishable by death.[10]

Upping the ante, in *The Woman's Protest* Mrs. William Forse Scott terrorized her readers with an article blaming woman suffrage for the ultimate decay of civilization and the human species:

Whenever in the past women have assumed the habits and conditions of men, they have weakened, even destroyed their ability to perform the specific duty of woman to the State by weakening the maternal instinct and disturbing the physical functions, with the result that they produce offspring of less than normal physical and mental endowment.[11]

But not everyone was so short-sighted, particularly in the frontier West. The women McCracken and other visitors met in Colorado represented a new breed who had begun to leave behind the false attributes forced on them in the East and were prepared to merge with the world of men. An especially strong-minded suffragist from Oregon is a good example.

John Tucker Scott and his wife Ann Roelofson Scott were originally from frontier Kentucky but had immigrated separately to Illinois Territory, where they met, married, and settled down near Peoria. As was all too common in those days, their union produced fourteen children in twenty years, nine of whom survived into adulthood. Their third child and second daughter was born on October 22, 1834, her parents' fourth wedding anniversary. They named her Abigail Jane but called her "Jenny" throughout her childhood.

Abigail's first year was aggravated by the Illinois weather that brought driving rain and flooding

followed by one of the worst droughts in [Illinois] history....Farm families had to rely for income even more heavily than usual on the wife's production of eggs, butter and woven "jeans." There was no time for pampering or cuddling. Jenny Scott spent her first summer, like many other frontier babies, sitting on the floor complaining and neglected, soothed only by a piece of bacon, attached by a string to a bed-post, or a loom stanchion, until [she] would fall asleep from exhaustion, a prey to numerous houseflies.[12]

Perhaps because of nineteenth-century American culture, the senior Scotts expressed a pleasure at the births and lives of sons that was lacking if the little one was a daughter. In her rambling but revealing autobiography, *Path Breaking: An Autobiographical History of the Equal Suffrage Movement in Pacific Coast States* published first in 1914, Abigail, in her later years wrote, "I remember that my mother informed me on my tenth

birthday that her sorrow over my sex was almost too grievous to be borne." Later, she recalled standing at her mother's bed upon the birth of yet another sister and hearing her overwrought mother cry, "Poor baby! She'll be a woman some day! Poor baby! A woman's lot is so hard!"

In 1852, the Scotts pulled up stakes, as so many frontier families did, in an ongoing search for something undefinable and headed west by wagon train. Abigail was seventeen. Her eight siblings ranged in age from young adulthood to infancy. Along the way, their mother, now an invalid, required special care and attention. That last Illinois winter had been particularly hard, causing her to suffer from general weakness and fatigue. Despite the ministering efforts of her family, she contracted cholera, a common illness along the Oregon Trail in the days before the importance of clean drinking water and unspoiled food was understood.

In Ann Scott's already weakened condition, there was little hope for recovery from a disease that, at the time, boasted an eighty percent mortality rate. As her horrified family looked on, she quickly weakened and within hours was dead. The wagon train paused fleetingly in its determined trek in order to lay its first fatality to rest. Ann's hastily marked grave somewhere along the shores of the Platte River joined the hundreds of other martyrs of the great migration who lie buried along the way. Having no other choice, the wagon train, with its mournful survivors, continued its journey.

The Scotts reached Oregon, settled on a small farm, and began to put their lives back together. The children old enough to do so looked for work. Despite the fact that she had received less than twelve months worth of formal education, Abigail was hired as the Eola District schoolteacher, a position that gave her a small income of her own and a sense of independence that would serve her well in later years. But her status as a single woman didn't last long in a land where men outnumbered women by nearly eight to one.

Benjamin Charles Duniway, a young rancher from nearby Clackamas County, had an outgoing personality and a talent for making friends. Abigail loved, and then in 1853, married him for just that but found it a burden as well, for his many bachelor friends were always showing up for dinner. She remembered the men chatting, smoking, and enjoying themselves "while I, if not washing, scrubbing, churning or nursing the baby, was preparing their meals in our lean-to kitchen."[13] In fact, her difficult days as a pioneer rancher's wife left a pretty bad taste in her mouth. In her autobiography, she wrote:

As I look back over those weary years, the most lingering of my many regrets is the fact that I was often compelled to neglect my little children, while spending my time in the kitchen, or at the churn or wash tub, doing heavy work for hale and hearty men—work for which I was poorly fitted, chiefly because my faithful mother had worn both me and herself to a frazzle with just such drudgery before I was born.[14]

After a few years, the Duniways moved to a farm in Yamhill County, where they lived for the next five years. Unfortunately, Ben's trusting nature got the best of him when he co-signed three bank notes to assist an acquaintance who was in some financial distress. Abigail's worst fears were realized when all three notes came due at once. In order to meet the unwisely made commitment, the couple was forced to sell their farm and move their young family to a small piece of land they owned in the nearby town of Lafayette.

The Duniways barely got settled when Ben had a serious accident. While he was working as a teamster to earn the money needed to buy a new farm, runaway horses knocked him down and dragged a heavy wagon across his back. Abigail noted that "though he lived for many years thereafter, [the accident] incapacitated him for physical labor on the farm, and threw the financial, as well as domestic, responsibility of our family upon my almost unaided self."[15]

Abigail returned to teaching, this time by opening a private school of her own, the Oregon Union School in Lafayette. By 1864, she was serving as its principal. Her life as a working wife and mother of six was difficult, but her regrets few. Because servants were rare on the frontier, she habitually arose at 3:00 A.M. in summer and an hour later in winter in order to begin the day's work before school began. Just before noon, she returned home to serve her family lunch, a significant meal at that time. She then headed back to school, where she taught from one to four o'clock. Upon returning home she completed her domestic chores then turned in for the night. "And yet, notwithstanding all this effort, I led an easier life than I had known on a pioneer farm."[16]

Moreover, it was during these demanding years that Duniway somehow found time to write fictional works for publication to bring in a little extra money. Her first attempts were poetry, but it wasn't long before full-length novelettes began to appear with titles such as *Captain Gray's Company; Madge Morrison, Mollala Maid and Matron;* and *Edna and John, A Romance of Idaho Flat.*

After a few years, Duniway sold her Lafayette school for a tidy profit, and the family moved to Albany, Oregon. Duniway opened a second school, but the troubled times made teaching difficult. The Civil War was raging, and the politics of secession crept daily into the school-house, frustrating efforts to teach. Duniway, always prepared to pull victory out of adversity, simply made a few changes. By adding shelves, counters, and showcases, she converted her schoolhouse into a shop that featured millinery and notions. Her innovative business was an immediate success, but one attribute of a woman-owned business deeply disturbed her.

As a shopkeeper, Duniway frequently overheard gossip from or about women. Many of them came to her seeking temporary work so that they could earn money to replace that which their husbands had spent on racehorses, cards, or liquor. These stories, plus memories of her own overburdened mother, produced in her a resolve to do what she could to improve the position of women. In discussions with her husband, she came to realize that the condition of women was not likely to change until they were able to express their needs at the polls as voting citizens. By the time she was thirty-six years old, Duniway had become a dedicated suffragist.

The Duniway family's next move was to Portland, which Abigail remembered as a village that "contained about eight thousand pioneers, who were nestled in primitive homes, among fallen trees and blackened stumps."[17] Seeking an effective means of voicing her increasingly determined opinions in the cause of women's rights, Abigail entered her third vocation.

On May 5, 1871, Duniway founded the *New Northwest* weekly newspaper, with a masthead reading in part, "Eternal Liberty, Universal Emancipation and Untrammeled Progression." She soon was writing, speaking, and raising funds to support woman suffrage. Her selection of journalism as a vocation certainly wasn't out of tune with the times. Newspapers had been one of the staples of her education, as it was with many frontier families. In 1830, French historian Alexis de Tocqueville noted, "The American frontiersman penetrates into the wilds of the New World with the Bible, an axe, and some newspapers."[18] In fact, newspapers were essential to frontier education and edification, and they were filled with poetry, local gossip, politics, fiction, and essays as well as national and international feature stories.

Despite the difficulties of circulating a newspaper over the vastness of Oregon Territory, especially when her lecture tours took her far from

home, Duniway and her family kept the presses running until 1886. Historian Eleanor Flexner wrote of her in 1959:

> Her articles while touring the Northwest are a vivid source of regional social history, as well as day-by-day history of an embryo social movement, that for woman's rights. She traveled literally thousands of miles in all seasons, by stage coach, river boat, and sleigh, to speak wherever a few would gather to hear her.[19]

Duniway's campaign was initiated by Susan B. Anthony, who, on a visit to Oregon, selected her as her speaking-tour manager. It wasn't long before Duniway was managing her own tours. She took to the road like a bird to flight. Learning quickly that churches wouldn't allow radicals to speak within their walls and that most considered suffragists radical, she scheduled speeches in theaters and private meeting halls. She discovered within herself a gift for oration and came away from the experience as the most powerful voice for woman suffrage the western states and territories ever produced.

Duniway sadly discovered that controversy had its down side. Partially because of the rabid militancy projected by suffragist leaders Susan Anthony and Elizabeth Cady Stanton, the movement had become the target of the most frenzied ridicule and hostility its opponents could summon. One particularly strident adversary proved to be Duniway's younger brother, Harvey Scott, publisher of the influential Portland *Oregonian* newspaper. At first, his animosity had proven perplexing to his sister because it had been Harvey who had encouraged the Duniways to come to Portland and Harvey who had assisted Abigail in establishing her newspaper.

Harvey Scott's publication was soon to be the leading newspaper in Portland, where it would be housed in the city's tallest building. The respected journalist quickly became a prominent member of the Portland community, where he was well known for his conservative views. During his lifetime, he dined with presidents Roosevelt and Taft, twice rejected diplomatic appointments, ran an unsuccessful campaign for the U.S. Senate, and became a controversial figure in his own right.

Lincoln Steffens once accused Scott of making illegal political bargains, an allegation that Scott firmly and eternally denied. On the other hand, according to the December 4, 1960 edition of the *Oregonian*, a writer for the *New York Sun* once referred to Scott as "the leading moral force and article of virtue in all Oregon."

Scott's philosophy was not unusual for a successful businessman of the Gilded Age. Scott stands as an articulate example of the status quo his sister was so determined to alter. He was a Social Darwinist who believed that those who were physically and intellectually strong would and should dominate their less fortunate brothers. He was an advocate of the Horatio Alger school of "bootstrap" success and once proclaimed, "Boys and girls you've got to work; and your school will help mighty little. The less help you have the stronger you'll be—if there's anything in you."[20] Not only did he oppose the establishment of public schools, partially because it would remove children from the work force, but he promoted the idea of leadership by "an aristocracy of mental superiority."[21] He ran his newspaper with a fierce sense of morality that allowed him to use it as a tool to promote the traditional nineteenth-century concept of good over evil. The *Oregonian* contends that Scott believed that "to fight such forces [as evil] it was not thought inappropriate to slant news stories and headlines."[22]

Perhaps most of all, Harvey Scott, along with so many of his countrymen, believed women incapable of casting rational votes and likely to be corrupted by the practice of participating in politics. As a leading republican of his day, he was outspoken in his disdain for his sister's cause. Always the gentleman, he managed to find ways to criticize woman suffrage while offering a reluctant respect for Duniway's efforts. Shortly after the 1906 defeat for woman suffrage in Oregon, Scott's newspaper carried the following editorial statement under the headline H. W. Scott:

The *Oregonian* has not supported woman suffrage, but has opposed it; and it will now take no part in the dispute between women who support it, as to why it was defeated in the recent election. But it will say that it has been an interested witness of the effort for it during the whole period of the agitation in Oregon, these forty years. It was begun by Mrs. Duniway, and has been carried on by her unceasingly; and whatever progress it has made is due to her more than to all agencies together. But for her, indeed, the subject would scarcely have been mentioned in Oregon to this day, and never seriously considered.[23]

Her brother was not her only critic, and he enjoyed printing letters in his newspaper that attacked Duniway's assertions. In the June 3, 1906 edition of the *Oregonian*, a letter from a C. V. Cooper bewailed:

The respectable woman, the woman whom we would naturally look to purify the political atmosphere by her vote...will not enter into the filthy political mess of modern politics; her whole nature shrinks from it, and she will not use her right to vote. But at the time the ballot was given to her it was given to her less fortunate sisters, the ignorant, the foreign women and the women of the brothels. This class will vote....This is how woman suffrage has worked out in the four suffrage states, and has proved itself to be a delusion and a snare. It has given such additional strength to the worst political element that...those who would vote for pure government, are snowed under at each election....St. Paul said: "Let your women keep silence in the churches; for it is not permitted unto them to speak; but they are commanded to be under obedience, as also saith the law." (I Corinthians, xv:34) Which means today that women should not vote.[24]

Out of a growing need for self-defense, Duniway learned to confront her opposition. She became skilled at addressing hecklers in the audience with shrewd ad lib comments. Her letters often appeared in the newspapers of the area she was visiting as well as in the *Oregonian*. Shortly before the 1906 defeat of the Oregon woman suffrage amendment, she wrote:

We are serenely hopeful as to the result of next Monday's battle of ballots, as, if we win, and we believe we shall, our long-drawn-out fight will end in Oregon; but if we do not get votes enough this time, we are holding ourselves in readiness to renew our appeal to the manhood of Oregon for another long-drawn struggle. There is but one way to stop women's plea for liberty, and that is by voting "Yes."[25]

Duniway could dish it out as well as she could take it. Her fictional works were bursting with tales of selfish brothers with inappropriate senses of superiority who competed with strong-minded heroines. Interestingly, the names of these brothers always began with *H*.

Duniway was equally forceful in person. In fact, she was criticized routinely for overstepping her bounds as a "lady" in making some of her more pointed comments. During her address in one western town, Duniway was pelted with "strong" eggs and heckled. She responded by

writing an editorial letter for the *New Northwest* in which she assailed prominent citizens of the area by using "the word cowards, etc. very generously attached before and behind their names." The response, of course, was to find fault with Duniway for having taken advantage of her "fortunate circumstance of being born a woman" to speak out so boldly. It went on to mention that a few rotten eggs "did her no particular bodily harm."[26]

Duniway's organizational skills were as acute as her many other talents. In fact, she probably wouldn't have survived her early womanhood on the frontier had she not been adept in this area. Recognizing that strength lay in numbers, she helped to found the Oregon Equal Suffrage Association in 1872 and, somehow, drummed up enough courage to begin lobbying efforts at the capitol in Salem. She was the first woman to visit the state legislature alone and, as such, was required by state house procedures to have a chaperon with her. After two days of rejection while she contacted every possible lead, she found Dr. Mary P. Sawtelle.

Dr. Sawtelle had been the first Oregonian woman to complete medical school and open a medical practice. Well known for her radical pronouncements regarding the dangers of corset-wearing and the need of women for exercise, she was as controversial to the conservative members of the Oregon legislature as was Duniway. In an attempt to clarify the purpose of the requirement, one lawmaker explained that women were expected to acquire the services of male chaperons. Despite objections, however, the letter of the law had been satisfied, and Duniway, her chaperon at her side, was allowed to speak before this august body of men.

Soon Abigail Scott Duniway had become a name to be reckoned with throughout the Northwest. She traveled throughout the region, speaking, organizing women along with the occasional man who supported them, and lobbying the nearest legislature. She spoke out in favor of prohibition, women's rights, and women's property ownership in addition to the right to vote. Her efforts were instrumental in the passage of numerous laws gradually recognizing more rights for women. But her victories were mixed discouragingly with defeats. In 1884 and again in 1906, the Oregon equal suffrage amendment, for which she had worked so hard, was defeated at the polls. Just three years later, Washington Territory lost its attempt to allow women to vote in its bid for statehood.

After traveling extensively through the Northwest and California, Duniway began to realize a need for a unifying force for women throughout the region. In 1899, she established the Pacific States Voting Alliance,

which united the suffrage efforts of citizens in Oregon, Washington, California, Utah, and Idaho. She then agreed to serve as the organization's first president.

Although Duniway was a dedicated prohibitionist, she adamantly insisted that the suffrage and temperance movements remain separate and distinct. Her objections placed her in direct opposition to the leaders of the suffrage movement, including long-time friend Susan B. Anthony, who saw a unity of moral efforts as a means of recruiting more women. Duniway's dissenting opinion grew out of a sense of realism few in the movement possessed. The years she had spent among the all-male lawmakers of various legislative halls had taught Duniway that the vast majority of governmental authorities adamantly opposed prohibition. She realized that women's efforts could not succeed without men's approval, and she feared that the increasing support woman suffrage was beginning to enjoy would be destroyed by its combination with the even more controversial temperance movement. She argued her case convincingly and, for a time at least, probably saved the organization from a costly political setback.

In 1886, Duniway backed her sons in their purchase of ranch land in Idaho. In order to do so, she sold the publishing company she had established as well as her beloved newspaper. A close friend of Harvey Scott, Oliver P. Mason, bought the *New Northwest*, promising to continue Abigail's weekly columns. It lasted barely two months before going out of business.[27] Isolated on her new ranch in rural Idaho with an invalid husband and too much time on her hands, Duniway's advocacy voice was nearly silenced. She continued to write short stories and novels and spoke when invited to do so, but the invitations came less and less often.

Even worse, the National American Woman Suffrage Association (NAWSA) turned against Duniway's stand on the unity of the suffrage and temperance movements. Although widowhood had returned her to the campaign trail, the 1905 NAWSA convention snubbed her in its proceedings. Even though she was present as the Oregon association's president, her name did not appear on the program. As determined as ever, the seventy-one-year-old campaigner forced her way to the podium and spoke her mind.

Duniway's local friends were more loyal. In 1905, Oregon hosted the Lewis and Clark Exposition in Portland. One of the earliest items on the schedule was reported by a local newspaper:

Only one woman has been honored by having a day set aside exclusively in her honor; October 6th was designated...as "Abigail Scott Duniway day," in honor of that grand old pioneer; and pioneer she is, not only in the sense of being one of the early settlers in the wilds of Oregon, but she has been a pioneer in the ranks of those struggling for the liberty and enfranchisement of women.[28]

While Duniway certainly appreciated this type of public gratitude, the exposition didn't give her her greatest thrill. That would have to wait until 1912, shortly after Oregon had adopted the equal suffrage proclamation written by Duniway herself. Following the legislative decision, she joined the governor to co-sign the bill into law and then officially became the first woman in the state of Oregon to register to vote. She was seventy-eight years old and had less than three more years to live.

Interestingly, Duniway's feminist views never got in the way of her relationship with her husband. Even though Ben's last years were difficult due to increasing helplessness that required continual nursing on her part, in Duniway's autobiography, she writes respectfully of him. In fact, Duniway acknowledged that it was Ben who made it possible for her to be away from home for such long periods. His generosity in assuming the nurturing role from time to time as their six children grew up won her eternal appreciation. In her memoirs, she wrote:

To my faithful, invalid husband...but for whose sterling character as a man I could not have left our growing family in the home while I was away, struggling for a livelihood and the support of my newspaper, nor could I have reached the broader field which now crowns my life with the success for which I toiled in my early itinerancy, I owe undying gratitude.[29]

* * *

By the late nineteenth century, virtually every barrier to women's equality was under attack, not only by the women of the frontier but by the men as well. Women had proved they could work outside the home by doing just that and doing it well. They did it first because they were forced to in order to avert poverty and then because they had come to enjoy it.

The first generation had worked outside Cult confinements in order to survive the hardships heaped upon the pioneer by the severity of the

land and the inhospitable culture of the frontier. Later generations, many of whom encountered little or no exposure to the Cult, worked because they wanted to. While the East continued to think the West extremist and too liberal toward the "fairer sex," frontiersmen saw in their women a strength and determination that eastern "ladies" rarely displayed.

At last, the Cult of True Womanhood was in a terminal decline, but not without its parting shots. A scathing letter appeared in a Mountain Home, Idaho newspaper in the 1880s. Its author was a strongly opinionated gentleman named Homer Stull. In speaking his mind, he firmly asserted that "a woman's duty was in the home, and allowing her to vote would threaten this natural division of labor." Jennie Bearby argued back in print that "man and woman are one; but the man is the one, and in many homes where there is no man there is no representation."[30]

18
MEDICINE WOMAN

With the exception of midwifery, which wouldn't become a common practice within the male realm until after World War I, formal pursuit of medicine had gradually closed to feminine endeavor. Before that time, women had practiced medicine throughout recorded history out of necessity. Medicine had long been an inexact science that depended upon handed-down recipes for homemade remedies. Because women remained at home and served as caretakers, healing had come under their guardianship.

This reality applied to the frontier even more than to previously settled areas. With nobody else to turn to, women learned to treat the snake bites, colds, measles, smallpox, cholera, diphtheria, and wounds that were a fundamental part of life on the frontier. Because of the filthy conditions, poor nutrition, and hard work, health was fragile, so women got plenty of practice in their own homes. Since so little was known about physiology and medical treatment and because mistakes were made, frequent failure required that women also know how to dress the dead. Besides, birth and death had been two of woman's many responsibilities since before the dawn of history.

Dr. Cass Barns noted that "the homesteader's family went without groceries, meat, port [wine], and milk for several years....The settlers were for long periods undernourished." In addition, he found the frontier environment to be a source of disease.

> It was not wholly the fault of the sod houses that contagious diseases and epidemics were common. The common drinking cup, the open dug well, the outdoor toilet, or no toilet at all, shared the blame with lack of ventilation and crowded quarters of the

sod house....The floor of a dugout, or sod house, was commonly the clay dirt, innocent of joist or board flooring. It was not possible to scrub it or disinfect it of the millions of germs that found a breeding place in the dirt trodden under foot. Food in open dishes, milk, butter and the table dishes were easily contaminated with the germs raised in the dust if an attempt to sweep up the floor was attempted....Disease germs were here, there, everywhere and anywhere. No wonder the mortality by diphtheria was so great among children and the old cemeteries tell the pathetic story of the wholesale slaughter of the innocents....Fleas and bedbugs infested the sod houses by the million....Added to the lowering of vitality by lack of a balanced ration of food, proper preparation, lack of clothing and carelessness in exposures to drafts and changes of temperature, the wonder is not so much that disease and infection took a heavy toll, as the wonder that so many survived.[1]

The scarcity or absolute lack of professional medical assistance for pioneer families, while frightening and frequently deadly, led to an important economic expansion of woman's role in the West. With the near unavailability of doctors in the West, frontier women learned to treat their own families first and, if requested, the neighbors second. Many grew skilled and confident enough to open medical practices and treat all comers. The son of Amy Louchs of Kakin, Kansas was quoted by historian JoAnna Stratton:

One time a posse summoned her to treat a badly wounded prisoner. With a small vial of carbolic acid as an antiseptic, a knitting needle as a probe and a pair of common pincers, she removed the bullet and saved the man's life.[2]

Laura M. Wright, the "Angel of Bob Creek," served as the itinerant doctor for parts of Colorado, driving her horse and buggy through the worst snows of winter. In the 1880s, she and her two small children had been abandoned by her first husband. Laura had had to work as a cook until she met and married her second husband, Watt Wright.

The Wrights settled a homestead on Bob Creek, where Laura began to care for her own family and then the neighbors when they became ill. In no time, the demand caught up with her, and she was working almost full time as a nurse and midwife.

Since the field of medicine had not formalized its training as quickly as law, and since medical assistance was needed more often than legal assistance, a number of frontier women were widely accepted as physicians. Kate Dunlap practiced midwifery and pharmacy in Bannack City and Junction, Idaho in the mid-1800s. Dr. Sarah Hall specialized in diseases of women and children in Fort Scott, Kansas. Dr. Charlotte Brown practiced medicine in San Francisco and there founded the Pacific Dispensary for Women and Children. The easy way into medicine was to slide in through the back door of necessity; the hard way was to earn a medical degree.

Bethenia Owens and her family left semi-civilized Missouri for the Oregon frontier in 1843. She was three years old, having been born February 7, 1840 in Van Buren County. She grew up with numerous brothers, her favorite being Flem, who was two years younger, and was nearly always treated as one of the boys. When she was thirteen, she lost a front tooth while wrestling with Flem and proudly filled the gap with a gold substitute when she was thirty-one. She remembered:

> I was a veritable "tom-boy" and gloried in the fact. It was father's custom to pat me on the head, and call me his "boy." The regret of my life up to the age of thirty-five, was that I had not been born a boy, for I realized very early in life that a girl was hampered and hemmed in on all sides simply by the accident of sex.[3]

Bethenia helped with chores inside and outside the house, and when the family moved to Portland in 1853, she, Flem, and a hired hand drove the cattle along the trail. Her formal education was limited to three months in a small frontier school when she was twelve.

As did many women in her day, Owens married at fourteen and began a family. According to her autobiography, Bethenia's youthful husband, Legrand Hill, spent most of his time either hunting or completely idle. She had to rely on friends and family to complete the house he had begun so she and her baby would have shelter during the winter. The man also had a temper and too often expressed it by beating his physically tiny wife and his small child.

Four years into her marriage, Owens had suffered enough to make a daring decision. With the support of her family, who were well aware of the drastic circumstances, she divorced Hill and, even more

scandalously, dropped his surname in favor of her own, a practice nearly unheard of at that time. It wasn't an easy decision:

> I found myself broken in spirit and health, again in my father's house from which, only four short years before, I had gone with such a happy heart, and such bright hopes for the future....At this time I could scarcely read or write.[4]

Weighing her options, she realized that as an uneducated eighteen-year-old she would have difficulty living on her own and providing for her young son, George. Despite her age, she committed herself to earning the education she had been denied by attending school with her younger siblings and taking in laundry to pay for her keep. Soon she was supplementing her income by nursing members of her family and community.

When she had completed her basic education, Owens took on the job of community schoolteacher but continued to save her money with an eye to the future. By 1867, she owned a home of her own and a dressmaking and millinery shop in Roseburg, Oregon. At a point when most women would have relaxed and enjoyed what they had earned, Owens remained dissatisfied with her life.

Recognizing that her true interests and talents lay in the field of medicine, Owens enrolled now teenaged George at the University of California at Berkeley under the guardianship of her friend Abigail Duniway. She then sought an appropriate higher education for herself. Virtually every medical school to which she appealed rejected her. She finally enrolled in the only medical school that would accept her, the rather controversial Eclectic School of Medicine in Philadelphia. It promoted the "science" of hydropathy, using medicated baths as treatment for nearly anything that ailed one. Years after Owens graduated, the head of the institution was convicted of selling fraudulent medical degrees.[5] The origins of her degree eventually would goad Owens into seeking more acceptable training.

Her immediate problem was the effect her decision had had on those around her. "My family felt they were disgraced, and even my own child was influenced and encouraged to think that I was doing him an irreparable injury, by my course. People sneered and laughed derisively."[6] That was just the beginning.

Upon graduation, Owens returned home to the cozy community of Roseburg, where she ran head first into a most humiliating form of sexual harassment. A town bum had died, and the local doctors were prepar-

ing him for autopsy. Strictly as a joke, they had invited Owens to attend, fully expecting her to refuse demurely. Suspecting nothing underhanded from people she had known so long, she was delighted at the invitation and viewed it as a sign that her colleagues had accepted her.

When she arrived at the scene of the autopsy, the shocked doctors tried to discourage her attendance. They adamantly pointed out that the repugnant work to be done would, in part, involve the gentleman's genitals and waited for her to blushingly withdraw. But they didn't know Owens. According to her autobiography, she replied, "I came here by written invitation, . . . and I will leave it to a vote whether I go or stay. But first I would like to ask Dr. Palmer [who had objected to her presence] what is the difference between the attendance of a woman at a male autopsy, and the attendance of a man at a female autopsy?"[7]

Realizing that Owens wasn't to be easily dissuaded, the doctors devised a new plan. Still hoping to discourage her entry into the masculine field of medicine, they handed Owens a scalpel and turned the autopsy over to her. To their surprise, she accepted the tools of her trade, rolled up her sleeves, and went to work. When she completed the job, she washed up and stepped into a street full of hooting, jeering citizens who made it abundantly clear that a woman doctor had no place in their community. She got the message. Hoping to find a more sympathetic population in a larger town, she moved on to Portland. But she never forgot the Roseburg incident.

> I can assure you it was no laughing matter then to break through
> the customs, prejudices and established rules..., which is always
> a risky undertaking, especially if it is done by a woman, whose
> position is so sharply defined.[8]

In its more sympathetic location, Dr. Owens' practice prospered. Her son eventually followed her into the medical profession, as did her foster daughter, Mattie. Owens paid for the educations of both, as well as that of a sister who attended nearby Mills College. When asked why she did not remarry, Owens' answer was always, "I am married. I am married to my profession."[9]

After further study at the University of Michigan and in Chicago, where she served her residency in homeopathic medicine, she took enough time off to spend six months touring Europe. When she returned to Portland, Owens served as a specialist in ear and eye diseases and, with the self-confidence she now exuded, a speaker for women's rights.

At forty-four, the good doctor married Colonel John Adair, hyphenated her surname, and three years later gave birth to a daughter, who died in infancy. Relocating her practice to Astroid to be near her husband's business concerns, Bethenia contracted a near-fatal case of typhus, which weakened her for years to come. Hoping to recover her health, in 1888 she moved to a farm in southern Oregon, where she stayed for eleven years, until the dampness and boredom drove her out. Returning to northern Oregon, she hung her shingle in the small town of North Yakima near Portland. There, Dr. Owens-Adair provided medical assistance to the community and campaigned for women's rights until well into her eighties.

The doctor opened her autobiography with a revealing salutatory which said in part, "I have endeavored to show how the pioneer women labored and struggled to gain entrance into the various avenues of industry, and to make it respectable to earn her honest bread by the side of her brother, man."[10] Perhaps she didn't realize how far she and her dauntless frontier sisters had come toward swinging those doors wide open.

* * *

Perhaps teaching and medicine were the first professions to admit women because the required tasks, at least to some extent, fell within the circle of well-defined responsibilities attributed to the role of womanhood. It wasn't a giant step from mother of children to teacher of children. The stride was somewhat longer from caretaker of sick children to universal healer, but still within the realm of possibility.

Nevertheless, while the law of supply and demand offered a fairly easy transition to teachers, it built menacing barriers in the paths of potential female physicians. Attacking the barriers took a special kind of courage, but by the back end of the nineteenth century, it was being done by more and more women, using individuals like Dr. Owens-Adair as models. Many of the crusade's earliest and most valiant warriors could be counted among the daughters of western pioneers. On the frontier, the need for medical assistance was often desperate enough to overcome anxieties attached to gender. There, as well, women were already performing some rather astounding feats, and having one as a physician didn't seem quite so peculiar. A few of these incredible women took on an even more arduous mission by assaulting the ramparts of the last noble profession to be exclusively male–law.

19
BREAKING DOWN
THE BARRIERS

It was time for the legal profession to allow those first few exceptional women into its midst. Once again, those not-so-timid steps were taken on the frontier, even though the new woman was making her mark across the entire continent. By the mid-nineteenth century, women poets and writers had become an accepted part of American society, even in the East. Thanks to western schoolmarms, female teachers had become a national phenomenon, although they were expected to work only until nice young men whisked them away from their dusty chalk trays to nearby altars. The abolitionist, temperance, and suffrage movements were even beginning to make reform-minded women seem commonplace. The barriers were beginning to crumble, but they still needed a push from those eccentric "she-males" in the West.

It may have started innocently enough as bold, new convictions of western women erupted to the surface. For each woman, the frustration was expressed differently. In 1891, Missouri Powell Propst, tired of the inequities surrounding her life, wrote an article for the magazine *Christian Advocate* ridiculing "man's habit of placing woman in an exalted position but at the same time making that position a prison." She concluded with a plea:

> "It is not well for man to be alone" did not mean that man, poor fellow, was lonesome and needed woman to make things pleasant for him, but that he needed her help in planning and working of school systems, conducting of newspapers (those going into families), the making of laws, choice of officials, caring for the poor, and by all means, man should not be left alone in the ministry.[1]

Propst was a woman ahead of her time. Probably due to its "radical" nature, the article wasn't accepted for publication. The author never got another chance, as typhoid prematurely ended the forty-four-year-old's life less than a year later. Her appeal should have been made to one of the many woman-owned newspapers that were popping up here and there in the West.

By the last quarter of the nineteenth century, women were becoming more educated and able to handle not only the written, but the printed, word. Their acceptance as poets and novelists seemed to lead naturally to recognition as newspaper publishers, especially in the West, where periodicals were rarer and less competitive. Duniway's *New Northwest* was far from unique. Newspaper publication was one of the first traditionally male occupations to open for women, and it did so rather quickly.

Ada Merrit and her husband moved to Salmon City, Idaho in 1883 hoping for easy riches in the gold mines. When Mr. Merrit accidentally drowned, Ada needed a way to support herself and her children. For a while she worked as Salmon City's schoolteacher and, with a distinct purpose in mind, put away every penny she could. During her spare time, what there was of it, she surveyed the commercial community for a business a woman could run successfully.

In July 1888, Ada and a male partner, O. W. Mintzer, bought a newspaper, *The Idaho Recorder*. She quickly learned the essentials of operating the presses, and, three months later, determined to control her own life, she bought out Mintzer's share of ownership. In so doing, she became the first female newspaper publisher in Idaho. She enjoyed a profound satisfaction in her new-found freedom and, despite her sex, was able to increase the paper's circulation substantially. Ada Merrit ran *The Recorder* entirely on her own and profitably until 1906.

Caroline Churchill moved from Canada to California and then to Denver, Colorado, where she started the monthly newspaper *The Antelope*. It was said that many of her male subscribers bought the newspaper out of amazement that a woman could do such a thing. Their subscriptions made her paper successful, and she soon was publishing weekly under the editorial name "Queen Bee."

In later life, Churchill analyzed the marriage she briefly endured before the welcomed advent of widowhood, musing, "People did not know what else to do with girls, as there were few avenues of employ-

ment for them. A husband was selected, and, however inappropriate, the girl was expected to conform to the condition."[2]

Mary Price, her husband Charles, and their three small children arrived in Sterling, Colorado in a Conestoga wagon in 1865. Charles, a newspaperman, rented a building in town and began to publish *The Sterling Democrat*. When the faithless Charles left town with another woman on his arm, Mary responded quickly. She and her children took over the paper and were soon able to pay off Charles' debts. She then bought a home for herself and her children and socked what was left into real estate. After five years, Mary sold the newspaper and turned her attention to politics. She was elected county clerk, a position she held for several terms. Her daughter remembered her as a strong woman who "never spoke one word to the children against their father."[3]

Somehow, journalism, politics, and law seemed to be ingredients of the same stew. Women journalists often went into politics, and politicians often turned to law. The first transition was easy enough for the strong-minded woman, but the second was usually impossible. The reason was simple. Law had become more formal and structured since the seventeenth century, requiring a training period and the knowledge of specific language and procedures. Because most women didn't attend school beyond the basic years and females were thought incapable of holding a rational thought and arguing effectively, its ranks had become exclusively male. Even though women had practiced law informally for centuries, they became persona non grata almost overnight. Yet certain educated, confident, and determined frontier women weren't willing to settle for half a loaf. They were strong enough to rebel against such artificial standards and find ways to succeed.

A defiant example is Clara Shortridge Foltz, who lived in the San Jose, California area in the mid-1870s with her husband and five children. Shortridge was born on July 16, 1849 in the frontier town of Lafayette, Indiana to attorney Elias Shortridge and his wife Talitha. At sixteen, while teaching school in Keithsburg, Illinois, Clara eloped with Jeremiah Foltz.

The young couple and their rapidly growing family drove onto the dusty trail leading to Oregon in 1874 and settled in Portland. Clara, eager to contribute to the meager family income, quickly established herself as a dressmaker, but within a year, the Foltzes were on the road again–this time heading for California.

In San Jose, Foltz developed into a well-known community activist. Her cause was woman suffrage. She traveled about the region lecturing on behalf of that desired reform as well as equal rights for women. While her early efforts were instrumental in the establishment of a paid city fire department for San Jose, her passionate causes remained out of reach.

Foltz's push for reform affected her private life when she divorced her husband in 1876. Although official documents confirm the divorce, she always referred to herself as a widow, perhaps because of the shame assigned to the term *divorce*. In a letter to fellow suffragist Clara Bewick Colby, she wrote:

> You doubtless know something of the busy life I lead and have lead [sic] since I came before the public, a very young widow, upward of twenty-five years ago. What with five little fellows, - neither one of whom could earn the milk he drank, with not a dollar in the world, with no one to help me, - an only sister of a family of younger sons, I was, have been and am steadily employed.[4]

Foltz apparently enjoyed the drama elicited by the phrase she had compiled regarding her young children (despite the inference in the quotation above, several of her children were girls, including her eldest, Trella, and Virginia)[5] and their considerable youth at the time of her "widowhood." She often used it in her letters with a precision of expression that indicated rehearsal or at least memorization.

Motivated by a preoccupation with law that could be traced back to her father's knee, Clara resolved to do whatever it took to become a trained, practicing attorney. At the time, law students were trained by serving apprenticeships with established attorneys. Once their instruction was complete, they could open their own practice after passing the state bar exam.

Foltz's first hurdle was to find a firm that would take her in. Even attorney Francis Spencer, a long-time family friend, responded to Foltz's request with a humiliating letter stating: "My high regard for your parents, and for you...forbid encouraging you in so foolish a pursuit–wherein you would invite nothing but ridicule if not comtempt. A woman's place is at home, unless it is as a teacher. If you would like a position in our public schools I will be glad to recommend you, for I think you are well-qualified."[6] Spencer's patronizing remarks served to inspire Foltz as she "silently went about preparing to do battle against all comers who would deny to a woman any right or privilege that men enjoyed."[7]

Finally, Foltz found a small, obscure firm willing to apprentice a woman but was rejected by the bar because of her sex. Foltz steamed into action, rewrote the law that excluded her by dropping the phrase limiting admission to men, and persuaded a legislator to sponsor her bill in the California legislature. The bill was officially recorded as California Senate Bill 66, but it was to be forever known as the "Woman Lawyer's Bill."

Needless to say, the bill was greeted with fury. One legislator denounced it as a threat to the essential nature of women's domestic role in the home. It met instant defeat on the floor, but a sympathetic legislator spotted a procedural error and called for a second vote. This time, realizing where she had gone wrong, Foltz carried on an intense lobbying effort. She met with virtually every legislator she could find in the single evening she had before reconsideration. On the second ballot, the bill passed by two votes. As a result, Clara Foltz was admitted to the bar as California's first female attorney. She remembered her first legal battle bitterly:

> The bill met with a storm of opposition such as had never been witnessed upon the floor of the California Senate. Narrow-gauge statesmen grew as red as turkey gobblers mouthing their ignorance against the bill, and staid old grangers who had never seen the inside of a courthouse seemed to have been given the gift of tongues and they delivered themselves of maiden speeches pregnant with eloquent nonsense.[8]

But the campaign wasn't over. Learning that the governor had little interest in her cause, Foltz attempted to see him. "Finding that I could not convince the Sergeant-at-Arms that...I must and I would see the Governor...I stooped to conquer, and slid through the door and landed in the middle of the big room with hat awry and hair disheveled."[9]

Having convinced the governor of the rightness of her cause and having obtained his signature, Foltz wasted no time. She set up a practice specializing in divorce and probate cases and met with such immediate success that she was soon in demand as a criminal lawyer as well. Her colleagues weren't as charitable.

Foltz's first appearances in court were nerve-wracking experiences punctuated with angry glares from her male colleagues and quizzical or judgmental glances from the jury. She was up against not only the social prejudice of her time but the desire of most competitive attorneys to win at all cost. She remembered well the opening

argument of San Francisco's District Attorney Stonehill who addressed the all-male jury:

> She IS A WOMAN...[so] she cannot be expected to reason; God Almighty decreed her limitations, but you can reason, and you must use your reasoning faculties against this young woman who will lead you by her sympathetic presentation of this case...to violate your oaths and let a guilty man go free.[10]

Foltz proved herself, however, as indicated by her extensive, rational response to Col. Stonehill, which she summarized in her editorial and then commented on:

> Counsel thought I was too timid to resent this miserable inference against women in courts of justice. I am descended from the heroic stock of Daniel Boone, and never shrunk from contest nor knew a fear. I inherit no drop of craven blood....But the patience which at first may have been a virtue would become criminal by longer exercise. This controversy was not of my seeking–a long series of abuses have [sic] forced it upon me.[11]

The career she had long hoped for was underway, but she yearned for more formal training.

In January 1879, Foltz enrolled in the University of California's Hastings College of Law in San Francisco hoping to sharpen her legal abilities. Although she had paid her ten dollars "matriculation fee" and attended two days of classes, she was dismissed by Dean Hastings, who claimed that "the rustle of ladies' garments would distract the attention of the young gentlemen." Foltz brought suit against the University of California citing that "the law provided for no distinction of sex in that institution." In her own words, "I had determined to enter Hastings Law School peacably if I could, and forcibly if I must."[12] In bringing suit, Foltz teamed with fellow erstwhile Hastings law student Laura de Force Gordon, a journalist who had edited and published newspapers in Stockton and Oakland. Gordon became a life-long friend and fellow suffragist. Combining legal efforts in the state supreme court with those in district court, Foltz prevailed after arguing a brilliant case. The opposing lawyer probably lent unwilling aid to her case when he stooped so low as to cite stereotypical evidence against women during his arguments.

Despite her close, long-term friendship with Gordon and the nature of their mutual efforts, Foltz always referred to herself as "the first woman admitted to the Bar of California," making no mention of her friend and colleague. In a letter to Alice Park, a noted Palo Alto suffragist and good friend, she detailed her right to the honor:

> About one year [after Foltz was admitted to the Bar,] Mrs. Gordon was admitted to practice, but that was after my Hastings Law College fight wherein I had mandamused the University and the Hastings Law College Directors, because the Directors...entertained the opinion that Hastings College was not necessarily a branch of the University and therefore not bound by the general law of the State University. That question settled, women ever since have enjoyed all the privileges granted to men.[13]

Interestingly, in their reporting, area newspapers had difficulty focusing on the legal issues of the case. One example is the *Sacramento Chronicle*, which, under the headline "Two Lady Lawyers Who Demand Admission to the Hastings Law College–How They Dress," painfully detailed every aspect of the clothing the women wore and the styles of their hair.

Foltz resumed her education in 1879 and spent two years at Hastings but was forced by her very successful, time-consuming practice to resign before she was able to complete the degree. Undeterred, Foltz continued to push female influence in new directions.

Clara's work with indigent clients led her into politics and publishing in an effort to reform the California legal system. It also gave her a reputation as a compassionate attorney willing to represent clients who couldn't afford to pay her.

Lobbying successfully for legislation requiring a public defense program for those who couldn't pay for legal representation, Clara wrote a bill detailing the qualifications, salary, duties, and term of office of such an officer. She described the officer's duties as being responsible to "defend without expense to them, all persons who are not financially able to employ counsel and who are charged with the commission of any contempt, misdemeanor, felony or other offense." Indeed, her bill, adopted in 1921 "after much legislative wrangling," became known as the "Foltz Defender Bill" and served as a model for other states.[14]

In San Francisco, Foltz crusaded to have iron cages that confined prisoners during their trials removed from the courtroom. She argued

successfully that the cages violated the constitutional presumption that defendants are innocent until proven guilty. She secured better treatment for San Francisco's prison inmates and was able to compel the system to separate juvenile offenders from adult prisoners. At the state level, it was through Foltz's efforts that California adopted its first parole system in 1893.

By this time, Foltz's achievements had become all but legendary. Her professional reputation was enhanced to such a degree that she eventually was one of the first women appointed to practice law before the United States Supreme Court.

Feminism was always primary among Foltz's guiding forces. She had been a woman suffragist since her early twenties, speaking out for the cause whenever she had time and opportunity. She served as president of the Los Angeles Votes for Woman Club around 1909, and when California finally enfranchised women in 1911, Clara Foltz was one of the reasons. Her strong opinions and frankness, however, often intensified a conflict between East and West within the ranks of the suffragist movement. In her letters, Foltz repeatedly bemoaned the failure of the eastern wing of the suffrage movement to recognize the efforts of the noble campaigners in the West. In 1908, she wrote to her friend Clara Bewick Colby:

> I reiterate it and emphasize it, that the women at the head of the suffrage question are incompetent; that the suffrage cause cannot be won until leaders of ability are chosen – women and men who can and will discuss the question from the constitutional and political points of view.[15]

Foltz's complaints also addressed her distinct impression that the eastern branch of the movement was populated, with few exceptions, by "rich women pretenders...that have been butchering and mangling a great cause."[16] But, she continues, "you cannot do those 'workers' in the East any good of any kind....They stopped thinking, most of them, fifty years ago."[17]

Foltz's letters often defended the efforts and intelligence of suffragist colleague Abigail Scott Duniway. In 1904, she wrote:

> True, in Portland [Oregon] you will find Abagail [sic] Scott Dunaway [sic] who has been and is the bravest of the brave, the truest of the true to the cause of women. Her work precedes us

all, and the women of the Pacific Coast should realize that they owe her a lasting debt of gratitude.[18]

From 1916 to 1918, as Foltz crusaded for an amendment to the Constitution that would grant women the right to vote in national elections, she found time to publish and edit a monthly magazine in Los Angeles entitled the *New American Woman*. Its objective was to encourage women to pursue the quest for women's rights. In the February 1916 issue, under the headline "What We Stand For," she wrote, "Women must have a voice in the nation's affairs; they must acknowledge no political or other limitation; they must prepare to think intelligently upon great matters of state, and cease to regard themselves as a second-rate power."[19]

For each issue of her journal beginning in April 1916, Foltz wrote an autobiographical sketch entitled "Struggles and Triumphs of a Woman Lawyer." By writing the series, which highlighted her professional experiences, she hoped to serve as an example to other women. In fact, her efforts on behalf of her gender were considerable.

Eager to share her success and hand off the torch, Foltz encouraged women to enter into the legal profession. She trained numerous women law students in her offices and established women lawyers' clubs in both San Francisco and Los Angeles. Then in 1930, at the age of eighty-one, Clara Foltz ran for governor of California. In doing so, she was realistic enough to know she had little chance of winning, but she could serve, one last time, as an example to her sex:

> This being a candidate for Governor is no small job! What with the interviews and posing for photos...I have been busy. Of course, I have no illusions as to the outcome of this last courageous effort of mine–I simply must go right on demonstrating our great cause. "For woman's cause is man's; they rise and fall together."[20]

With the passage of the Nineteenth Amendment to the U.S. Constitution in 1920, women seeking additional reforms for their sex contacted Foltz hoping for support from one of her renown and stamina. Alice Park, in a woman-led effort to revoke the "Comstock Laws" outlawing the dissemination of birth control information through the mails, pleaded with Foltz: "Ignorance of birth control is not a protection....Full open knowledge is the best protection there is."[21] There is no record of Foltz's reply, but within months, Park contacted Foltz concerning the

Equal Rights Amendment to the U.S. Constitution. Foltz, convinced that suffrage alone would in time correct other social ills affecting women, declined to support such an amendment because

> the law cannot [provide equal rights for women]. It is up to you and me and every other woman striving for the betterment of humanity to become so efficient that her advice will be desired and her labor will be sought.[22]

Refusing to rest until advanced age gave her no choice, Clara Shortridge Foltz died on September 2, 1943 at the age of eighty-five. Years earlier, synopsizing her decades of conflict with male associates, Foltz, always willing to express a strong opinion, wrote, "Men are the sentimentalists....They become so tearfully emotional that it all spills out over 'home and mother' every time you offer a suffragist argument."[23]

* * *

The courage to make a difference had become a motivating force for many women by the turn of the twentieth century. Frontier women, particularly second-generation frontier women, were the vanguard of that reformation. They had worked with their hands and their bodies; now they were prepared to work with their minds. Once self-confidence had been achieved and intelligence recognized as womanly, even if only by themselves, there was no stopping them. The barriers to equality were under siege.

20

THAT'S THE WAY IT WAS

By the early twentieth century, the vast region that had been the American frontier was rapidly becoming an agricultural and industrial giant in its own right. As the day-to-day hardships of frontier existence found relief in the arrival of machinery, towns, cities, and the Sears mail-order catalog, other transformations also became apparent. Thanks in large part to women's pioneering experience in the western wilderness, woman's role in American society was undergoing an evolutionary, and some would say revolutionary, change.

The advance of the frontier and the opportunity it offered those strong enough to stand up to it presented Americans with options never before available and never to be experienced again. Anyone who could afford the relatively small initial investment, survive the transcontinental trek, and wrest a homestead out of the wilderness could build a future.

Historian Frederick Jackson Turner first theorized on the uniqueness of the American frontier experience in his celebrated epic, *The Frontier in American History*. His innovative thesis declared that the existence of expansive areas of available land and the westward march of American settlement were the forces that spawned the unique character of the American people.

In arguing this proposition, Turner stated:

> The peculiarity of American institutions is the fact that they have been compelled to adapt themselves to the changes of an expanding people—to the changes involved in crossing a continent, in winning a wilderness, and in developing at each area of this progress out of the primitive economic and political conditions of the frontier into the complexity of city life.[1]

Considering, as historians of his day commonly did, the history of humankind as the progress of white men only, Turner failed to see the influence frontier life had on the even more acutely delineated role of American women. Nor did he appraise the characters of western minority groups. Modern historians, attempting to impose on him the gift of prophesy, have taken Turner to task for his omissions. Yet, history in the late nineteenth century was exactly what the word implied, "his story." The presumed inferiority of non-Caucasians and women was so much a natural component of American thought that individuals within these groups were not regarded as contributing facets of the society. It would have required a scholar more remarkable than Turner to include these "lesser beings" among his objects of research. Turner's natural oversight should not despoil the acumen of his conclusions. In fact, Turner's thesis does apply across a broader spectrum, as this work has attempted to demonstrate.

Although Turner may not have considered the impact of the frontier experience on women or minorities, his theory fits them just fine. The consequences on the development of American society of repeatedly returning to primitive conditions where land was so readily available is as significant for women as for men. The fact that these conditions altered the traditional institutions of American society allowed women to take strides that would have been inconceivable in the more moribund East. The forces of the frontier are unavoidably democratic. The type of self-determinism that evolved from this reality is the stuff that Americans are made of. That includes not just white men but all Americans. Turner said it best:

> The frontier is productive of individualism. Complex society is precipitated by the wilderness into a kind of primitive organization based on the family. The tendency is anti-social. It produces antipathy to control, and particularly to any direct control..Frontier individualism had from the beginning promoted democracy.[2]

How could this sort of democracy have failed to inspire those within the society whose activities had been so severely restricted by the artificial barriers of a more sophisticated culture?

The austerity and demands of frontier living eventually precluded the existence of the artificial ideas of sexual identity that had grown out of industrialization. Pioneers, pressured by the need to survive, simply did what needed to be done in any and every situation. As frontier editor Bill

Nye indicated in his brief Wyoming newspaper article, "There are few households here as yet that are able to keep their own private poet."[3]

Pioneer women simply found it impossible to satisfy the genteel requirements of the sexual role they had carried with them from the East. Life on the frontier forcibly wrested them from its influence and began the task of molding a new sort of woman from the frail, pious, and refined creature she had been told she was.

Nevertheless, the first generation of frontier women tried with all its might to follow its eastern-bred ideas of femininity. Struggling to reincarnate the refinements left behind at the other end of the trail, many of them came to despise the wide open spaces that beckoned them to step out of their traditional role. Too many of these adult women who had survived the long trek from civilization to wilderness were destined to become martyrs to the Cult of True Womanhood. They had learned to play their eastern role and refused to learn another. Making the adjustments necessary to live on the untamed frontier was difficult. The older the woman, the more difficult the adjustment. Some refused to change their ways and lived the rest of their lives in misery. Some made the adjustment out of a need to survive but forever regretted it. Some simply pretended to be what they weren't until they died. Some, as Dr. Barns reported, simply packed up and turned their wagons into the morning sun.

Younger women who traveled west found change to be easier, but they were not always convinced of its worth. While they often learned to ride, shoot, and wear trousers, most of them felt guilty about it. Some traveled alone and found relatively acceptable ways to earn their keep until they located men to support them. A few even wore trousers to escape the liabilities and restrictions inherent in being an unaccompanied female. Even so, most of them firmly believed that gentility and the rest was the natural order of things. Given a chance, they might have sat delicately on their velvet cushions with their eastern sisters but were realistic enough to know that frontier hardships made that impossible. Some of them were saints, some prostitutes, and some suffragists. Others were women who sought adventure outside of any type of womanly role.

Among this last group were females who lived out their lives disguised as males. There is no single category for these women. They were pragmatists who did what they had to or wanted to do. Quite a few of them learned to like it enough to maintain the masquerade as long as they could draw a breath.

Real, revolutionary change had to wait for the second generation. These women were reared in relative sexual equality and knew little of

the proclamations of the Cult of True Womanhood. They rarely saw reason to behave like ladies or to disguise themselves as men. They had grown up with a more natural style–a do-it-if-you-can style that allowed them a freedom of expression that would have been shunned by the more structured society of the East. They had been reared as capable, self-sufficient individuals and had learned to thrill to the challenges of the frontier. Their radically independent lifestyle helped them to develop self-confidence.

This generation had known since childhood that trousers worked better than long skirts among the brambles and tumbleweeds and that riding astride "clothespin style" was the only safe way to round up cattle. They had taken advantage of western schools that were more willing to educate girls than were those in the East and were equals to their brothers intellectually. They drove stagecoaches, laid railroad track, studied law, or even joined the lawless adventurers of their day. Whatever they accomplished, they rarely thought that they might have been better off sitting in overstuffed chairs reading poetry and crocheting doilies. In fact, had they been forced to return to that pedestal of social restraint, they surely would have been miserable. These were women who had developed dynamic lifestyles that removed them from the inequities of womanhood's pedestal and allowed them to contribute to society and the economy according to the dictates of their minds as well as their bodies.

Life on the frontier produced a practical, aggressive, self-assured American woman unable to live within the limitations of an outdated culture based on obsolete economic realities. Eventually, these women were equally unwilling to do so. Frederick Jackson Turner's statement concerning the frontier's influence applied to these women as well as it applied to anyone:

> From the conditions of frontier life came intellectual traits of profound importance....The result is that to the frontier the American intellect owes its striking characteristics. That coarseness and strength combined with acuteness and inquisitiveness; that practical, inventive turn of mind, quick to find expedients; that masterful grasp of material things, lacking in the artistic but powerful to effect great ends; that restless, nervous energy; that dominant individualism, working for good and for evil, and withal that buoyancy and exuberance which comes with freedom.[4]

NOTES

Introduction

1. Catherine M. Scholten, "'On the Importance of the Obstetrick Art': Changing Customs of Childbirth in America, 1760-1825," *William and Mary Quarterly* 34 (1977), pp. 426-45. *The Statistical History of the United States from Colonial Times to the Present* (Stamford, CT: Fairfield Publishers, 1965), pp. 19, 20, 21, 24, 25, 26, 28-30.
2. Rosalind Rosenberg, *Divided Lives: American Women in the Twentieth Century* (New York: Hill and Wang, 1992), p. 5. Reay Tannahill, *Sex in History* (Chelsea, MI: Scarborough House/Publishers, 1992), p. 413.
3. Ibid., pp. 5, 17, 245.

Chapter 1

1. Mary R. Beard, *America Through Women's Eyes* (New York: The MacMillan Company, 1933), pp. 78-79
2. Nancy F. Cott (ed.), *Root of Bitterness: Documents of the Social History of American Women* (New York: E. P. Dutton and Co., 1972), p. 141.
3. Julie Roy Jeffrey, *Frontier Women: The Trans-Mississippi West 1840-1890* (New York: Hill and Wang, 1979), p. 6.
4. "A Real Lady," *Godey's Magazine and Lady's Book* 21 (July 1851), p. 80.

Chapter 2

1. Lydia Waters, "Account of a Trip Across the Plains in 1855," *Quarterly of the Society of California Pioneers* 6 (March 1929), pp. 59-79, cited by Sandra L. Myres (ed.), *Ho for California: Women's Overland Diaries from the Huntington Library* (San Marino, CA: Huntington Library, 1980), p. 67.
2. Martha Mitten Allen, "Women in the West: A Study of Book Length Travel Accounts by Women who Traveled in the Plains and Rockies with Special Attention to General Concepts That the Women Applied to the Plains, the Mountains, Westerners and the West in General" (Ph.D. dissertation, University of Texas at Austin, 1972), p. 96.
3. Ibid., p. 116.
4. Another incident cited in this source was that of a woman from New York who settled in the Plains about 1860 and "was found crying—crying because there was

nothing beautiful at which to look; everything was hopelessly ugly." Ellen Austin, "Soddy Homemaker," *American History Illustrated* (May 1982), p. 38.

5. Cass G. Barnes, *The Sod House* (Lincoln: University of Nebraska Press, 1930), p. 40.

6. T. A. Larson, *History of Wyoming* (Lincoln: University of Nebraska Press, 1965), p. 196.

7. Ibid.

8. Margaret Fuller-Ossoli, *Woman in the Nineteenth Century and Kindred Papers Related to the Sphere, Condition, and Duties of Women*, ed. Arthur B. Fuller (Boston: John P. Jewett and Company, 1855), p. 15.

9. Lura Smith, "Lura Smith Papers" (San Marino, CA: Huntington Library), cited by S. J. Senkewicz, *Vigilantes in Gold Rush San Francisco* (Stanford University Press, 1985), p. 129.

10. Warren P. Trimm, "Two Years in Kansas," *American Heritage* 2 (Feb/Mar 1983), p. 73.

11. Ruth Barnes Moynihan, *Rebel for Rights: Abigail Scott Duniway* (Hartford: Yale University Press, 1983), p. 108. Rosalind Rosenberg, *Divided Lives: American Women in the Twentieth Century* (New York: Hill and Wang, 1992), p. 5. Reay Tannahill, *Sex in History* (Chelsea, MI: Scarborough House/Publishers, 1992), p. 413. Moynihan states the higher average of eight childbirths per woman in her work. Rosenberg cites seven as the average. Perhaps the most carefully gathered statistic is that cited in Tannahill's work. She declares that in 1800, American women averaged 7.04 children in their lifetimes, but by 1880, the figure had dropped to 4.24 thanks to improved contraception and a cultural acceptance of marital abstention in Victoriana— an age that condoned male infidelity.

Chapter 3

1. Joan Swallow Reiter, *The Old West: The Women* (Alexandria, VA: Time-Life Books, 1974), p. 130.

2. Dee Brown, *The Gentle Tamers: Women of the Old Wild West* (New York: G. P. Putnam's Sons, 1958), p. 254

3. Anne M. Butler, *Daughters of Joy, Sisters of Mercy: Prostitutes in the American West 1865-90* (Urbana: The University of Illinois Press, 1985), p. 1.

4. Reiter, *The Women*, p. 135.

5. Laura Ingalls Wilder, "Frontier Times Remembered," *American History Illustrated* 19 (September 1984), p. 11.

6. Carrie Adell Strahorn, *Fifteen Thousand Miles By Stage: A Woman's Unique Experience During Thirty Years of Path Finding and Pioneering from the Missouri to the Pacific and From Alaska to Mexico*, vol. 1, 1877-1880 (Lincoln: The University of Nebraska Press, 1988), p. 146.

7. Ibid., vol. 2, p. 89.

8. Ibid., p. 103.

9. Ibid., p. 179.

Chapter 4

1. R. G. Thwaites, ed., *Early Western Travels*, 32 vols. (Cleveland: 1904-1907), 10, pp. 128-133, cited by William Forrest Sprague, *Women and the West: A Short Social History* (Boston: The Christopher Publishing House, 1940), p. 68.

Chapter 7

1. Warren J. Brier, "Tilting Skirts and Hurdy-Gurdies: A Commentary on Gold Camp Women," *Montana, The Magazine of Western History* 19, no. 4 (Autumn 1969), pp. 58-67.
2. Robert Schick, "Prostitution," *The Reader's Encyclopedia of the American West*, Howard R. Lamar, ed. (New York: Thomas Y Crowell, 1977), p. 973.
3. Jeffrey, *Frontier Women*, p. 121.
4. U.S. Bureau of the Census, From the Tenth Census (1880), Colorado, Rolls 87 and 88, Districts 5, 6, 9, 10, RG 29, NA. National Archives, Washington, D. C. Cited by Butler, *Daughters of Joy*, p. 27.
5. The most historically accurate source available on the subject of frontier prostitutes. Butler, *Daughters of Joy*, p. 34.
6. A relatively recent, well-documented historical work. Nancy Wilson Ross, *Westward the Women* (New York: Alfred A. Knopf, 1944), p. 125.
7. Betty Penson-Ward, *Idaho Women in History* (Boise, ID: Legendary Publishing Company, 1991), p. 104.
8. Ibid.
9. Larson, *History of Wyoming*, p. 269.

Chapter 8

1. Laurence P. James and Sandra C. Taylor, "Strong Minded Women: Desdemona Stott Beeson and Other Hard Rock Mining Entrepreneurs," *Utah Historical Quarterly*, vol. 46, no. 2 (Spring 1978), p. 149.
2. Ibid, p. 139
3. Sprague, *Women and the West*, pp. 115-16.
4. Sandra L. Myres, *Westering Women and the Frontier Experience, 1800-1915* (Albuquerque: University of New Mexico Press, 1982), p. 264.
5. Joyce Litz, "Lillian's Montana Scene," *Montana, the Magazine of Western History*, vol. 24, no. 3. (Summer 1974), p. 61.
6. Christiane Fischer, *Let Them Speak for Themselves: Women in the American West, 1849-1900* (Hamden, CT: Shoe String Press, 1977), p. 158.
7. Wallace, *The Miners*, p. 22.

Chapter 9

1. Adjutant General's Office, Circular No. 6, *General Orders, Circulars, and General Court-Martial Orders,* 1883 (Washington: Government Printing Office, 1884). Ibid., Circular No. 8, 1887 (Washington: GPO, 1888). Cited by Patricia Y. Stallard, *Glittering Misery: Dependents of the Indian Fighting Army* (San Rafael, CA: Presidio Press, 1978), p. 55.
2. Oliver Knight, *Life and Manners in the Frontier Army* (Norman: University of Oklahoma Press, 1978), p. 68.
3. Mrs. Oremus B. Boyd, *Cavalry Life in Tent and Field* (New York: J. Selwin Tait and Sons, 1894), pp. 276-79. Cited by Stallard, *Glittering Misery*, p. 23.
4. Sandra L. Myres, "Romance and Reality on the American Frontier: Views of Army Wives," *The Western Historical Quarterly* 13, no. 4 (October 1982), p. 421.
5. Ibid., pp. 416-17.
6. Ibid., p. 417.

2. William Forrest Sprague, *Women and the West: A Short Social History* (Boston: The Christopher Publishing House, 1940), p. 67.

3. JoAnna L. Stratton, *Pioneer Women: Voices from the Kansas Frontier* (New York: Simon and Schuster, 1981), p. 160.

4. Nell Brown Propst, *Those Strenuous Dames of the Colorado Prairie* (Boulder, CO: Pruett Publishing Company, 1982), p. 26.

5. Ibid., p. 41.

6. Ibid., p. 18.

7. Ibid., p. 160.

8. Cott, *Root of Bitterness*, p. 236.

Chapter 5

1. Joan M. Jensen and Darlis A. Miller, "The Gentle Tamers Revisited: New Approaches to the History of Women in the American West," *The Pacific Historical Review* 49 (May 1980), p. 189.

2. Eleanor Flexner, *Century of Struggle: The Woman's Rights Movement in the United States* (Cambridge: Harvard University Press, 1959), p. 159.

3. T. A. Larson, "Dolls, Vassals, and Drudges—Pioneer Women in the West," *The Western Historical Quarterly,* 3 January 1972, p. 7.

4. Lynne Cheney, "It All Began in Wyoming," *American Heritage* 24, 3 (April 1973), pp. 62-66, 97.

5. Bill Nye, *Bill Nye's Western Humor* (Lincoln, NE, 1968), cited by T. A. Larson, "Women's Role in the American West," *Montana, The Magazine of Western History* 24 (Summer 1974), pp. 76-77.

6. T. A. Larson, "Women's Role in the American West," *Montana, the Magazine of Western History,* 24, No. 3 (Summer 1974), p. 11.

7. Sprague, *Women and the West*, p. 98.

8. Robert Wallace, *The Old West: The Miners* (Alexandria, VA: Time-Life Books, 1975), p. 175.

9. T. A. Larson, *History of Wyoming* (Lincoln: University of Nebraska Press, 1965), p. 78.

Chapter 6

1. Obviously an attempt to justify her actions, this work is unique in that most trans-vestites hid their identity until death. The book reveals not only the difficulties suffered by widows of the day but an appreciation expressed for the alternative lifestyle she chose. Mrs. E. J. Guerin, *Mountain Charley: Or the Adventures of Mrs. E. J. Guerin, Mountain Charley: Or the Adventures of Mrs. E. J. Guerin, Who was Thirteen Years in Male Attire: An Autobiography Comprising a Period of Thirteen Years Life in the States, California, and Pike's Peak* (Dubuque, IA, 1861; reprint ed., Norman: University of Oklahoma Press, 1968), p. 37.

2. Ibid., p. 46

3. Roger Rickert, "Little Jo," *Frontier Times*, vol. 46487 (July 1971), pp. 39, 52-53.

4. "Jo Monaghan," *The New York Post*, 21 December 1952, p. 10M.

5. "Joe Monaghan Was a Woman," *Idaho Daily Statesman*, 12 January 1904, p. 1. "Joe Monaghan's Life," *Idaho Daily Statesman*, 13 January 1904, p. 5.

7. Ibid., p. 419.
8. Elizabeth B. Custer, *Tenting on the Plains or General Custer in Kansas and Texas* (First published in 1887. This revised edition published in 1895. Reprint by Williamstown, MA: Corner House Publishers, 1973), p. 126.
9. Ibid., p. 191.
10. Ibid., p. 256.
11. Ibid., p. 173.
12. Ibid., pp. 174-75.
13. Ibid., p. 121.
14. Ibid., p. 120.
15. Katherine Gibson, *With Custer's Cavalry. From the Memoirs of the Late Katherine Gibson, Widow of Captain Francis M. Gibson of the Seventh Cavalry, U.S.A. (Retired)* (Caldwell, Caxton Publishers, 1942), pp. 44-61. Cited by Oliver Knight, *Life and Manners in the Frontier Army* (Norman: University of Oklahoma Press, 1978), p. 63.

Chapter 10

1. June Sochen, *Herstory: A Woman's View of American History* (New York: Alfred Publishing Co., 1974), p. 114
2. Glenda Riley, "Not Gainfully Employed: Women on the Iowa Frontier, 1833-1870," *The Pacific Historical Review* 49 (May 1980), p. 261.
3. Frances Trollope, *Domestic Manners of the Americans* (London, 1832), cited by Sprague, *Women of the West*, p. 77.
4. "The Diary of Molly Dorsey Williams," p. 71, cited by John Mack Faragher, *Women and Men on the Overland Trail* (New Haven: Yale University Press, 1979), p. 53.
5. Fischer, *Let Them Speak for Themselves*, pp. 290-91.
6. Elizabeth McCracken, *The Women of America* (New York: MacMillan Company, 1904), pp. 16-17.
7. Vernon Gladden Spence, *Pioneer Women of Abilene* (Burnet, TX: Eakin Press, 1981), p. 5.
8. Ibid., p. 11.

Chapter 11

1. Jane's sense of sensationalism is obvious in her autobiography (*Calamity Jane, Life and Adventures of Calamity Jane*, Joint Collection, University of Missouri, Western Historical Manuscript Collection—Columbia State Historical Society of Missouri, 1896).
2. This is a questionable source, but some information is well documented. Ellen Crago Mueller, *Calamity Jane* (Laramie, WY: Jelm Mountain Press, 1981), p. 5.
3. Ibid., p. 7.
4. Jane worked just long enough to buy the next round of drinks. Duncan Aikman, *Calamity Jane and the Lady Wildcats* (New York: Blue Ribbon Books, 1927), p. 53.
5. Ibid., p. 85.
6. Ibid., p. 94.
7. Larson, *History of Wyoming*, pp. 203-204.
8. There exist a diary and a collection of letters said to have been written by Jane to a daughter adopted by James O'Neil, and English sea captain. They seem too literate to have been written by a person of Jane's breeding and contain numerous factual

errors. They may have been created to support a claim of one who called herself Jean Hickok, appeared in 1912, and said she was Jane's daughter by Bill Hickok. Her written evidence was examined by the U.S. Department of Public Welfare, which then granted Jean Hickok McCormick old age relief. ("Copies of Calamity Jane's Diary and Letters," Joint Collection, University of Missouri Western Historical Manuscript Collection-Columbia State Historical Society of Missouri Manuscripts.)

9. Mueller, *Calamity Jane*, p. 18.
10. Ibid., p. 19.
11. James D. Horan and Paul Sann, *Pictorial History of the Wild West: A True Account of the Bad Men, Desperadoes, Rustlers and Outlaws of the Old West - And the Men Who Fought Them To Establish Law and Order* (New York: Crown Publishers, 1954), p. 127.
12. L. R. Chrisman letter to Earl Jones, March 10, 1960, pp. 1-2. Joint Collection, University of Missouri, Western Historical Manuscript Collection. Columbia State Historical Society of Missouri Manuscripts, Columbia, Missouri.
13. Chrisman's letter mentioned a ragged, dirty, eight-to-ten-year-old girl with Jane in 1902 or 1903. When women reformists threatened to take her away, Jane took her to the Sisters of Charity. It is possible that the child was Jane's, but her age at the birth would have been about forty-five. (Ibid)

Chapter 12

1. A serious study of western outlaws is fraught with pitfalls. There are as many versions of their lives as there are biographical attempts. Many are more fiction than fact. McLoughlin's facts compare well with other sources, but his work is poorly documented. Denis McLoughlin, *Wild and Wooley: An Encyclopedia of the Old West* (New York: Doubleday and Company, 1975), p. 488.
2. Cole Younger, *The Story of Cole Younger,* 1903, cited by Ramon F. Adams, *Burs under the Saddle: A Second Look at Books and Histories of the West* (Norman: University of Oklahoma Press, 1964), p. 580.
3. Aikman, *Wildcats,* pp. 200-201.
4. Horan and Sann, *Pictorial History*, p. 200.
5. Ibid., p. 227.

Chapter 13

1. Wilcomb E. Washburn, *The Indian in America* (New York: Harper & Row, 1975), p. 11.
2. Harold P. Howard, *Sacajawea* (Norman: The University of Oklahoma Press, 1971), p. 190.
3. Penson-Ward, *Idaho Women,* p. 3.
4. Ibid.
5. Ibid., p. 5.
6. Ibid., p. 10.
7. Elinor Richey, *Eminent Women of the West* (Berkeley, CA: Howell-North Books, 1975), p. 137. This revelation was told by Sarah to a newspaper reporter, who inquired as to the reason for her divorce. Sarah went on to say that she was especially bitter over the fact that Bartlett had sold all her jewelry.
8. Sarah Winnemucca Hopkins, *Life among the Piutes: Their Wrongs and Their Claims,* ed. Mrs. Horace Mann (New York: G. P. Putnam's Sons, 1883), p. 214.

9. Richey, *Eminent Women*, p. 145.
10. Ibid., p. 146.
11. Winnemucca Hopkins, *Life among the Piutes*, p. 267.
12. Ibid., p. 89.
13. Ibid., p. 5.
14. Richey, *Eminent Women*, pp. 150-51.
15. Dorothy Clarke Wilson, *Bright Eyes: The Story of Suzette LaFlesche, an Omaha Indian* (New York: McGraw-Hill Book Co., 1974), p. 157.
16. Ibid., p. 117.
17. Helen Hunt Jackson, *A Century of Dishonor* (New York: Harper and Brothers, 1881. Re-print, Harper Torchbooks, 1965), p. 187.
18. Wilson, *Bright Eyes*, p. 248.
19. Francis Paul Prucha, *Americanizing the American Indians: Writings by the "Friends of the Indian" 1880-1900* (Cambridge: Harvard University Press, 1973), p. 29.
20. Ibid., pp. 123-28.
21. Wilson, *Bright Eyes*, p. 368.
22. Roxanne Dunbar Oritz, *Indians of the Americas: Human Rights and Self-Determination* (New York: Praeger Publishers, 1984), p. 127.

Chapter 14

1. Gerda Lerner, *The Majority Finds Its Past: Placing Women in History* (New York: Oxford University Press, 1979), p. 70.
2. The information in this book is a collection of facts derived from various sources among the governmental records of the State of California. Delilah Beasley, *The Negro Trail Blazers of California* (Los Angeles, 1919. Reprint, San Francisco: R and E Research Associates, 1968), p. 56.
3. Ibid., p. 56.
4. Ibid., p. 65.
5. Ibid., p. 69.
6. Butler, *Daughters of Joy*, pp. 39-40.
7. Ronald Dean Miller, *Shady Ladies of the West* (Los Angeles: Westernlore Press, 1964), p. 63.
8. Sources disagree on the number of individuals in Brown's party. At the time of the "colonization," newspapers reported numbers centering around 20. Brown's obituary raised the number to 34. A poorly documented and highly fictionalized biography of Brown published in 1970 held the number to 16.
9. W. Sherman Savage, *Blacks in the West* (Westport, CT: Greenwood Press, 1976), p. 84.
10. Gary Cooper, "Stage Coach Mary, Gun-toting Montanan Delivered U.S. Mail," *Ebony* (October 1959), p. 97.
11. Ibid., p. 99.
12. Beasley, *The Negro Trail Blazers*, p. 90.
13. Ibid., p. 109.
14. Savage, *Blacks in West*, p. 123.
15. Beasley, *The Negro Trail Blazers*, p. 96.

16. *Alta*, 23 July, 30 December 1853; Helen Holdredge, "Mammy Pleasant" (New York, 1953), p. 44. As related by Rudolph M. Lapp, *Blacks in Gold Rush California* (New Haven: Yale University Press, 1977), p. 102.
17. Ibid., p. 134.
18. Ibid., p. 169.
19. *Bulletin,* 24 February 1858 as cited by Lapp, *Blacks in Gold Rush*, 1977, p. 171.

Chapter 15
1. *Historic Sketches of the Cattle Trade of the West and Southwest,* as cited by Walter Prescott Webb, *The Great Plains* (Lincoln: University of Nebraska Press, 1981), pp. 220-21.
2. Ibid., p. 223.
3. Myres, *Westering Women*, p. 262.
4. *Cheyenne Democratic Leader*, 23 April 1885, cited by Brown, *Gentle Tamers*, p. 255.
5. Eulalia Bourne, *Woman in Levis* (Tucson: University of Arizona Press, 1967), pp. 16-17.
6. Myres, *Westering Women*, p. 261.
7. Teresa Jordan, *Cowgirls: Women of the American West* (New York: Anchor Press, Doubleday and Co., 1980), p. xxvii.
8. Penson-Ward, *Idaho Women*, p. 76.
9. Ibid., p. 52.
10. Ibid., p. 51.
11. Harvey St. John, "The Golden Queen," *True West* (July-August 1964). Cited by Penson-Ward, *Idaho Women*, p. 51.
12. Ibid.
13. Ibid., pp. xxvii-xxix.
14. Ibid., pp. 188-89.
15. Propst, *Those Strenuous Dames*, p. 213.
16. Ibid., pp. 214-15.
17. Ibid., p. 215.
18. This is a colorful but undocumented work. Richard Erdoes, *Saloons of the Old West* (New York: Alfred A. Knopf, 1979), p. 204.

Chapter 16
1. Penson-Ward, *Idaho Women*, p. 178.
2. Ibid., p. 181.
3. Mary Earhart, *Frances Willard: From Prayers to Politics* (Chicago: University of Chicago Press, 1949), p. 30.
4. Flexner, *Century of Struggle*, p. 183.
5. Earhart, *Frances Willard*, p. 125.
6. Flexner, *Century of Struggle*, p. 184.
7. Penson-Ward, *Idaho Women*, p. 174.
8. Ibid.
9. Earhart, *Frances Willard*, p. 239.
10. The "Chicago Inter-Ocean," 20 October 1895 as cited in Earhart, *Frances Willard*, p. 335.
11. Brown, *Gentle Tamers*, p. 274.
12. Ibid., p. 275.

Chapter 17

1. Lynne Cheney, "It All Began in Wyoming," *American Heritage* 24 (April 1973), p. 62.
2. Ibid., p. 64.
3. Ibid., pp. 66-67.
4. Ibid., p. 97.
5. Stratton, *Pioneer Women*, p. 265.
6. Penson-Ward, *Idaho Women*, p. 177.
7. McCracken, *Women in America*, p. 94.
8. Ibid., pp. 111-12.
9. Olive M. Reamy, "The Suffragist's Mothers Helper," *The Reply: An Anti-Suffrage Magazine*, vol. 1, no. 1 (May 1913), pp. 7-8.
10. "Bills To Be Presented before the First Woman's Legislature," *The Reply*, vol. 1, no. 6 (October 1913), p. 124.
11. Mrs. William Forse Scott, "Woman and Government: The Demand for Right As Opposed to the Recognition of Duty in Relation to Government," *The Woman's Protest*, vol. 1, no. 1 (May 1912), pp. 5-6.
12. Probably the most complete and thoroughly researched biography of Duniway. Moynihan, *Rebel for Rights*, p. 2.
13. Abigail Scott Duniway, *Path Breaking: An Autobiographical History of the Equal Suffrage Movement in Pacific Coast States* (James, Kerns and Abbot. Reprint, New York: Schocken Books, 1914), p. 9.
14. Ibid., p. 12.
15. Ibid., p. 16.
16. Ibid., p. 17.
17. Ibid., p. 31.
18. Moynihan, *Rebel for Rights*, p. 9.
19. Flexner, *Century of Struggle*, p. 159.
20. "Combative Oregonian Editor Harvey Scott Known as Man To Meet Problems Headon," *The Oregonian* (4 December 1960), p. 44.
21. Ibid.
22. Ibid.
23. "H. W. Scott," *The Oregonian* (20 August 1906), p. 2.
24. "The Debate on Woman Suffrage," *The Oregonian* (3 June 1906).
25. Ibid.
26. "A Severe Lesson," *The West Shore*, vol. 5, no. 7 (July 1879), p. 219.
27. Moynihan, *Rebel for Rights*, p. 174.
28. Duniway, *Path Breaking*, p. 194.
29. Ibid., pp. 42-43.
30. Penson-Ward, *Idaho Women*, p. 175.

Chapter 18

1. Barns, *The Sod House*, pp. 245-47.
2. Stratton, *Pioneer Women*, p. 75.
3. Bethenia Angelina Owens-Adair, *Dr. Owens-Adair: Some of Her Life and Experiences* (Portland: Mann and Beach, Printers), p. 8.
4. Ibid., p. 52.
5. Reiter, *The Women*, p. 150.

6. Owens-Adair, *Dr. Owens-Adair*, p. 80.
7. Bethenia Owens-Adair, from her autobiography, cited by Cathy Luchetti and Carol Olwell, *Women of the West* (St. George, UT: Antelope Island Press, 1982), p. 181.
8. Owens-Adair, *Dr. Owens-Adair*, p. 97.
9. Ibid., p. 184.
10. Ibid., no page number.

Chapter 19

1. Propst, *Those Strenuous Dames,* pp. 68-69.
2. Fischer, *Let Them Speak for Themselves*, p. 166.
3. Propst, *Those Strenuous Dames*, p. 173.
4. Clara Shortridge Foltz, letter to Clara Bewick Colby, June 6, 1904, p. 1. The Huntington Library, San Marino, California.
5. Clara Shortridge Foltz, "Struggles and Triumphs of a Woman Lawyer," *The New American Woman* (April 1916 - July 1918). Foltz edited and published this monthly periodical beginning in February 1916 from her law office at 723-724 Merchants Trust Building at Second and Broadway in Los Angeles. Her editorial series ("Struggles and Triumphs ...") began in the April 1916 issue and tended to be autobiographical.
6. Foltz, "Struggles" (June 1916), p. 5.
7. Ibid.
8. Foltz, "Struggles," (August 1916), p. 11.
9. Mortimer D. Schwartz, Susan L. Brandt, and Patience Milrod, "Clara Shortridge Foltz: Pioneer in the Law," *The Hastings Law Journal*, vol. 27 (January 1976), p. 549.
10. Foltz, "Struggles" (January 1918), p. 10.
11. Ibid., p. 16.
12. Foltz, "Struggles" (November 1916), p. 9.
13. Clara Shortridge Foltz, letter to Alice Park, December 18, 1923, p. 1.
14. Schwartz, "Foltz," p. 557.
15. Clara Shortridge Foltz, letter to Clara Bewick Colby, June 26, 1908, p. 4. The Huntington Library, San Marino, California.
16. Ibid., p. 3.
17. Ibid., p. 6.
18. Clara Shortridge Foltz, letter to Clara Bewick Colby, June 6, 1904, p. 2. The Huntington Library, San Marino, California.
19. Clara Shortridge Foltz, "What We Stand For," *The New American Woman* (February 1916), p. 3.
20. Clara Shortridge Foltz, letter to Alice Park, March 20, 1930, pp. 1-2. The Huntington Library, San Marino, California.
21. Alice Park, letter to Clara Shortridge Foltz, January 8, 1923, p. 1. The Huntington Library, San Marino, California.
22. Clara Shortridge Foltz, letter to Alice Park, December 18, 1923, p. 2. The Huntington Library, San Marino, California.
23. Schwartz, "Foltz," p. 548.

Chapter 20

1. Frederick Jackson Turner, *The Significance of the Frontier in American History* (New York: Henry Holt and Company, 1921), p. 2.

2. Ibid., p. 30.

3. Bill Nye, *Bill Nye's Western Humor* (Lincoln, NE: 1968), cited by T. A. Larson, "Women's Role in the American West," *Montana, The Magazine of Western History* 24 (Summer 1974), pp. 77.

4. Turner, *Significance of the Frontier*, p. 37.

BIBLIOGRAPHY

PRIMARY SOURCES CITED

Unpublished Materials

Canary, Martha Jane. "Calamity Jane's Diary and Letters, 1877-1903." Joint Collection, University of Missouri Western Historical Manuscript Collection, State Historical Society of Missouri. Columbia, Missouri.

Foltz, Clara Shortridge. Collection of personal letters, June 6, 1904 - April 24, 1931. The Huntington Library Archives. San Marino, California.

Periodicals

Foltz, Clara Shortridge. "The Struggles and Triumphs of a Woman Lawyer." *New American Woman* (June 1916): 5.

Foltz, Clara Shortridge. "The Struggles and Triumphs of a Woman Lawyer." *New American Woman* (August 1916): 11.

Foltz, Clara Shortridge. "The Struggles and Triumphs of a Woman Lawyer." *New American Woman* (January 1918): 10.

Trimm, Warren P. "Two Years in Kansas." *American Heritage* 34 (February/March 1982): 65-80.

Wilder, Laura Ingalls. "Frontier Times Remembered." *American History Illustrated* 19 (September 1984): 44-45.

Books

Barns, Cass G. *The Sod House.* 1930; reprint ed., Lincoln: University of Nebraska Press, 1970.

Bourne, Eulalia. *Woman in Levis.* Tucson: University of Arizona Press, 1967.

Burke, Mrs. M. *Life and Adventures of Calamity Jane by Herself.* Joint Collection, University of Missouri Western Historical Manuscript Collection, State Historical Society of Missouri. Columbia, 1896.

Custer, Elizabeth B. *Tenting on the Plains or General Custer in Kansas and Texas,* 1887, revised 1895; reprint ed., Williamstown, MA: Corner House Publishers, 1973.

Duniway, Abigail Scott. *Path Breaking: An Autobiographical History of the Equal Suffrage Movement in Pacific Coast States.* Portland: James, Kerns and Abbot, 1914; reprint ed., New York: Schocken Books, 1917.

Fuller-Ossoli, Margaret. *Woman in the Nineteenth Century and Kindred Papers Related to the Sphere, Condition and Duties of Woman.* Edited by Arthur B. Fuller. Boston: John P. Jewett and Co., 1855.

Guerin, Mrs. E. J. *Mountain Charley: or the Adventures of Mrs. E. J. Guerin, Who was Thirteen Years in Male Attire: An Autobiography Comprising a Period of Thirteen Years Life in the States, California, and Pike's Peak.* Dubuque, IA, 1861; reprint ed., Norman: University of Oklahoma Press, 1942.

Hopkins, Sarah Winnemucca. *Life Among the Piutes: Their Wrongs and Claims.* Edited by Mrs. Horace Mann. New York: G. P. Putnam's Sons, 1883.

McCracken, Elizabeth. *The Women of America.* New York: The MacMillan Company, 1904.

Myres, Sandra L., ed. *Ho For California: Women's Overland Diaries from the Huntington Library.* San Marino, CA: Huntington Library, 1980.

Owens-Adair. *Dr. Owens-Adair: Some of Her Life Experiences.* Portland, OR: Mann and Beach, Printers, N.D. No copyright date exists. However, the author mentions that she is writing during the administration of President Theodore Roosevelt, she gives her own retirement date as October 10, 1905, and she died in 1908. Therefore, the approximate date of publication is between 1906 and 1908.

Strahorn, Carrie Adell. *Fifteen Thousand Miles by Stage: A Woman's Unique Experience during Thirty Years of Path Finding and Pioneering from the Missouri to the Pacific and from Alaska to Mexico.* 1906; reprint editions 1911 and Lincoln: University of Nebraska Press, 1988.

SECONDARY SOURCES CITED

Unpublished Materials

Allen, Martha Mitten. "Women in the West: A Study of Book Length Travel Accounts by Women Who Traveled in the Plains and Rockies with Special Attention to General Concepts that the Women Applied to the Plains, the Mountains, Westerners and the West in General." Ph.D. dissertation, University of Texas at Austin, 1972.

Chrisman, L. R. Private letter to Earl Jones, March 10, 1960. Columbia, Missouri. Joint Collection, University of Missouri Western Historical Manuscript Collection – State Historical Society of Missouri, Columbus, Missouri.

Periodicals

Austin, Ellen. "Soddy Homemaker." *American History Illustrated* 10 (May 1982): 38-45.

"Bills To Be Presented Before the First Woman's Legislature." *Reply: An Anti-Suffrage Magazine* 1, no. 6 (October 1913): 124.

Brier, Warren J. "Tilting Skirts and Hurdy-Gurdies: A Commentary on Gold Camp Women." *Montana, The Magazine of Western History* 19 (Autumn 1969): 58-67.

Cheney, Lynne. "It All Began in Wyoming." *American Heritage* 24 (April 1973): 62-66, 97.

"Combative Oregonian Editor Harvey Scott Known as Man to Meet Problems Headon." *Oregonian*, 4 December 1960.

Cooper, Gary. "Stage Coach Mary, Gun-toting Montanan Delivered U.S. Mail." *Ebony* (October 1959): 97-100.

"The Debate on Woman Suffrage." *Oregonian*, 3 June 1906.

"H. W. Scott." *Oregonian*, 20 August 1906.

James, Laurence P., and Taylor, Sandra C. "Strong Minded Woman: Desdemona Stott Beeson and Other Hard Rock Mining Entrepreneurs." *Utah Historical Quarterly* 46 (Spring 1978):136-50.

Jensen, Joan M., and Miller, Darlis A. "The Gentle Tamers Revisited: New Approaches to the History of Women in the American West." *Pacific Historical Review* 49 (May 1980): 173-213.

"Jo Monaghan." *New York Post*, 21 December 1951. 10M.

"Joe Monaghan Was a Woman." *Idaho Daily Statesman,* (12 January 1904). 1.

"Judge Williams on Woman Suffrage." *Oregonian,* 3 June 1906.

Larson, T. A. "Dolls, Vassals, and Drudges–Pioneer Women in the West." *Western Historical Review* 49 (January 1972): 4-16.

Larson, T. A. "Women's Role in the American West." *Montana, The Magazine of Western History* 25 (Summer 1974): 3-11.

Litz, Joyce. "Lillian's Montana Scene." *Montana, the Magazine of Western History* 24, no. 3 (Summer 1974): 61.

Myres, Sandra L. "Romance and Reality on the American Frontier: Views of Army Wives." *Western Historical Quarterly* 13, no. 4 (October 1982): 421.

Reamy, Olive M. "The Suffragist's Mothers Helper." *Reply: An Anti-Suffrage Magazine* 1, no. 1 (May 1913): 7-8.

Rickert, Roger. "Little Jo." *Frontier Times* 46487 (July 1971); 39, 52-53.

Riley, Glenda. "Not Gainfully Employed: Women on the Iowa Frontier 1833-1870." *Pacific Historical Review* 49 (May 1980): 237-64.

Scholten, Catherine M. "On the Importance of the Obstetrick *Art: Changing Customs of Childbirth in America,* 1760-1825," *William and Mary Quarterly,* vol. 34 (1977), pp. 426-45.

Schwartz, Mortimer D., Brandt, Susan L., and Milrod, Patience. "Clara Shortridge Foltz: Pioneer in the Law." *Hastings Law Journal* 27 (January 1976): 545-64.

Scott, Mrs. William Forse. "Woman and Government: The Demand for Right as Opposed to the Recognition of Duty in Relation to Government." *Woman's Protest* 1, no. 1 (May 1912): 5-6.

"A Severe Lesson." *West Shore* 5, no. 7 (July 1879): 219.

Books

Adams, Ramon R. *Burs Under the Saddle: A Second Look at Books and Histories of the West.* Norman: University of Oklahoma Press, 1964.

Aikman, Duncan. *Calamity Jane and the Lady Wildcats.* New York: Blue Ribbon Books, 1927.

Beard, Mary R. *America Through Woman's Eyes*. New York: The MacMillan Company, 1933.

Beasley, Delilah. *The Negro Trail Blazers of California*. Los Angeles, 1919. Reprint San Francisco: R and E Research Associates, 1968.

Brown, Dee. *The Gentle Tamers: Women of the Old Wild West*. New York: G. P. Putnam's Sons, 1958.

Butler, Anne M. *Daughters of Joy, Sisters of Mercy: Prostitutes in the American West 1865-90*. Urbana: University of Illinois Press, 1985.

Cott, Nancy F., ed. *Root of Bitterness: Documents of the Social History of American Women*. New York: E. P. Dutton and Co., 1972.

Earhart, Mary. *Frances Willard: From Prayers to Politics*. Chicago: University of Chicago Press, 1944.

Erdoes, Richard. *Saloons of the Old West*. New York: Alfred A. Knopf, 1979.

Faragher, John Mack. *Women and Men on the Overland Trail*. New Haven, CT: Yale University Press, 1979.

Fischer, Christiane, ed. *Let Them Speak for Themselves: Women in the American West 1849-1900*. Hamden, CT: Shoe String Press, 1977.

Flexner, Eleanor. *Century of Struggle: The Women's Rights Movement in the United States*. Cambridge: Belknap Press of Harvard University Press, 1959.

Horan, James D., and Sann, Paul. *Pictorial History of the Wild West: A True Account of the Bad Men, Desperadoes, Rustlers and Outlaws of the Old West—and the Men Who Fought Them to Establish Law and Order*. New York: Crown Publishers, 1954.

Howard, Harold P. *Sacajawea*. Norman: The University of Oklahoma Press, 1971.

Jackson, Helen Hunt. *A Century of Dishonor: The Early Crusade for Indian Reform*. New York: Harper and Brothers, 1881. Edited by Andrew F. Rolle. Harper and Row, Publishers, 1965.

Jeffrey, Julie Roy. *Frontier Women: The Trans-Mississippi West 1840-1890*. New York: Hill and Wang, 1979.

Jordan, Teresa. *Cowgirls: Women of the American West*. New York: Anchor Press, Doubleday and Co., 1982.

Knight, Oliver. *Life and Manners in the Frontier Army*. Norman: University of Oklahoma Press, 1978.

Lapp, Rudolph M. *Blacks in Gold Rush California.* New Haven, CT: Yale University Press, 1977.

Larson, T. A. *History of Wyoming.* Lincoln: University of Nebraska Press, 1965.

Lerner, Gerda. *The Majority Finds Its Past: Placing Women in History.* New York: Oxford University Press, 1979.

Luchetti, Cathy, and Olwell, Carol. *Women of the West.* St. George, UT: Antelope Island Press, 1982.

McLoughlin, Denis. *Wild and Woolly: An Encyclopedia of the Old West.* New York: Doubleday and Company, 1975.

Miller, Ronald Dean. *Shady Ladies of the West.* Los Angeles: Westernlore Press, 1964.

Moynihan, Ruth Barnes. *Rebel for Rights: Abigail Scott Duniway.* Hartford, CT: Yale University Press, 1983.

Mueller, Ellen Crago. *Calamity Jane.* Laramie, WY: Jelm Mountain Press, 1981.

Myres, Sandra L. *Westering Women and the Frontier Experience 1800-1915.* Albuquerque: University of New Mexico Press, 1982.

Oritz, Roxanne Dunbar. *Indians of the Americas: Human Rights and Self-Determination.* New York: Praeger Publishers, 1984.

Penson-Ward, Betty. *Idaho Women in History.* Boise, ID: Legendary Publishing Co., 1991.

Penson-Ward, Betty. *Who's Who of Idaho Women of the Past.* Wilder, ID: Parvin Printing, 1981.

Propst, Nell Brown. *Those Strenuous Dames of the Colorado Prairie.* Boulder, CO: Pruett Publishing Co., 1982.

Prucha, Francis Paul, ed. *Americanizing the American Indians: Writings by the "Friends of the Indian"* 1880-1900. Cambridge: Harvard University Press, 1973.

Reiter, Joan Swallow. *The Old West: The Women.* Alexandria, VA: Time-Life Books, 1978.

Richey, Elinor. *Eminent Women of the West.* Berkeley, CA: Howell–North Books, 1975.

Rosenberg, Rosalind. *Divided Lives: American Women in the Twentieth Century.* New York: Hill and Wang, 1992.

Ross, Nancy Wilson. *Westward the Women.* New York: Alfred A. Knopf, 1944.

Savage, W. Sherman. *Blacks in the West*. Westport, CT: Greenwood Press, 1976.

Schick, Robert. "Prostitution." *The Reader's Encyclopedia of the American West*. Howard R. Lamar, ed. New York: Thomas Y. Crowell, 1977.

Senkewicz, S. J. *Vigilantes in Gold Rush San Francisco*. Stanford, CA: Stanford University Press, 1985.

Sochen, June. *Herstory: A Woman's View of American History*. New York: Alfred Publishing Co., 1974.

Spence, Vernon Gladden. *Pioneer Women of Abilene*. Burnet, TX: Eakin Press, 1981.

Sprague, William Forrest. *Women and the West: A Short Social History*. Boston: Christopher Publishing House, 1940.

Stallard, Patricia Y. *Glittering Misery: Dependents of the Indian Fighting Army*. San Rafael, CA: Presidio Press, 1978.

Statistical History of the United States from Colonial Times to the Present. Stamford, CT: Fairfield Publishers, 1965.

Stratton, JoAnna L. *Pioneer Women: Voices from the Kansas Frontier*. New York: Simon and Schuster, 1981.

Tannahill, Reay. *Sex in History*. Chelsea, MI: Scarborough House/Publishers, 1992.

Turner, Frederick Jackson. *The Frontier in American History*. New York: Henry Holt and Company, 1921.

Wallace, Robert. *The Old West: The Miners*. Alexandria, VA: Time-Life Books, 1976.

Washburn, Wilcomb E. *The Indian in America*. New York: Harper and Row, 1975.

Webb, Walter Prescott. *The Great Plains*. Lincoln: University of Nebraska Press, 1981.

Wilson, Dorothy Clarke. *Bright Eyes: The Story of Susette LaFlesche, An Omaha Indian*. New York: McGraw-Hill Book Co., 1974.

PRIMARY SOURCES CONSULTED

Unpublished Materials

Burt, Mrs. Elizabeth J. "Forty Years in the Regular Army 1862-1902." Manuscript. Washington, D.C. Library of Congress Manuscripts Division.

Periodicals

Foltz, Clara Shortridge. "The Struggles and Triumphs of a Woman Lawyer." *New American Woman* (February 1916 - March 1918).

"Editors Table." *Godey's Magazine and Lady's Book* 24 (October 1854): 365.

"May: The Squatter's Daughter." *Godey's Lady's Book and Magazine* 54 (January 1857): 23-26.

"A Real Lady." *Godey's Magazine and Lady's Book* 21 (July 1854): 80.

"Table of Contents." *Godey's Lady's Book and Magazine* 54 (January 1857): iv.

Books

Blanc, Marie Therese de Solms. *The Condition of Women in the United States: A Traveller's Notes.* Boston: Roberts Brothers, 1895.

Lockley, Fred. *Conversations with Pioneer Women.* Eugene, OR: Rainy Day Press, 1981.

Nelson, Margaret A. *Home on the Range.* Boston: Chapman and Grimes, 1947.

Tibbles, Thomas Henry. *Buckskin and Blanket Days, Memoirs of a Friend of the Indians.* New York: Doubleday, 1957.

SECONDARY SOURCES CONSULTED

Unpublished Materials

Beeton, Beverly. "Woman Suffrage in the American West 1869- 1896." Ph.D. dissertation, University of Utah, 1976.

Melder, Keith Eugene. "The Beginnings of the Women's Rights Movement in the United States 1800-1840." Ph.D. dissertation, Yale University, 1964.

Periodicals

Armitage, Sue. "Western Women: Beginning to Come into Focus." *Montana, The Magazine of Western History* 32 (Summer 1982): 2-9.

Bennion, Sherilyn Cox. "Ada Chase Merritt and the Recorder: A Pioneer Idaho Editor and Her Newspaper." *Idaho Yesterdays* 25 (Winter 1982): 22-30.

Bentz, Donald N. "Frontier Angel." *True Stories of the American West* (July 1972): 6-8, 60-61.

Clum, John P. "Nellie Cashman." *Arizona Historical Review* 3, no. 4. (January 1931): 9-35.

de Graaf, Lawrence B. "Race, Sex, and Region: Black Women in the American West 1850-1920." *Pacific Historical Review* 49 (May 1980): 285-313.

Drury, Clifford M. "Wilderness Diaries." *American West* (November/December 1976): 4-9, 62-63.

"Fifty Years Ago in the *Statesman.*" *Idaho Sunday Statesman*, 24 January 1954, 11.

Forrey, Carolyn. "Gertrude Atherton and the New Woman." *California Historical Quarterly* 55 (Fall 1976): 194-209.

Griswold, Robert L. "Apart But Not Adrift: Wives, Divorce and Independence in California 1850-1890." *Pacific Historical Review* 49 (May 1980): 265-83.

"Joe Monaghan's Life." *Idaho Daily Statesman,* 13 January 1904, 5.

Keen, Effie R. "Lola Oury Smity." *Arizona Historical Review* 4 (January 1931): 20-22.

Larson, T. A. "Woman Suffrage in Wyoming." *Pacific Northwest Quarterly* 56 (April 1965): 57-66.

Lerner, Gerda. "The Lady and the Mill Girl: Changes in the Status of Women in the Age of Jackson." *American Studies Journal* 10 (Spring 1969): 5-14; reprint ed., Midcontinent American Studies Association, 1969.

Lyon, Peter. "The Wild, Wild West." *American Heritage* 11 (August 1960): 32-48.

Myres, Sandra L. "A Woman's View of the Texas Frontier 1874: The Diary of Emily K. Andrews." *Southwestern Historical Quarterly* 12 (July 1982): 44-48.

Patterson-Black, Sheryll. "Images of Women on the Agricultural Frontier." *Frontiers, A Journal of Women's Studies* 1 (Spring 1972): 67-68.

Pence, Mary Lou. "Petticoat Rustler." *American History Illustrated* 17 (June 1982): 52-27.

Reply: An Anti-Suffrage Magazine 1, no. 1 (May 1913).

Reply: An Anti-Suffrage Magazine 1, no. 2 (June 1913).

Reply: An Anti-Suffrage Magazine 1, no. 3 (July 1913).

Reply: An Anti-Suffrage Magazine 1, no. 4 (August 1913).

Reply: An Anti-Suffrage Magazine 1, no. 5 (September 1913).

Reply: An Anti-Suffrage Magazine 1, no. 6 (October 1913).

Reply: An Anti-Suffrage Magazine 1, no. 7 (November 1913).

Riley, Glenda. "Images of the Frontierswoman: Iowa as a Case Study." *Western Historical Quarterly* 8 (April 1977): 189-202.

Riley, Glenda. "Women in the West." *Journal of American Culture* 3 (Summer 1980): 311-29.

Snell, Joseph W., ed. "Roughing It on Her Kansas Claim: The Diary of Abbie Bright 1870-1871." *Kansas Historical Quarterly* 37 (Autumn 1971): 233-68; 38 (Winter 1971): 394-428.

Underhill, Lonnie E., and Littlefield, Daniel F. "Women Homeseekers in Oklahoma Territory 1889-1901." *Pacific Historical* 17 (Fall 1973): 36-45.

Welter, Barbara. "The Cult of True Womanhood 1820-1860." *American Quarterly* 18 (Summer 1966): 152-64.

Williams, Patricia Owens. "Self-Made and Unself-Made: The Myth of the Self-Made Man and the Ideologies of the True Woman, New Woman and Amazon 1820-1920." Ph.D. dissertation, University of New Mexico, 1982.

Woman's Protest 1, no. 1 (May 1912).

Woman's Protest 1, no. 2 (June 1912).

Woman's Protest 1, no. 3 (July 1912).

Woman's Protest 1, no. 4 (August 1912).

Woman's Protest 1, no. 5 (September 1912).

Books

Andreas, Carol. *Sex and Caste in America.* Englewood Cliffs, NJ: Prentice Hall, 1971.

Beard, Mary R. *Woman as Force in History: A Study in Traditions and Realities.* New York: MacMillan Company, 1946.

Bishop, Beverly D., and Bolas, Deborah W., eds. *In Her Own Write: Woman's History Resources in the Library and Archives of the Missouri Historical Society.* St. Louis: Missouri Historical Society, 1983.

Coolidge, Olivia. *Women's Rights: The Suffrage Movement in America 1848-1920.* New York: E. P. Dutton and Company, 1966.

Degler, Carl. *At Odds: Women and the Family in America From the Revolution to the Present.* New York: Oxford University Press, 1980.

DePauw, Linda Grant, and Hunt, Conover. *Remember the Ladies: Women in America 1750-1815.* New York, Viking Press, 1976.

DeVoto, Bernard, ed. *The Journals of Lewis and Clark.* Boston: Houghton Mifflin Company, 1953.

Dick, Everett. *The Sod-House Frontier 1854-1890.* Lincoln, NE: Johnson Publishing Company, 1954.

Drago, Harry Sinclair. *Notorious Ladies of the Frontier.* New York: Dodd, Mead and Company, 1969.

Ellet, Mrs. *Pioneer Women of the West.* New York: Charles Scribner, 1898.

Faulkner, Harold Underwood. *The Quest for Social Justice 1898-1914.* New York: MacMillan Company, 1931.

Fowler, William W. *Woman on the American Frontier: A Valuable and Authentic History of the Heroism, Adventures, Privations, Captivities, Trials, and Noble Lives and Deaths of the "Pioneer Mothers of the Republic."* Hartford, CT: S. S. Scranton and Co., 1879.

Hahn, Emily. *Once Upon a Pedestal.* New York: Thomas Y. Crowell, 1974.

Hinding, Andrea, ed. *Women's History Sources: A Guide to Archives and Manuscript Collections in the United States.* 2 vols. New York: R. R. Bowker Company, 1979.

Malone, Michael P. *Historians and the American West.* Lincoln: University of Nebraska Press, 1983.

McCallum, Jane Y. *Women Pioneers.* New York: Johnson Publishing Company, 1929.

Noun, Louise R. *Strong-Minded Women: The Emergence of the Woman Suffrage Movement in Iowa.* Ames: Iowa State University Press, 1969.

Parker, Gail, ed. *The Oven Birds: American Women on Womanhood 1820-1920.* Garden City, NY: Doubleday and Co., 1972.

Rascoe, Burton. *Belle Starr: The Bandit Queen.* New York: Random House, 1941.

Rasmussen, Linda; Rasmussen, Lorna; Savage, Candace; and Wheeler, Anne. *A Harvest Yet to Reap: A History of Prairie Women.* Toronto: The Women's Press, 1976.

Riley, Glenda. *Frontierswoman: The Iowa Experience.* Ames: Iowa State University Press, 1981.

Riley, Glenda. *Women and Indians on the Frontier* 1825-1915. Albuquerque: University of New Mexico Press, 1984.

Ryan, Mary P. *Womanhood in America: From Colonial Times to the Present.* New York: New Viewpoints, a division of Franklin Watts, 1975.

Schlissel, Lillian. *Women's Diaries of the Westward Journey.* New York: Schocken Books, 1982.

Smith, Page. *Daughters of the Promised Land: Women in American History.* Boston: Little, Brown and Co., 1970.

Welter, Barbara. *Dimity Convictions: The American Woman in the Nineteenth Century.* Athens: Ohio University Press, 1976.

West, Elliot. *The Saloons on the Rocky Mountain Mining Frontier.* Lincoln: University of Nebraska Press, 1979.

INDEX